Knidos
Memories of
Aphrodite

Knidos
Memories of
Aphrodite

Richard Hodges

Brick Tower Press
New York

Brick Tower Press
Manhanset House
Dering Harbour, New York 11965-0342
bricktower@aol.com
www.BrickTowerPress.com

Copyright © 2021 by Richard Hodges
First Edition
Library of Congress Cataloging in Publication Data
Hodges, Richard
Knidos, memories of aphrodite.
Cover design by Craig Coulthard

Includes index.
1. ART—History—Ancient & Classical. 2. History—Ancient Greece. 3. Social Science—Archaeology. I. Title.

ISBN: 978-1-899694-87-7
February 2021

Table of Contents

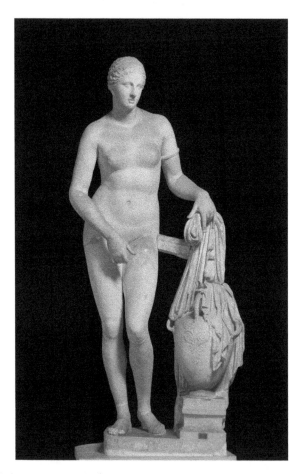

A Roman (2nd-century) copy of the Aphrodite of
Knidos in the Vatican Museum, Rome
(courtesy of Scala).

To Charlotte, Rafi and Will

'the Traveller who commences Author on the humbler Pretenſions of a plain and faithful Relation of what he has feen, whoſe Candor and Accuracy are more at ſtake than his Taſte or Judgement, cannot more effectually recommend himſelf to public Favour than by a fair Account of the Opportunities he had of being informed, the Means by which he acquired his Knowledge, and the Manner in which he collected his Facts.'

Richard Chandler, *Ionian Antiquities*, Vol. 1 (London, 1769), i.

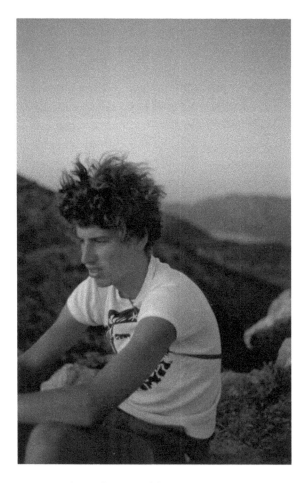

The author at Knidos, August 1971.

Prologue

Ruins of Cnidus, December 26th, 1857

'On the 10th of this month I was conveyed from Budrum to this place in the Supply, with a select party, consisting of Mr. R. P. Pullan, the architect attached to the expedition; the carpenter of the Supply; a sergeant and six marines, who are assigned to the party as a guard, and two sappers, – one a photographer, the other a mason. We landed in the teeth of a bitter north wind. The anchorage is not very safe, and the harbour very shallow, with no pier. However, we managed to get on shore the timbers of six of our huts before the Supply was forced to leave to take shelter in the snug bay of Budrum. Having chosen a site for an encampment within the peribolos of a temple, on the shore near the isthmus, we proceeded to put one of our huts together.

'We are surrounding our little encampment with a wall, and intend to keep a strict watch at night; for though I do not think an attack of pirates likely, still it might occur if we were careless. There are many islands within one or two days' sail of Cape Crio, which could muster thirty or forty armed ruffians for such an enterprise; and in my short experience of Turkey I have known whole towns surprised and plundered by bands not more numerous, for want of a sentry at night.

'There is something very attractive in this place – the delicious freshness of the air, the beauty of the scenery, the stir and activity of our little colony in the midst of such loneliness and ruin The sea-view here is much more lively than at Budrum, as we have a glimpse of all that passes up and down on the great highway between the Dardanelles and Rhodes.

The French and Austrian steamers going to and fro with letters, almost within hail of us, are a cheerful sight, one of the pleasantest that can gladden the heart of an exile.'

–Charles T. Newton, *Travels and Discoveries in the Levant* (London, 1865), 160-62.

Knidos has resisted change. To come upon Cape Crio along the coast road or to sail there is to discover a magical world, a lost civilization, a place appropriately associated with a goddess.

Are we the last generation to experience the spirit of ruins and the adventure of discovery that reaches back to 18th-century antiquarians, like Richard Chandler who graced the beginnings of the European Enlightenment, and irrepressible Victorians like Charles Newton? This enchanted world has been almost eviscerated. You cannot weep for it, nor can you deny an affecting nostalgia for its colours and visceral textures, so authentic and certain. In 1971 when I joined Iris Cornelia Love's archaeological expedition to Knidos, in south-west Turkey, the last embers of the world that Chandler and Newton knew still existed. More to the point, Charles Newton was metaphorically still amongst us – he gave bearings to our quotidian purposes – and, improbably, his Victorian world of peasants and brigands and coal-fired steamers still more or less existed. There was one difference, apart from our jeeps and land-rovers. Iris Love's expedition was privately funded by donors from Manhattan's Fifth Avenue, unlike Newton's mammoth campaign whose support was obtained by a parliamentary vote in the House of Commons.

Iris, like Newton, was in search of trophies. Principally, Praxiteles's timeless, naked Aphrodite had eluded the Victorian archaeologist, hence Iris's quest. Its numerous imitators reveal its canonical importance for the story of artistic creativity. In her

book on the statue, Christine Mitchell Havelock establishes its peerless status thus:

'The female nude as a subject for art in its three dimensional and monumental form was introduced by the late classic sculptor Praxiteles. The work was the statue of Aphrodite purchased by the city of Knidos in about 350 BC. It was an innovation of great significance and major consequences. Not only did Praxiteles introduce the naked Aphrodite as a subject into classical Greek art; it is also accepted that his work inspired later Greek versions of the goddess. These in turn were adopted by Rome, which disseminated them far and wide. In this way the female nude as a subject for the plastic arts entered the mainstream of the West'.[1]

It takes supreme imagination today to provenance this ground-breaking intervention in world art to this rugged, almost outlandish place.

Ancient Knidos lies at the tip of a long mountainous finger of land jutting out into this sea. It is as unexpected as it is magical. Today, as forty years ago, because the twisting road along the corniche is so narrow and perilous, most visitors arrive by yacht, anchoring in the Hellenistic Commercial harbour inside the safety of the ancient moles.

Modern Knidos, known locally as Tekir, amounts to very little. Ruşan's restaurant remains at the terminus of the wonky, makeshift jetty; Cengez's café remains too, though it is no longer a shack. There is a *Jandarma* for the military and an anonymous store for the excavation finds. This loose gaggle of buildings is dwarfed by the scale of the sprawling Hellenistic, Roman and Byzantine city. The lost metropolis rises up like a

[1] Christine Mitchell Havelock, *The Aphrodite of Knidos and Her Successors* (New York, 2007), 1.

theatre on countless terraces, occupying the last three kilometres of the peninsula as well as the adjoining islet of Cape Crio where a stunted Victorian lighthouse, replacing an ancient pharos, still serves as a seamark.

Charles Newton was excavating at a time when the British navy ruled the Mediterranean Sea, deploying a ship of the line and sappers at the height of the Crimean War. A little over a century later Iris's dig spanned the Vietnam War and involved veterans, and introduced a cohort of East Coast young women, from the most selective of schools, to the rigours of archaeological fieldwork and the glories of crossing cultures, especially in affairs of the heart. As with all archaeological digs, there was a galaxy of unlikely personalities. Each selected for his or her task. I was the youngest of a field team numbering around twenty-five, and apart from the pot-washing boys, much younger than the legion of upwards a hundred men hired from the surrounding villages. These men created homes in lean-tos of branches brought from their fields, flimsy bowers amongst the ruins. We slept in shoddy tents on the narrow beach in the lea of Cape Crio and ate and worked in a spare dig-house close by. There was one electrical light, a makeshift shower from a single pipe of water, and a 'loo with a view' that attracted a menacing multitude of flies. The rim of our world for the sojourn of the expedition was shaped by the dark shadow of the cape, then as in Newton's time a seamark for navigators threading their way through the Aegean Sea islands of the Dodecanese, almost perpetually floating in a blaze of crystalline blue, or at dusk wreathed with vermillion.

A phantom amongst us, the Victorian had been there, excavated it, observed and travelled on to become a great intellect in 19th-century London society. Our Newton had been only a junior keeper in the British Museum before rising to be Her Majesty's consul in the islands opposite Asia Minor. With

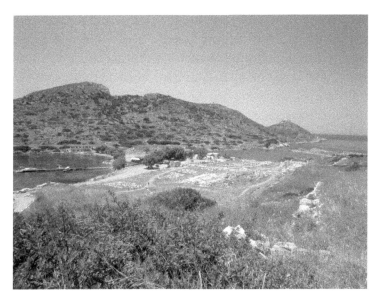

Commercial harbour, the camp on the isthmus, and its beach
to the left. Beyond the Trireme harbour is the Cape Crio
lighthouse (photo by the author).

unimaginable initiative today he managed to win government support in the form of a steam corvette and sappers in order to appropriate sculptures from the ancient city. With resolution he also mapped and excavated Knidos on a propitious scale. The rhythm of his daily activity bears no resemblance to our experiences, exhausting though these were. His goals were titanic, and so was his effort. Men died, crushed by his ambition, their memories swiftly lost as millions came to stare at the treasures transported to London. Tons of rock were displaced and tons of marble sculpture were loaded onto *HMS Supply*. Two of these many marble trophies displaced to the British Museum have forever captivated visitors.

Pride of place goes to the seven-ton hollow-eyed lion (disengaged by Newton's sappers from atop a grandiose Hellenistic tomb). Today it mounts guard in the Great Court of the British Museum. So much has this great beast seen. His chance discovery, though, was perhaps his downfall, as Newton himself recalled:

'Pullan presented himself to my astonished gaze in a state of most unusual excitement, for he is naturally of a most equable temperament. His hat was crowned with a large wreath of oleander flowers, his eyes had a wild expression like those who had passed the night on Parnassus or Snowdon. "I have found the lion," he said.'[2]

The lion, captured, transported, tamed, no longer a great seamark, deprived of his majesty is a meeting point in the British Museum where flocks of visitors pause to take selfies.

Newton's other great treasure, a matronly statue of the goddess, Demeter, today is just one of countless in the British Museum. The finger of exceptionalism fell upon her in Victorian times but rarely does today.

[2] Charles T. Newton, *A History of Discoveries at Halicarnassus, Cnidus and Branchidae* (London, 1862), 480.

I knew nothing of this Demeter when I arrived in June 1971 to be dispatched, with ten workmen and their mules, to excavate the Temenos where Charles Newton had discovered the goddess that long before, by his own admission, had spell-struck him:

'The features and form are those of an elderly woman wasted with sorrow, and do not exhibit that matronly comeliness and maturity of form which usually characterize Demeter in ancient art'.

She also captivated the Edwardian novelist, E. M. Forster, whom on one winter's day journeyed to Knidos. On hiking up across the terraces to the Temenos high above the harbours, Forster mused thoughtfully on the goddess:

'She was there [in the British Museum] at that moment, warm and comfortable in that little recess of hers between the Ephesian Room and the Archaic Room, with the electric light fizzling above her, and casting blue shadows over her chin. She is dusted twice a week, and there is a railing in front, with "No Admittance", so that she cannot be touched. And if human industry can find that lost arm of hers, and that broken nose, and human ingenuity can put them on, she shall be made as good as new'.[3]

Charged by the blithe and sometime daffy spirited Iris Cornelia Love, our director patrolling Newton's footsteps, my task in 1971, I now suspect (though no-one said so at the time), was to find those limbs.

Viewed through the transforming lens of memory the past seems so enchanted that even thought is possibly unworthy of

[3] E.M. Forster, Cnidus, *Abinger Harvest*, (London, 1936), 171-72.

it: it amounts to indelible memories shaped by the daily, makeshift science of trenching into a lost metropolis. The memory is the sum of a few bleached photographs complementing journal jottings in a small grocery pocket-book, or perhaps more accurately, adolescent musings released by the infinite wonder of ancient Triopion. More than four decades have passed so this account is charted through the prism of a career in ruins, mostly in the Mediterranean. Back then, aged eighteen, my world largely encompassed the bounds of a parish in the rolling southern hills of the Cotswolds, where I knew every farmer and every lynchet, and where the badgers had made their setts. Here I had discovered adolescent purpose on the excavations of a Roman villa in the vicar's garden. Here I first troweled down to encounter those tell-tale rounded mites of sand that magically signpost the presence of a mosaic pavement. Here I founded a village archaeological society, enticing significant names in archaeology – of my age now — to grace evenings in our midst. Aged eighteen, my compass was overly assured of so much. Raised in arcadia I arrived at Knidos in a surplus naval jacket and flared trousers unprepared for the timeless form of things. I knew nothing of Turkey or its political instability following a military coup three months earlier. My summer home was a peninsula in no sense domesticated except for the ruined metropolis of Knidos meeting blue miles of sea. This was a world orchestrated to the beat of peasants and mirages from afar, universes in American colleges and Manhattan with moralities I scarcely understood. Like a dutiful student I willed to learn.

Now I appreciate the unrequited generosity to me of Iris Cornelia Love, of Henry, of Tim Tatton-Brown, of Sheila, and of many others including the workmen from Knidos' villages. Did I seem feckless or just unshaven and immature in my fraying shorts and Che Guevara shirt from Rome's Campo de' Fiori

market: a head of thick curls with eyes of a Minoan, so Iris said? To answer, however reluctantly, is to enter the penumbra of shadow cast by time. The deeds of decades have refracted my Ionian pleasures and memories. For sure Knidos rendered me the discovery of myself. I learnt to tame my impatience, to listen, and to love. Above all I learnt. With the passage of decades since Cape Crio the tones of my voice have indubitably hardened and mellowed at the same time, yet I am no less certain of the pleasures of that summer. The scented blessing of sea-blown thyme never ceases to transport me back to my personal odyssey to discover Demeter, or at least bits of her.

1

To Knidos

Through the veil of billowing dust, clinging tightly to the back of the Willy's jeep, I could see the lofty outline of Cape Crio. At first sight it resembled a slumbering giant, dark and forbidding. The faintest hint of the sunset lingered, then in a wink slipped away. I eased myself back, and turned to my companion. Brushing the dust from my eyes, I edged along the back-board towards Emin, soon to be the cook's assistant. Wary of the jeep bouncing over the corniche road with its plunging drops alongside us, he flashed a winning grin through a mask of dirt, as if to say we'd survived.

'Knidos', he shouted, 'bewtiful, very bewtiful.' Plainly satisfied to have practiced his English, he turned to look at the far horizon.

Seconds later, with the afterthought of the sun's rays dismissed, the darkness became peppered with stars. Our worst fears expunged, our journey had become thrilling. On the jeep struggled, like a mule racing cantankerously towards some indefinable goal, towards Knidos. This, the most frightening day of my life, was the first of July. I had arrived to join Iris Cornelia Love's excavations.

Little over a week had passed since I had left England. Long unkempt hair, wiry thin, and raised on a safe dosage of novels and romances in an English village, could I be a budding archaeologist? The cheap option of reaching ancient Triopion involved a journey spanning a week. Travelling with my regulation rucksack by train for two days to Rome, I joined a

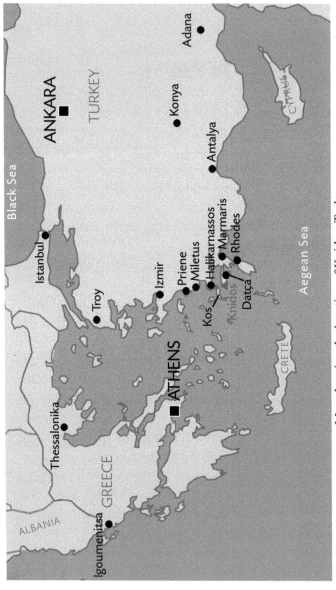

Map showing the location of Knidos, Turkey
(drawn by Sarah Leppard).

land-rover convoy that set out for Knidos from the British School at Rome.

We were the vanguard of Iris Cornelia Love's archaeological team, the sixth season at Knidos, 1971. Led by her pint-sized chief-of-staff, a curator from the Metropolitan Museum kitted out in pressed khaki, Marie Keith, we numbered three Brits – Henry, Tim and myself, and a nervy Canadian photographer, named Matthew.

Marie was the tight-lipped mistress of our travels, defying age and discomforts to lend romance to her curatorship. Henry was gangly, square-jawed, buck-toothed, inimitably Oxbridge and naturally patrician. The son of an Indian Army officer of Anglo-Irish descent, consigned to public school where he discovered archaeology in the mud of the Midlands, then a scholarship to St. John's, Cambridge where in the 'sixties archaeologists were nurtured in the effete bosom of Dr. Glyn Daniel. With such experiences, Henry advanced effortlessly from excavating a large Roman villa at Box (near Bath), where I first met him, to being the municipal archaeologist to Gloucester City Council. The Knidian excursus was an escape from his role as the Council's fig-leaf, protecting their patrimony as Gloucester's medieval heart was wantonly desecrated to erect new malls. Tim was no less quintessentially English, faintly corpulent with wire-framed glasses, and the cut-glass gravity of the officer class. As a chorister he was undoubtedly a cherub, but his receding hairline and broad forehead, as well as his fidgeting together with a tendency to disquisition, lent Tim the instant aura that age would not be kind to him. He was obviously bruised, but heroically determined not to show it. An exact contemporary of Henry's, after public school Tim had flunked university and, in a bother, had discovered archaeology, and by serendipity landed at Knidos the previous year. His travelling companion was a full-throttle obsession with antiquity

and the mystique of its arcane lexicon. Matthew, a taciturn Canadian, larval about the every quotidian twist and turn sought sanctuary in a silence broken only by his word-heavy monotone. Being a grammar school boy, timidly younger, and little travelled, an obvious mismatch soon emerged between my companions and me.

We motored out of Rome at dawn on a bright Friday morning past Monte Cassino to Brindisi, where we took a ferry by way of Corfu to Igoumenitsa and thence threaded our way through Epirus to Thrace. There was the pleasure of seeing Albania's forbidden mountains at dawn, the unvarnished villages with canopies of stout sycamores in upland Greece and the warm seafront at Salonika, my first dinner on the dark Aegean. As Lawrence Durrell wrote, 'you are aware of a change in the heart of things; aware of the horizon beginning to stain at the rim of the world'.

On Sunday afternoon we raced across the golden plains to the Hellespont, past thousands of peasants gathered around heavy wheeled wagons, collecting the harvest. We motored onwards like royalty. Flocks of children waved to us, shrieking 'goodbye, goodbye!' and the women paused to stare, cupping their hands over their eyes. In the dark we dropped down to the Dardanelles, queued with lines of trucks, before taking the ferry to Çanakkale. On reaching Asia Minor we sought accommodation in a petrol station outside Troy. With dawn we visited the lost city, an amorphous collection of grassy mounds and unkempt walls, then with renewed purpose sped south past Assos in blazing sunshine to make a rendez-vous in Izmir.

The objective of the three and a half-day drive at full tilt was to meet Iris and diggers recruited from Istanbul as well as America in the Büyük Efes hotel in Izmir. This glass palace was perfect for Iris, the last of the Guggenheims, with its acres of

sparkling pools, smooth yachting types, and uniformed bell-boys, an air-conditioned oasis from the Ottoman every-day and indeed ours. Any concern that this adventure might soon be punctured by new rules quickly dissolved. In reception Marie discovered a telegram from Iris - she'd been delayed in New York by two weeks!

Marie took this news in her stride. Spinsterish, now in charge, eschewing recriminations about Iris's betrayal, she determined to fill the time purposefully. Supplies and equipment would be purchased. Then, onto Knidos we would go for the excavation season. Henry and Tim like schoolboys allergic to chores decamped to ancient Sardis, while under Marie's matronly tutelage we were treated to a tour of the bazaar in the company of our new Turkish team-members. Covered, busy, yet illuminated by shafts of treasured light and resonating to the discordance of bird song and hawkers's calls, the market with its crooked streets was intimate. In gnome-sized dark shops no bigger than booths with counters of groaning homespun produce, sacks of sugar were purchased, next door shovels were weighed and bought; and then picks and iron wheel-barrows were ordered. At each point on this odyssey we drank strong black tea and enjoyed the serene obsequious pleasures of negotiation. A lorry-load of materiel was assembled; Tim and I would accompany it to Knidos. Apparently, we were needed to nurture the driver along the road. Many times in the past, Marie said in a matter-of-fact tone, drivers had turned back, petrified. My ears pricked up. Petrified. Marie was not one to exaggerate.

Later, with Henry and Tim returned, loftily regaling us with their bold adventures, we ate altogether for the first time as a team, completing dinner with fresh strawberries. Tacitly marginalized by my British peers to the far end of a lengthy table, I discovered a liberating pleasure from the land-rover

confinement in talking with the three Turkish girls, Ilknur Küçük, Nermin Ünsel and Ender. Ilknur and Nermin were old project hands; Ender was new and her English troubled her. All were studying archaeology at Istanbul, destined to be professors, teachers or accredited site guides. All three flashed smiles easily, and like a chorus inhaled conscientiously on their contraband American cigarettes. Radiant, palpably released, they were taking flight for Knidos from their regulated lives. Only later would I begin to grasp the freedoms that Knidos meant for them.

I mentioned that I was accompanying the lorry-load of materiel, with Tim. It gave me some purpose for my presence in the group, although it was an allusion to my concerning sense of adolescence, accentuated by Henry and Tim's patrician attitude to me.

'Terrible drive; really terrible. So dangerous. Sheila went over. Over the edge two years ago', Nermin said to Ender but clearly staring at me, her brown eyes brightening, acknowledging the perverse pleasure as if we were about to pass through the gates of Hades to paradise. She then smiled shyly, perhaps realizing the error in magnifying the perils in store.

'Best by *kayik* from Bodrum', she added, as if to assuage my fears.

Looking back across the decades, that day the door to my old world arranged around an English village and its excursus to university began closing and a magical new one was taking shape.

At dawn, when I woke, Tim had gone. He left me a bus ticket and scribbled directions. The others departed in pre-arranged vehicles, Marie with Henry directly to Knidos, while the Turkish girls would wait for me in Marmaris. The revised plan was to meet there before embarking upon the Datça road and thence

Cape Crio. Alone for the first time in Turkey I mused on Tim's prank – as I interpreted it, on the malice of separating me from the others. Looking back, I should not have worried. Pamukkale coaches were new Mercedes; the service aimed to be good. The driver's assistant doled out eau de cologne, and then free drinks from an ice-box at the back. Around Izmir's arcing bay we travelled, then south to Selçuk, where the coach paused, before steaming along the unsurfaced road to the anonymous provincial capital of Muğla. Here, during a short lay-over, a tiny woman head-to-toe in black with a timid waif-like boy beside her peeled a pear and handed it to me. No gesture could have been more reassuring. I hesitatingly attempted to respond in Turkish. The faintest smile crossed her lips. This kindness prepared me for the next leg of this journey, the penultimate test before the Knidian road. The zig-zag descent to the Ceramic Gulf was hair-raising, unlike anything I had encountered before. Again and again the coach eased close to the vertiginous cliff-edge. The driver, struggled manfully, perpetually blasting his horn, and narrowly evaded a line of nonchalant camels laden with paniers. How many coaches had perished here, I wondered, as no doubt did my companions stilled to silence by fear. The aftermath was a release: dark pine forests, woodsmen, charcoal burners, and clearings occupied by black skin tents.

Emerging into the evening sunlight we advanced upon Marmaris, ancient Physius, set in its deliciously serene bay. Dominated by a ruined keep atop a rock, the little port had unpretentious charm.

A thin bespectacled student waited as the coach parked, and then sought me out.

'Welcome to Marmaris! You've survived Turkey riding a bus', he said in perfectly annunciated English. Bülent was the son of a distinguished archaeology professor, and from the outset

genial and gracious. Tonight we were staying in the Otel Imbat close to the castle, marble-panelled and stark with a pervasive smell of mothballs, and a room with Bülent lit by a bare bulb.

'Time for a raki!' Bülent observed as soon as I had dumped my rucksack on the iron bedstead. We joined Ilknur, Nermin, Ender, Matthew and a new American recruit, Celia. Celia, a Peace Corp veteran in her mid twenties, had heard Iris lecture in Washington DC and had decided how wonderful it would be to return to Turkey for a summer. But raki was not to her liking, 'Hateful stuff', she said too emphatically as Bülent handed her the small glass. Ilknur was not so proud: 'The opium of Turkey for rich boys like him (and she toasted him) and the poor peasants at Knidos'.

Very quickly the conversation was directed to one issue, as though this was our last supper.

'How is the drive to Knidos?' Celia asked, clearly wondering why she had signed up for this dig.

'Terrible, just terrible', Nermin said without hesitation, 'We take a taxi to Datça then another to Knidos.'

'I heard the road isn't surfaced', Celia interjected.

Bülent smiled and downed his raki, as Ilkur now explained to Celia the situation that no-one wanted to say openly, least of all at a lecture in Washington DC:

'The road is terrible. In parts it's only for walking. Two years ago, Freddie, an American girl was so frightened she walked. Sheila Gibson was nearly killed when her jeep went over the edge and was saved by a tree. She climbed up and walked down to Knidos and had a broken collar bone'.

I could only picture a strong, large younger woman surviving this mishap. Soon one of the more remarkable people I have known was to enter my world, utterly different from this limp caricature of valour.

Nermin now joined in: 'Sheila is wonderful. So brave. We have to get a taxi for us. Just us', before she fired off something rapidly to Ender in Turkish that made Bülent stand up and order another raki.

'Shall we make it?' Bülent enquired provocatively.

Seeing my concern, Nermin allowed herself to smile: 'We'll read our futures to find out! Hand', she instructed Celia, who offered, then withdrew her left one.

'Bülent!' Nermin insisted, and together with Ender she laughed at what she saw. Nothing was revealed.

Nermin removed her sunglasses, then looked up, beckoning me to open my palm for inspection.

Nermin, how can I describe her? Opposite me, flanked by Ilknur and Ender, I studied the pink painted finger nails first, then the luminosity of her glossy black hair tied back in the fashion of the time. Most of all, across the decades, I can hear her flickering flirtation, not so much brazen as reassuring:

'You are an idealist', the last word drawn out for Bülent's amusement; 'you will be successful and ...' she paused, her brown eyes closing, conjuring up whatever it was, 'there will be a parcel for you when you return home.'

Her momentary nervousness was distracted by Celia: 'I'm going with him', she said sharply, 'he's gonna make it!'

At dawn there was a fight in the square below our window. Bülent and I leaned out to watch. The taller man had been talking to the other's wife. A knife was pulled, and then others arrived from nowhere to remove the skirmishers.

Marie and Henry unexpectedly appeared as we were eating breakfast. They had stayed in grander surroundings, separate from us, but now needed Ilknur to venture the last stretch to Knidos. Our day was now really about to start. Nermin and Ilknur stared hard at each other before hugging. As they

released one another Ilknur spoke quietly, and then quickly went to get her bags.

The rest of us ambled along the sea-front and posed for photographs.

'All just in case', Bülent said. Nermin replied quickly, 'Ilknur will get us a good *dolmuş* at Datça; it'll be fine'.

The *dolmuş* to Datça left the centre of Marmaris at one-thirty. A worn red minibus with seats for nine, and an ample roof rack, we were eighteen when we set out. The conductor clung to the ladder on the side. Datça was seventy kilometres across rugged mountains. Thirty-five kilometres separated Datça from Knidos.

A welcome mile or so of tarmac turned into a dusty graveled road. To comfortably numb his clients the driver inserted a tape into his cassette and blasted us with music featuring an electric saz. This was a road trip, Turkey style. Squeezed in, sweating, with waves of dust settling on us, we passed a view of the sparkling ocean that is the Ceramic Gulf. Once we paused at a fountain to drink in turn the sweet chilled water. On we ploughed to the insistent sound of the saz. What happened next was more a memory than a realization. Hurtling along, the driver cursed and fought furiously with the steering wheel, braking hard. Billowing dust enveloped us as the vehicle drew to a halt. The driver turned to Celia and with studied care detached her hands from his shoulder. She let out a stifled, giggly cry. From above there were coarse shouts and hawking, before each person on top leapt down, addressed the driver, by now nonchalant about his driving, and then like dogs after a shower, shook themselves free of dust. All because of an obstinate hound.

The dog had stood its ground where the road crossed the narrowest point of the peninsula. Only 800 m. wide and 50 m above sea level, this was Bencik, where the Knidians started a

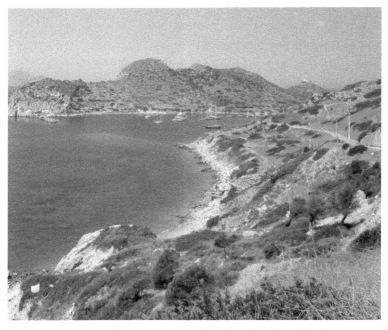

The coastal road to Cape Crio (photo by the author).

ditch to defend themselves from a foreseeable Persian attack. On taking advice from an oracle at Delphi, the ditch was abandoned and the Persian hordes came nonetheless.

The dog was still the subject of banter when we reached Datça. With its gentle cove, it was redolent of Devon, unlike the crystalline gulfs and mountains of the journey so far. Being mid afternoon, the little town was empty. The six of us took our bearings from Nermin, who marched off to ask in a café where Ilknur's jeep was to be found. Moments later a green Willy's jeep approached us, and the lanky driver stepped out. From the outset he looked sheepish. He had accepted Ilknur's payment, but the fee was not binding. Nermin and then Bülent set to talking at him. A deal was a deal. He stared at them as if they were aliens, and so Celia tried her Turkish on him for extra measure. Charm was not in her lexicon. Without knowing a word of Turkish it was obvious that there was no meeting of minds because the driver welcomed two friends with six cylinders of gas and three steel camp-beds that were then roped onto the roof of the jeep. Nermin buzzed around the newcomers, stamping her foot occasionally to accentuate her consternation. She seemed to have succeeded so she and Celia settled into the front of the jeep, and the four of us – Bülent, Ender, Matthew and myself – squeezed into the back on its bare benching. No sooner done than two shaven-headed militiamen crammed in beside us. Nermin tore the driver off a strip. Celia interpreted his insouciant reply for my benefit:

'The road is so bad, so we might as well die with a full load as an empty one!'

No sooner said than Celia squealed. With that more men joined us, between the militiamen and the back-board; and then some actually standing on the back-board, a woman squeezed between the driver and the door flap. Doing the math of feet visible through shafts of light in this sardine can,

we were now seventeen and about to ascend Bozdağ, the mountain that separated Datça from Knidos.

Not an uncommon payload, I was to learn later.

'Dikkat; dikkat (careful, careful)', Celia's incantation as if this helped.

The militiamen were like ghosts, frozen. They must have been my age, shaven-headed from eastern Turkey, and ill-at-ease with aliens. The muzzles of their carbines with every alternate bump touching first my cheek then Matthew's.

As the jeep engine throttled hard, struggling with the rutted road that wound its uneven way up and over Bozdağ, Celia unwisely tried to engage the driver in conversation. Bülent translated for me:

'Freddie's corner, where she got out and walked. You remember that story? The driver says he met a truck here two weeks ago and it was him or the truck. So the truck is down there'.

I concentrated on the carbine, its worn mechanism and scuffed stock. First gear – second; first, stop; second and into third; stop; first gear. The wheels spun to seek a grip and time stood still. Up around the damned mountain like a mule, stumbling but viciously goaded onwards, picking its way. Thank god our driver had faith, I kept thinking, as there was nowhere to rest my eyes or to assuage my fear. Then there was less struggling and more movement, down we came, releasing our collective terror as we did.

Arriving in the village of Sindiköy, the tension thawed and three passengers left us. As if to acknowledge his achievement, the driver sat back, no longer grappling with his steering wheel. With unaccustomed speed, we came to Çesmeköy, where our two soldiers left us, liberating our view for the first time. They mumbled salutations as they threaded their way out the back of the jeep. Bülent politely responded. Workmen for the dig

were hired here, though most came from the next village, the nearest to Knidos, Yazıköy and by now Nermin was chatting to the driver as if all that had happened was history. As the jeep drew to a halt in the village, the back-board passengers sprang off, allowing me my first view of a vine-draped café, and a welcoming crowd, peering in at us like paparazzi.

Bobbing heads eager to identify us, flat caps for all. Worn strongly shaped faces, most with moustaches, unshaven. The women, far fewer in number, in colourful pantaloons and more discrete. Ilknur had passed through earlier with Marie and Henry, announcing our imminent arrival.

A rattling of sounds, *Hoş geldeniz*; *hoş geldeniz* – welcome, welcome, as Nermin was picked out and each of the older men pressed her hand shyly, and in turn she thanked them, replying in iteration *Hoş bulduk*. A hawk-nosed smaller man whose hand she held the longest had a Disneyesque grin. All of us were subjected to inspection; a new digging season meant work, now the harvests were collected.

I clambered out onto the back-board as we passed through the high-walled lane ushering us out of Yazıköy. Children were still haring after us, oblivious to the drift of the dust churned up by the jeep. 'Goodbye! Goodbye!' they yelled; exuberant chanting, quite unaffectedly excited after the formal exchange of pleasantries with their parents. Ten kilometres remained and I calculated that I could still leap clear if the jeep proved to reprise Sheila Gibson's infamous experience at the hellish curve half way to Knidos. Next to me was the grinning cook's boy, Emin, the younger brother of Halil, a legend at Knidos who was now cooking on an American yacht.

The road was alive with people. Peasants racing back to the village before sunset; women stooped low, bearing bundles of sticks to Yazıköy. Men lazily astride mules, small boys who

brazenly doubled back alongside us to peer in and shout; women in white scarfs with bunches of tobacco.

A few minutes after the last of these commuters, we spied Knidos. Ancient Triopion, a place celebrated since Charles Newton's titanic excavations made with British sappers at the time of the Crimean War. We passed through the necropolis and then the Hellenistic walls, accelerating towards a fix on the beaming lighthouse. Down towards the harbour and the pin pricks of light assembled around Ruşan's restaurant and a reception. We had passed through the looking glass into an imaginary community.

2

Buried Metropolis

'The high mountains of the peninsula are on the right, and on the left is the great Triopian promontory, joined to the mountains by a flat and narrow strip of sand. Thus the city is shaped like a dum-bell – having a throne on the mountains, a throne on Triopia, and a smooth causeway whereby she may pass between them'.[4]

Strabo in the age of Augustus described Knidos as a theatre. So it seemed now in the safe warmth of the night. Our bivouac was on the narrow beach of the Commercial harbour. A lean-to dwelling was the dig base with a makeshift kitchen, store, a room with stacked crates of bagged finds, and a single toilet. In front under an awning was a long table where we ate. Here, we gathered after our arrival to eat bolgar rice and aubergines, and to compare stories about the journey from Marmaris. The most exuberant was the self-exalted Tim. His driver had wept but Tim had officiously used every Turkish curse he knew to force him forwards. Did he screw up his eyes to ape the anguish of the hapless driver, removing his glasses to embroider his point? He pealed with laughter. Celia winked at me. Silently I interpreted her no-nonsense appraisal. The happenstance of our jeep-ride had bound its company to each other. Ilknur and Nermin caucused in quick-fire Turkish with Bülent and Ender, and then enjoined me to share with them our fears. What next, we all speculated, and with that note of curiosity we ended our first evening. Now we would wait for Iris Cornelia Love to arrive, diligently putting order into the

[4] E. M. Forster, Cnidus, *Abinger Harvest*, 171.

overladen fruit crates of pottery found and unsorted from the previous year's excavation campaign. Beyond the tilley lamps our world was silken black, wondrously so.

Strabo's topographic observation made perfect sense when I woke with the fierce sun rising over the hammered pewter sea. Penetrated by its rays that had broken free from the ragged mountains to the east, Knidos soared up in front of us, while Cape Crio lay featureless and grey at our back. Then it was upon us, pitiless at first, a steely yellow, as though we were hypnotized by a serpent's eye. Camped on the ridged isthmus separating the Commercial from the Trireme harbours, practical havens for two opposing winds, we were actors performing under a searchlight on a stage, visible from just about everywhere. So began days beneath a limpid, burning sky, repeated identically day after day. To challenge this power it was important to engage with the ruins now illuminated with spectral clarity.

If Charles Newton was the protean placemaker, giving explicit grandiosity to this finger of land, Iris Cornelia Love gave it contemporary meaning. In the foreground was the faint modern afterlife of the ancient metropolis drawn here by Iris's venture: Cengez's lean-to, next to it the flat café built by villagers from Yazıköy to compete with Ruşan for our custom. Ruşan's dapper little white house-cum-restaurant lay a dozen yards beyond, tucked against the hillside. From it extended a little wooden jetty. Two other buildings made up the ensemble: the so-called museum in its own compound, beside Cengez's place, and the *Jandarma*. Never open, the museum was a store for all the treasures discovered by Iris since 1966. The *Jandarma* lay within an entangled barbed wire fence, with a post for a permanently limp, frayed flag. Here an ever-changing cohort of shy militia men kept an eye on us and any pirates that might ply these waters.

Set back behind modern Knidos was a small Hellenistic (lower) theatre. As the sun swiveled to focus its intent upon us, it gave shape to the gleaming, freshly restored ancient seating. Here, two millennia earlier four to six thousand spectators could watch plays or just gawp at the backdrop of spangled light in the Commercial harbour, in the lea of Cape Crio.

When E. M. Forster visited Knidos on a stormy day in 1904 he recounts that the orchestra of this theatre 'is planted with Jerusalem artichokes, and the mud in it is more glutinous than the mud outside'. No artichokes now, just a patch worn down on festivals. Indeed, tobacco rather than artichokes adds the only hint of greenery to this treeless hillside in summer. Terrace after terrace of tobacco plots full of plants looking like docks. Within these lay the relics of Newton's huge investigations, trenches, walls, streets, pathways, all reminders of his Victorian ambition. One after another terraces ascending in tiers filled the ruined insulae to a point below the unexcavated monumental theatre set into the imposing ragged peak at the back of Knidos. Most of this site of spectacles was despoiled by Kevalah Mehmet Ali Pasha (1769-1849) for an ostentatious palace in Cairo. Today it lingers ignobly under the shadow of the acropolis. Following the level of this upper theatre to the right and, with the eye of faith, the diminutive Temenos of Demeter comes into view. Cleared of earthquake boulders and scree on a gargantuan scale by Charles Newton, its re-investigation was to be my bailiwick, as I shall describe. Beyond it a deep gully conceals the city wall, so the eye drops down to the mole −now a pile of stones and rock − that much reduced in scale still juts out into the Commercial harbour. This mole and a more prominent one on the far side below Cape Crio were the pins for an iron chain, a security screen, strung across the harbour mouth in time of danger.

Cape Crio is altogether different– the islet Triopion itself with its three faces. The terraces are inclined, hanging, ascending to a ruined pharos and then the crags of a plunging edge. A modern lighthouse marks the western point of the island. Gleaming in the sunshine, white and stumpy, it is an exact replica of any around the coastline of Cornwall. It serves the smaller Trireme harbour in which the fishermen tie their boats. In antiquity the narrow harbour entrance was guarded by towers, one of which, with tumbled blocks, remained commandingly impressive. The coast rising up to the Round Temple is mostly composed of cascades of rock. In amongst the boulders is a thin beach streamlined by the wind. White orchids grow here even in summer and seaweed is mixed with the ruined churches gathered around the harbour's ruined temples and warehouses. Let the eye settle and the harsh outlines of the coast, twisting upwards to the acropolis are soon eschewed. It is hard not to be drawn to the marble columns and giddy paths that convey the continuity of history, grand and ruined.

Impressive as Knidos seemed from the stage, it was a startlingly majestic place when viewed from the Temenos of Demeter or the acropolis itself. From on high the real configurations of the silhouette, which first came into view as Emin and I peered out from behind the Willys jeep, lie within a greater lapis lazuli panorama. From above the two harbours scooped out either side of our base-camp serve like butterfly wings to give purpose to the body where we lived.

The most vivid spectacle lies in the archipelago beyond Knidos' harbours. The light and islands are omnipresent in any understanding of Triopion. Beyond the Round Temple, floating in shimmering crystalline, basks the long spindly island of Kos. The spoiled child of the Dodecanese, Lawrence Durrell called it. An enchanted place staring at Halicarnassos, modern

Bodrum, on the Turkish mainland, sharing with it a mighty castle from the late Indian Summer of the crusaders. A few compass points westwards, and Nisyros slips into view, sharpest in the morning light. An extinct volcano, its ancient crater is raggedly clear even though it no longer smokes. On its flanks a white washed village periodically glints. The seascape dims into the horizon staining the sky between Nisyros and Tilos, the next far distant islet. Beyond this charmed realm, at the terminus for the white Greek ferry that daily plies these sea-lanes, lies noble Rhodes.

Knidos, stranded at the tip of its peninsula, belongs to these islands, sharing in the serene glow that indefinably blesses this region. The roots of this affinity, however, are deep. Knidos with the three great cities of Rhodes, Lindos, Ialysos and Kamiros; and with Kos and Halicarnassos was a member of the Dorian Hexapolis. Herodotus, a native of Halicarnassos in the 5th century, tells us about this association, and their games. Being the largest of the cities, the common sanctuary of the Hexapolis was based here at Knidos in the great temple to Apollo. No tourist depredations or distractions, this primitive league enjoyed a paradise. It was a dream world, benign except when the dry *meltem* winds blow from the north. Kamiros, in its idyllic cove; Ialysos, high above the sea; Lindos and its cluster of white-washed houses; Kos, lush, green and beautiful; Halicarnassos, now dominated by the castle of knights of Rhodes.

But these reflections are far from the reality of the time. The quaint, shuffled skylines of the modern Greek and Turkish ports were once orderly and astoundingly ambitious in design. Ancient Knidos, as the terracing reveals, was a metropolis housing tens of thousands of people. At some time in the 5th century BC Hippodamos of Miletus, the great architect of his age, designed a new city at Knidos like those of Priene and

Map of ancient Knidos
(after Ian Jenkins, drawn by Sarah Leppard).

Miletus, further up the Aegean coast. The star architect of his era had cut his teeth on Piraeus. The petty war-bands of the Homeric world offered only an epic ancestry to the Gilded Age aspirations of Hippodamos' generation. The new Knidos covered an area about three kilometres long and roughly a kilometre wide. Impossible to imagine today: straight, paved, parallel streets traversing the hillsides, lined with sparely ornamented monumental ashlar buildings erected like Manhattan malls.

Sailing from Kamiros in the centuries before Christ, the silhouette of Knidos would have been shaped by its townscape not its craggy natural context. Some houses might have been washed in lime, but the predominant impression must have been strangely Victorian. Fashioned to exploit maritime connectivity, it was a conurbation astride two harbours, where merchants mixed with intellectuals and athletes. All now ruined.

The sketchy history of Knidos is as spirited as any of its neighbours. The bare litany hardly does justice to the vaunting audacity in constructing a city in this improbable place. A few facts put its zenith into perspective. The wrath of the Persian army fell upon it early in the 5th century BC; its games were held in high esteem throughout the Hellenic world; its traders bore merchandise far afield setting up colonies in Italy like other restless city-states; it minted pellet-sized silver coins and produced vinegary wines that found consumers from the Levant to North Africa. It bore the Roman yoke stubbornly then lucratively, and it was prized once more in the two centuries before Justinian. The collapse of a civilization, a millennium old, in the later 6th or 7th centuries put paid to this idyllic place, its grandiloquent destiny inadvertently handed to Ottoman plunderers and ultimately archaeologists.

The origins of Knidos are a matter of controversy. Who cast the die that led to the metropolis? Archaeologists dine out on

such things, and not unnaturally it was Iris' favourite subject once the wine was uncorked. Her nemeses were Professors Bean and Cook. These erudite (English) gentlemen learnedly postulated that the original Knidian colony lay a little east of Datça at Emeçik, where the dog interrupted our *dolmuş* drive from Marmaris. This is the narrowest part of the thin spindly peninsula as well as a sheltered niche out of the summer winds and autumn torrents. Iris resisted this. She yearned for control of Knidos' origins. Knidian pioneers simply had to start at Cape Crio. Her thesis, further fueled as a rule by bourbon following a long day in the sun, never seemed wholly watertight. Yet she was proven to be right. Painted potsherds and other debris of the Mycenean-Minoan age lay deep beneath metres of classical levels next to the Trireme harbour. These brazen sherds resembled others of the Homeric age found at Kos, Bodrum and Kamiros. Whether it was the site of a Bronze Age colony as such, or simply the debris of a village with roots as deep as the deposits in Anatolia are altogether more difficult questions to answer.

Herodotus, a scion of Halicarnassos, writing in the early 5th century, provides a measured explanation. The Knidians, he would have us believe, came from Lacedaemon on mainland Greece. They were Dorians, descendants of the peoples that had otherwise been eliminated by the Mycenean-Minoans. Their leader was Triopas. Some said his flight was to escape the wrath of Demeter because he had chopped down her sacred grove at Dotion in Thessaly. Anyway, his band established rites called Triopian, after his name. These were the same *Triopia sacra* that were transported to Gela on the sandy south littoral of Sicily by Greek colonists of a later epoch. Charles Newton linked the rites to the worship of Demeter and speculated the temenos dedicated to that goddess may have been the original

seat of the *Triopia sacra*. Such stories of course are the stock of oral tradition.

As the greatest city in the Dorian Hexapolis, Herodotus explains, Knidos was the venue for the games. Its hippodrome supposedly lay in the now isolated valley behind the acropolis, a place where the echoes of thousands could be contained. Trouble arose at one oft-remembered occasion, as Herodotus relates. It was customary for the prize-winners to be awarded a bronze tripod. Victors were not permitted to take their prizes home. Instead, custom required them to dedicate the tripod in the great Temple of Apollo. The historian recounts how one winner defiantly brought his tripod back to Halicarnassos where he hung it up in his house. In protest the other cities censored Halicarnassos and so the league became a Pentapolis as a result.

The great temple that attracted the crowds from the other Dorian cities, where the tripods were dedicated, must have been splendid. It probably resembled the monumental temple still to be seen at Didyma, a little to the north of Bodrum. The Didymaion, as it is known, measured roughly 85m x 40m in the 6th century BC and although its friezes famed today from their portrayal on travel posters, are of Roman date, the original ornamentation must have been quite as striking to garner Herodotus' admiration.

Knidos' entanglement with Cyrus the Great, the Persian warlord who swept through western Anatolia in the 5th century, was memorable but hardly heroic. Herodotus records that the Knidians considered the only way to stop the advancing horde was to cut the peninsula off from the mainland. All but a narrow neck is surrounded by water, the Ceramic Gulf lying to the northward and the sea of Symi and Rhodes to the southward. The neck of the peninsula is about half a mile across, and while Harpagus (the Persian commander in Caria) was pursuing his

victorious campaign in the region of Ionia, the Knidians began to dig, hoping to make their country into an island. The isthmus they were trying to cut lies just where the Knidian territory ends on the mainland side east of Datça. An army of men set to the task, but it was observed that the workmen got hurt by splinters of stone in various places about the body, especially the eyes, more often than was expected. Something was so unnatural that an emissary was sent to Delphi to ask what it was that was hindering the work. The Priestess gave them the following answer:

> 'Do not fence off the isthmus; do not dig.
> Zeus would have made an island, had he willed it.'

With this counsel, the Knidians stopped digging, whereupon they were attacked and surrendered without a struggle.

Was such a channel humanly possible? In their book *The Rodian Peraea and Islands,* Fraser and Bean argue that the channel was indeed initiated and claim that the Victorian surveyor, Thomas Spratt, found traces of this aborted project at Bencik where the peninsula is only 800 metres wide. Was the trip to Delphi a face-saving exercise to put a stop to an outrageously time-consuming endeavour? In any case, did the Persians glide across from Halicarnassos as most modern visitors do, and force a landing in one of the coves? Whatever happened we might imagine the Persian militiamen, like their unshaven Turkish counterparts in the *Jandarma* at Knidos (from the east of the country) wandering a little bewildered through Triopion's crowded streets and alien company.

Another story, circulating a century after Herodotus, provides a different angle on the earliest occupants of Cape Crio. Myth had it in the 4th century BC that the Greek warrior

Podaleirios was ship-wrecked on the Carian coast after the fall of Troy. There he tended to the king's daughter who had been injured in a fall from a roof. Podaleirios apparently married his illustrious patient and soon afterwards founded the city of Syrnos. Three branches of this noble family pursued this medical tradition in the area at Rhodes, Kos and Knidos. So it was that Knidos like Kos, became a famed centre for medical studies in the ancient world.

The reputation of Knidos as a refuge for the sick has always been overshadowed by Kos, the birthplace of Hippocrates. That arbour of greenery has monopolized the fame that belongs to all the lineages descended from Podaleirios. At the blissful Asklepieion there is a view across the placid sea to the purple mountains of Turkey. Here the physician-priests studied their patients as a whole man. His ailments were prognosed and treated, while he was inducted into the practices of the cult of the temple. The doctors at Knidos, by contrast, depended less on the powers of the divine, and studied the diseases themselves evolving simple procedures leading to better diagnoses. Their professionalism, as at Kos, became an enduring thread in the history of the place, spanning the Dorian, Persian Hellenistic and earlier Roman ages.

Commerce, too, spanned the ages. Knidos had no real agrarian hinterland to speak of, hence it depended upon trade. Numismatists have long cherished the coins produced by its mint. Some of the earliest silver coins were struck by its city fathers as indices that might be recognized where-ever its merchants wandered. Being at the crossroads from Asia to North Africa, where Turkey began and the islands ended, and where the west coast turned southwards to Palestine, it was an obvious place for an emporium and a meeting of minds. The distribution of its coins sheds a flicker of light on these far-flung contacts, but the millions of amphora sherds lending colour to

the wind-beaten edges around the two harbours reveal the real story. Knidos handled wine and vinegar. Presumably it was a finer hock – 'rot-gut' was our deprecating term for it – than the acidic stuff made locally nowadays. Perhaps we had the misfortune to be wined and dined on the legacy of its great vinegar trade. But was its wine produced locally – in the deep sheltered valleys around Yazıköy and on the slopes of Bozdağ – or was it simply warehoused here en route from north to south, east to west? Patient examination of those potsherds might reveal the answer. Are they Knidian wares or the products of factories located around the Black Sea or outside Antioch on the Orontes?

In the ancient world there were myriad ports dealing in wine and oils. For the ancient authors the city was special for a reason. Knidos possessed a spirituality that its merchants and sailors ascribed to the great naked statue of Aphrodite that was the symbol of the city. Pliny the Elder tells us that this marine Venus stood 'in a shrine which allowed the image of the goddess to be viewed from every side'. His laconic observation presupposes a round temple.

Praxiteles' statue dominated the port for seven hundred years – from its purchase by the Knidians, in the mid 4th century BC until it mysteriously disappeared as Christianity displaced the ancient cults in the 4th century AD. Of two life-size masterpieces made by the artist and offered originally to the citizens of Kos, the first was clothed and was chosen by the Koans, who rejected the evident indiscretion of Praxiteles's second statue – a nude conceived as a corporeal vision, silent and serene. The Knidians were not so prudish.

All we know about this talismanic creature comes through the eyes of men, and deductions made from numerous later imitations in marble, stone and terracotta. Was this beauty, a courtesan or mistress of Praxiteles, portrayed as a luminous

beauty, soft and gentle? Drawing on earlier sources, Pliny the Elder leads us to believe this was Phryne, the sculptor's model for a statue of a Smiling Courtesan, wherein ones detects 'the love of the artist and the reward revealed in the face of the courtesan'.[5] This beauty was rich, vulgar, vain and uninhibited according to the sources. She was also mischievous. Pausanias recalls how she asked Praxiteles to name his favourite statue. The artist prevaricated. So Phryne sent him a message stating that his workshop was on fire. Rushing there, the artist aimed to save his statues of Eros and a Satyr. On arriving he found his muse who confessed to her ruse and requested the Eros that she promptly dedicated to her home at Thespiai.[6]

One thing is certain, the statue was created for one age, described lasciviously and imitated by Romans, and has cornered the fascination of male and female art historians since Joachim Winckelmann first studied this Knidian masterpiece two centuries ago. Much resides in its simplicity. The sculptor represented his muse in a *contrapposto* pose: apparently her head was turning to the left, while the weight of her slender body was on her right leg as her left one bends slightly. No less affecting is the gesture of the goddess's right hand and arm. The arm is bent with minimal effort to accentuate the sculpture's composition. Deliberately ambiguous, is she inviting the awe of the observer while exposing her divine authority? It is for the viewer to decide. She leans on nothing; this appears to define her boldness. Almost certainly painted in discrete polychrome colours, and even wearing arm jewelry, it is hard now to grasp how affecting this statue was in the ancient world. The illusion was that this freestanding life-size statue was a real woman about to take a private bath, surely erotic to any male gaze?

[5] Havelock, *ibid.*, 46; Pliny, *NH* 34.70.
[6] Havelock, *ibid.*, 47.

Her importance for Knidos is beyond doubt. This Aphrodite fostered love and fertility in the city as well as protecting the city's sailors. 'A cult statue, [she] was a dignified image enframed in a small shrine that the pilgrim could enter. The goddess was alone and motionless, sensuous but not available', writes Christine Mitchell Havelock in her biography of the statue and its imitations.[7] Conceived in the 4th century as a serene and undemanding divinity,[8] this was to change. Travelling, trading and touring increased markedly in the 2nd century BC and once, under Roman dominion, Knidos became a free port as of 129 BC, visitors to the shrine became more numerous, and imitations became common. Of course, the ambiguity of the original remained. Roman imitations are seldom really engaged with the observer. She never lies down, sleeps, or closes her eyes. Her actions are self-absorbing, and her eyes are open but remain unfocussed. She was a subject for poetry. Epigrams were composed about her. One poem describes the goddess herself circling around like a tourist to admire Praxiteles's work: 'Where did Praxiteles see me naked?' she asks tartly. We learn that she was apparently proud of her long list of lovers ('Paris, Anchises, and Adonis saw me naked. Those are all I know of, but how did Praxiteles contrive it?'[9]). Erotic, of course, but in essence the absence of inhibition defined the desirable expectations of a mistress.

Much of this enduring lure can be found in the philosopher, Lucian's account. A visitor to the port in the 2nd century AD, he recalls his profound exultation on encountering the naked Venus:

'We then determined to enter the port of Knidos, in order to see the place, and from an anxiety to visit the temple of

[7] Havelock, *ibid.*, 134.
[8] Havelock, *ibid.*, 138.
[9] Havelock, *ibid.*, 121.

Venus celebrated for its statue, the exquisite production of the skill of Praxiteles. We gained the shore in almost perfect stillness, as if the goddess herself was guiding the bark, under the influence of her own bright and unruffled serenity. Whilst the crew employed in ordinary preparations, I made the circuit of the town, having one of my agreeable companions on either arm ... In approaching the sacred enclosure we were fanned by the most delicious breezes; for within, no polished pavement spreads its barren surface, but the area as suited to a sanctuary of Venus, abounds with productive trees, extending their luxuriant foliage to the sky, and canopying the air around. But chiefly the blooming myrtle fertile from its earliest growth and covered with a profusion of fruit, graces its mistress Those which are not productive of fruit are distinguished for their beauty, the ethereal cypress, the lofty plane, and Daphne, who once shunned the goddess. All these the ivy longingly embraces, while the clustering vines declare the happy union of the two deities. In the deeper shades are pleasant seats for convivial meetings, which although rarely resorted to by the people of the city, are much frequented by other inhabitants of the Knidian territory. Having satisfied ourselves with admiring these beauties of nature we entered the temple. In the centre stands the goddess, formed of Parian marble – a most beautiful and splendid work, a half suppressed smile is on her mouth. No drapery conceals her beauty, nor is any part hidden except that which is covered unconsciously as it were by the left hand ... Charicles (Lucian's companion), as if bereft of his senses, cried aloud, "Happy amongst the gods he that was enchanted for thee" and springing forward with neck outstretched as far as possible (the statue was probably surrounded by a rail), he repeatedly kissed the statue.

'We could not refrain from repeated exclamations of admiration, and particularly on the harmony of the back, the

wonderful fitting of the flesh to the bones, without too great plumpness, and the exquisite proportion of the thigh and leg, extending in a straight line to the foot'[10]

At this point Lucian's companions evidently muttered something injudicious and he whisked them away to a bench in a shady spot where he chided them for such crassness.

Lucian and his friends would have been familiar with many imitators before they arrived at the authentic Aphrodite. These have become the stuff of Art History classes including a taxonomy of seven different Aphrodites owing their origin to Praxiteles's original.

There are the Capitoline and Medici Aphrodites from Rome and Florence respectively with their 'pudica gesture'. Kenneth Clark remarked that the Knidian Aphrodite was open and unafraid whereas the Capitoline version was 'impregnable', and stood like a fortified citadel. In 1803 the neoclassical sculptor, Canova, copied the Medici Aphrodite for the King of Etruria, but it was appropriated by Napoleon.[11] The concept for the common Crouching Aphrodite found at Hadrian's Villa outside Rome dates to the mid to later 4th century BC. The kneeling posture was apparently appealing. as was the 'heavy weight of the pear-shaped body, the pendulous breasts, and the ample rolls around the abdomen'.[12] This was no Phryne, but an explicit statement about a more mature woman as goddess. The third type is Aphrodite loosening her sandal. The effect is momentary and unpretentious, perhaps light-hearted. Commonly distributed around the Mediterranean in marble, bronze, stone and terracotta, this Aphrodite was beloved by Hellenistic and Roman patrons alike. Aphrodite Anadyomene, 'rising from the sea', was the work of Praxiteles' contemporary, the painter,

[10] Pseudo-Lucian, *Amores*, 11.
[11] Havelock, *ibid.*, 74-80.
[12] Havelock, *ibid.*, 80.

Apelles. Its subject was none other than Phryne, walking naked into the sea at Eleusis. The painting graced the sanctuary of Asclepius at Kos until the Emperor Augustus had it shipped to the temple of the divine Julius Caesar in Rome. Replicated commonly, one of the most affecting of renditions, the muse is drawing her hair outwards as if to plait it. This statue was found at Benghazi and is in the University Museum in Philadelphia.[13] There is a half draped Anadyomene, an image found on the 2nd-century coins of the Emperors Commodus and Marcus Aurelius, and the nude Anadyomene from the Palazzo Colonna in Rome. This Aphrodite has a pained expression, very different from the serenity of the original. Popular sometimes even in this obese form with a mischievous grin, this was beloved by Roman patrons. The penultimate is the celebrated Aphrodite of Melos that graced a niche in this Cycladic theatre. Late Hellenistic in date, this is a beauty, with small features, a faint smile and soft modeling. There is a fluid torsion through her body as if to stay the drapery sensuously held around her hips, yet she emits a sublime indifference.[14] Lastly there is the Aphrodite Kallipygoe 'of the fair buttocks'. Known originally from a Venus discovered in Nero's Golden House, this sculpture won the hearts of many Renaissance and Enlightenment collectors, mostly in the form of a plaster cast. The reason is not hard to see. This Aphrodite lifts her garments in provocation. Without modesty, the head is set on the neck directing the viewers' eyes to admire her buttocks. Did this creature belong to a cult involving religious prostitution?

These seven Aphrodites in their countless numbers first served admirers in the conservative Hellenistic era when nudity was seldom portrayed. Mores changed in Roman times as the generals, officers and troops brought back new habits of luxury

[13] Havelock, *ibid.,* 86-87.
[14] Havelock, *ibid.,* 94-95.

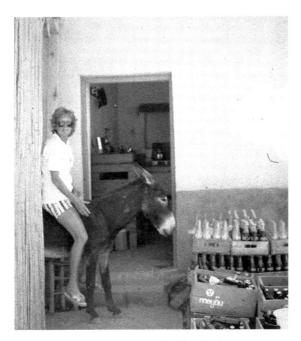

Iris Cornelia Love on a donkey in the camp
(photo by the author).

and entertainment, none more affecting than Cleopatra. Over the arc of half a millennium, Praxiteles' voyeurism, corporealizing his mistress, proved to be a step towards flesh and stone becoming indistinguishable.

Charles Newton was not detained by Aphrodite. Perhaps he simply assumed that Praxitiles' masterpiece had been long since appropriated and no longer existed at Knidos. This set the stage for Iris Cornelia Love. Her story is best recalled in her own unalloyed words:

'My great-uncle, Daniel Guggenheim, and his brothers – including Uncle Solomon, who founded the museum – had made their money digging in the earth for minerals, mining copper in Colorado and developing Alaska during the Gold Rush', Iris proudly told journalists. 'Uncle Daniel was also very interested in aeronautics. He met a young physicist named Robert Goddard and financed all of his experiments. It was the rocket Goddard developed that put man on the Moon. The wonderful connection is that my ancestors dug for the riches of the earth and used some of that money to finance research for the future. And I've dug in the earth for the riches of the past'.

Iris Cornelia Love was born in 1933 at 713 Park Avenue, a townhouse just a few blocks from where she spent most of her life. Her parents – the stockbroker Cornelius Ruxton Love Jr. and Audrey Barbara Josephthal, an heiress to the New York private securities firm Josephthal & Co., and to the Guggenheim fortune – met on a boat to China and married after a long courtship. The household was soon to become a shrine to art.

'I grew up eating at a table Daddy had made from a Coromandel screen from the Summer Palace, which he had turned on its side and covered with glass.... I had a wonderful English governess, Katie Wray, who had also

brought up my mother, and she had had a classical education. Although she read me the usual children's stories, I hated them, so she turned to tales from classical Greek and Roman mythology, which I loved. Sometimes she would read them to me in Latin, so when I began to study it in school I was already several steps ahead'.

It was this governess who took the young Iris to the Metropolitan Museum of Art, where her first infatuation was a trio of monumental Etruscan terracottas.

After a Manhattan education she matriculated to Smith College, where her professors included the redoubtable Phyllis Williams Lehmann. Here was planted the lure of Greek art. She enrolled for graduate work at the Institute of Fine Arts but after completing her exams she dropped out, falling back on her trust fund to support her. A decade later in August 1966, after nine seasons of digging with the Lehmanns, the Fifth Avenue heiress struck out on her own. She first visited Knidos with a Turkish archaeologist, a scion of the late Sultan, three days after her 33rd birthday.

'I was sitting on the prow of the caïque and suddenly a school of dolphins – which are sacred to Aphrodite – appeared and escorted us into the Bay of Knidos…somehow I knew that this was part of my destiny', she recalled almost fifty years later.

Her intuition no less focused than Newton's, Iris was to discover the temple in which Praxiteles' statue had stood the day man set foot on the moon. It was and is her most spectacular discovery. Many since the discovery in 1969 have derisively dismissed it as a Roman temple podium similar to a

temple at Hadrian's Villa outside Rome. Iris found some clues to support her theory.

High up on the terraces, overlooking the sea at the point where the jagged spine of the hill has been axed by the Aegean, she uncovered a podium made of exquisitely shaped blocks. Prominent and positioned to be seen from far and wide, it is all that remains from the venue visited by Lucian and his salacious friends. Iris' battalion of workmen worked all hours to clear the rubble overlying the temple and its precincts on the steep terraced tiers beneath it. The dust billowed up and whipped manically in hoops around the men when the *meltem*, the summer wind, blew in from the north. Protected by divers' goggles, the peasants were given no pass as Iris' passion to uncover the setting for Knidos' touchstone became a near obsession.

Further support for Iris' theory came in 1970. An inscription was found close by which included the word "ΠΡΑΞ" ("PRAX"). This and other shattered epigraphic fragments led her to conclude that an inscription here once referred to Praxiteles' statue and served to guide ancient tourists to see it.

Positioning herself on the podium for visitors and donors, ignoring the clockwork noises of her worker bees, Iris would declaim. A Love lecturing on Aphrodite. Who better? To cargo ships below, of course, the silken white statue would have been little more than a speck. No matter, its existence defined Knidos as a place.

Iris, of course, was aiming to find Aphrodite herself, the original. She was convinced that shattered fragments were concealed amongst the debris of the windblown terrace. In a stroke the authentic would eclipse any clumsy imitation from the Roman period. Her obsession was easily grasped. There was a problem, however. With the adoption of Christianity by

the Knidians, overtly the cult of the goddess of love faded. What
then happened to this Venus in the face of these iconoclasts?
Die-hard classicists contend that statues like Praxiteles' talisman
were discretely taken to a place where their cults persisted in
secret. Deep down, in their minds, the Middle Ages was an
iniquitous barbarian interlude. In this case, though, a Byzantine
source claims that Aphrodite was cherished and spirited away
to Constantinople to perish in a 12th-century fire. This was an
anathema to Iris. Like many a driven archaeologist, her opinion
was a capricious variant on these explanations, as I shall
describe later on. So, she never relinquished hope of finding
some pieces of this storied trophy.

Sunburnt and aching with weariness, drinking beer in
Ruşan's restaurant, many of us mused upon Praxiteles' muse
being eventually discovered in a 5th-century church wall,
ignominiously cemented alongside other classical inscriptions
and statues. Uncharitable, but given the circumstances this was
not far-fetched. Byzantium has left an indelible mark upon
Knidos. Its churches were erected over almost all the fine
classical buildings, These in turn had suffered the wrath of the
classical afterlives of the Mediterranean. An ill-chipped Arabic
graffito in the nave of Knidos' cathedral next to the agora set
the scene. This graffito symbolized the termination of the city's
final flourish, marking a raid in the 7th century when Islamic
pirates threatened the gates of Constantinople itself. Finished
as a port, as a centre of medical studies, and as the hub of a
great cult, Knidos' temples, agora, harbours and insulae
decayed till they were fit for tobacco terraces and ripe for
plunder by Ottoman architects and enquiry by antiquarians.

Iris had pinpointed Knidos with the same determination as
her Victorian predecessor, Charles Newton. Walking round her
excavations only the precision vertical trench elevations and the
painted survey benchmarks revealed that this was a new age –

the Darwinian age when layer upon layer (stratigraphy) is credited with meaning. Some of her excavations were as good as any in the Mediterranean, and some were less so. She excavated around the Trireme harbour, within the theatre, and at points within several insulae. Thanks to her, the Temple of Apollo and the Round Temple were uncovered. Their podiums were glistening once again. The agora, the bouleuterion (council chamber) and a few of the thousands of tombs beyond the city limits were also trenched. Instead of writing letters to friends and donors as was the vogue in Newton's time, she kept faded green field notebooks and the museum brimmed full with fruit boxes of catalogued potsherds, fragments of sculpture and not a few inscriptions. Coming from an English country village, where we had had a little Roman dig in the vicar's garden, the operation at Knidos was epic, extraordinary for the ambitious, romantic quest to seek out Aphrodite's legacy, appropriately compromised by unrestrained moments of unbridled passion. Then too there was the clashing of cultures in this erstwhile medicinal bower: cool aid, Vietnam veterans, architects, millionaire yachts, students from small US colleges and Turkish universities enduring marshal law, and the otherworldliness of a Turkish peasant culture confronting its twilight years.

3

Discovery

The New Yorker in 1978 pictured Iris Cornelia Love at Knidos:

'Miss Love ..is a handsome woman, who looks her best – and most at home – in the field. At five-feet-seven, she stands eight inches shorter than the "Aphrodite" did. Her skin is tanned a deep bronze by more than twenty summers in the Aegean sun, and her hair is bleached almost white. Her eyes are dark brown and very large, and make her look ingenuous, which is probably an asset to a woman who must persuade governments to give her permits and rich people to give her money. At Cnidus, she usually dresses in very short shorts and a T-shirt, white sneakers, and tennis socks with pom-poms at the back, and she is almost always trailed by two dachshunds – Phryne (after Praxiteles' mistress, who was the model for his "Aphrodite") and Carl Phillipp Emanuel Endoxus von Cnidus, or Carlino'.

Iris lived as a neon celebrity: bold, flamboyant and dressed to be photographed. A thatch of honey-blond hair, shaped to exaggerate her sharp profile. She was unhooked from obligation, as alien to all of us in her team, as she was to the army of peasant workmen in their flimsy cottons and sandals. She knew it and flaunted it. Kooky with a black charisma, six mornings a week, attired for hanging out in the Hamptons, with a seemingly injudicious blob of zinc sunscreen on the tip of her nose, she took roll-call of the workmen. The ritual was faintly Victorian, though I doubt her predecessor at Knidos, Charles Newton, himself had checked off the names of his men. Iris urgently wanted the approbation of the stick-thin pick and

shovel men, the wizened barrowers and the eager pot-washing boys.

How did Iris discover Knidos and make Aphrodite and her myths her own?

Was it the dolphins that accompanied her caïque to the harbour in 1966?

Of course not, Tim would say, ready to provide an alternative origin myth.

According to him, Iris learnt of the promise of Knidos from John Ward Perkins, the irascible director of the British School at Rome, while he was on sabbatical at Princeton University. Ward Perkins had been lecturing and writing a book about ancient town planning. Hippodamos' street grid at Knidos was an exemplar, barely understood by the pioneering antiquarians, the Dilettanti and the Victorian, Charles Newton. Perhaps a chance encounter with the bluff ex-Colonel Ward Perkins was the germ that set the caïque's course to Knidos. As probable, though, were the ample descriptions of the haul of treasures from the earlier campaigns. Tellingly, for a rich scion of New York called Love, Aphrodite was missing.

Iris was not Knidos' first modern celebrity. She knew she walked in the footsteps of extraordinary forebears. Her gospel – treated to irreverence late at night – was Charles Newton's *A History of Discoveries at Halicarnassus, Cnidus and Branchidae* (1862), a three-volume monograph, ponderously illustrated with lithographs, that was published a mere three years after his excavations terminated in 1859. Newton (1816-94) was no slouch in whatever he did. For the Turks he was simply the 'crazy Englishman who makes holes in the ground'. Newton never concealed that his research was built on the earlier observations of the Society of Dilettanti. With these grand tourists the modern history of Knidos begins.

Formed in 1734 by a group of peers and gentlemen disdainful of the grand tour, the Society of Dilettanti ambitiously aimed to open a window on Mediterranean antiquities. Horace Walpole damned its affectations and described it as 'a club, for which the nominal qualification is having been in Italy, and the real one, being drunk'. Its members were to include Joseph Banks, David Garrick, Sir William Hamilton and Joshua Reynolds. At first the Dilettanti set their sights on Pompeii and Paestum. Then the Levant beckoned. In 1764 the Society raised funds to send a mission into Ottoman territory, to Greece and Asia Minor. Richard Chandler of Magdalen College, Oxford was selected to lead this expedition. A man of evident reputation in London, he was the editor of *Marmora Oxoniensia*. Chandler himself chose two travelling companions, the architect, Nicholas Revett, already familiar with Athens, and the 22-year old promising painter, William Pars. This trio sailed for the Dardanelles on the sloop, *The Anglican*, where its captain put them ashore.

The three men headed for Izmir. From there they visited the great ancient sites reaching down to Knidos, collecting materials for their groundbreaking monograph, *Ionian Antiquities*, published in 1769. Their work completed, the indefatigable trio continued to Athens, where they acquired fragments of sculpture from the Parthenon:

'We purchased two fine fragments of the frieze which we found inserted over the doorways in the town, and were presented with a beautiful trunk which had fallen from the metopes, and lay neglected in the garden of a Turk'.

Ionian Antiquities was well received. It showered shafts of light on a host of mythic places, signals that numerous adventurers and explorers pursued from the dying years of the

Charles Newton in a portrait by Henry Wyndham Philips
(courtesy of the British Museum).

Napoleonic wars onwards. The first of these was Captain Francis Beaufort (1774-1857). Few more extraordinary individuals paused at Knidos. He joined the navy when he was fourteen, embarking upon a lifetime of self-education. Shipwrecked because of a faulty chart the following year, and being the son of a map-maker, Beaufort became a hydrologist, making maps that have stood the test of time. By 1800 he had seen serious action and was badly wounded at Malaga. In 1810 he returned to active service as a Captain, and was sent to survey the Rio de la Plata estuary in Argentina. Not content with hydrology, he worked on a weather notation coding. His notations became the standard, the so-called Beaufort scale. It is hardly surprising, then, to find Beaufort in south-west Turkey in 1811-12. The coastline beckoned to be plumbed.

The ruins at Knidos, however, grabbed his attention. Two pages in his account - *Karamania or a brief description of the South Coast of Asia Minor and the remains of Antiquity* (1817) - vividly convey his regard for Knidos. Here is a sample:

'Few places bear more incontestable proofs of former magnificence and still fewer of the ruffian industry of their destroyers. The whole area of the city is one promiscuous mass of ruins; among which may be traced streets and gateways, porticoes and theatres'.

A sketch map of the harbour offers a tantalizing hint of the place. But Beaufort had to abandon his surveying and give chase to a suspicious vessel. *Karamania* contains notes on many similar places, accompanied by sketches evoking their unknown drama. His expedition was dramatically terminated when Beaufort was wounded in the thigh in an engagement with dervishes near Alanya. His career was far from over. Opportunities for exploration for such a restless intellect were to be found everywhere - in the stars, along foreign shores, in the evolving understanding of mammals. Raised to a Rear

Admiralship when he was 72, he was awarded a knighthood as a pillar of London's scientific community.

Was it Beaufort's letters, long ahead of the publication of *Karamania*, that prompted the Society of Dilettanti to resurrect their Ionian adventures after a fifty-year break? The new expedition was led by the classical artist, Sir William Gell (1777-1836), best known for his later studies of Rome and its countryside. As a young man he had befriended Byron in Greece, and attempted to pinpoint the location of Troy in Asia Minor. With him came two architects, John Peter Gandy and Francis Bedford, as well as the indefatigable antiquarian and soldier-spy, Colonel William Martin Leake (1777-1860). Leake had fought with the Ottoman army against the French in Egypt, and besides travelling through the Sultanate, he became British plenipotentiary to Ali Pasha in Ioannina, Epirus. Archaeology was his passion.

Gell's mission camped at Knidos from October 1811 until the following spring. One of their most singular achievements was Gell's wide-angled engraving of Knidos, dating from 1812. He must have been standing on the point on Cape Crio where today the lighthouse sits. A photograph could not have done it greater justice. The sweeping panorama has depth and lends a serene majesty to the buried metropolis. Ruins appear in places, but far more evident are the trees and scrubs that convey the gracefulness of an English landscape as opposed to the empty terraces of today. Beyond, a grey almost ugly coxcomb of mountains disappearing into the distance. Leake was no less captivated by Knidos. Admiringly he recalls its Greek history, sparing only specious comments for its later Roman and Byzantine periods. His eye, though, was on the urban planning and the city's Doric monuments, fragments of which, for sure, he procured.

On the coat-tails of the Dilettanti came Thomas Spratt. A naval lieutenant assigned to Beaufort's hydrological survey and attached to HM. surveying ship, *Beacon*, he visited Knidos in the company of Edward Forbes, professor of Natural History at King's College, London. Spratt sought out the aborted rock-cut ditch intended to halt the Persians, east of Datça. Another visitor was William Waddington (1826-94), briefly Prime Minister of France, and for ten years the French Ambassador to London. His English father owned a textile plant in France, so took French citizenship, but sent his son to Rugby and Cambridge where he studied classics, launching a lifetime's fascination for ancient history and its coinage. He travelled widely around the Mediterranean and with a certain inevitability he arrived at Knidos. Clearly cognizant of Gell's mission, Waddington was curious to see the city that had produced the silver coins bearing Aphrodite's image. In his eventual report he disdainfully laments Mehmet Ali's plundering of the monuments for his new palace in Cairo.

Mehmet's impact on Knidos was modest compared to the works of the crazy Englishman, Charles Newton. Newton did not just visit Knidos, he changed it forever on the ground as well as in the annals of archaeology. He also created the storyboard for Iris Cornelia Love's campaigns.

Newton was a founding father of classical archaeology. Something of his character is to be found in a bust by Sir Joseph Edgar Boehm. Commissioned in admiration by the Earl of Carnarvon and Newton's peers in 1889, the archaeologist at the time was seventy-three, on the verge of declivity. Boehm specialized in sculpting celebrity busts. Queen Victoria and the Duke of Wellington had sat for him. Boehm portrays Newton as gentle and pensive, as a philosopher, perhaps baleful. All the elements including the unnaturally high forehead, a long equine nose and, above all, serene eyes barely squared with a

life lived to the full. Forty years before he set out his philosophy in an address to the Archaeological Institute's meeting at Oxford on 18 June 1850:

'The Archaeologist cannot like the scholar, carry on his researches in his own library, almost independent of outward circumstances. For *his* work of reference and collation he must travel, excavate, collect, arrange, delineate, decipher, transcribe, before he can place his whole subject before his mind. He cannot do all this single-handed....

'A museum of antiquities is to the Archaeologist what a botanical garden is to the Botanist...'[15]

Hardly revolutionary today, these views called for a systematic approach from the field to the showcase to what had hitherto been a simple craft of mining and burrowing to obtain antiquities. Newton was an archaeologist not an antiquarian, a pioneer proclaiming the need for order.

Professor R.C. Jebb in a memorial oration captures the essence of the man in unfussy Victorian terms:

'There are those in this room to whom the impressive personality of the master whom we commemorate will be a lasting recollection, – that singularly fine head and pose, which themselves seemed to announce some kinship with ancient Hellas, – that voice which so often within these walls expressed the knowledge thrice-refined by ripe study and experience; a few years more, and these will be only traditions: but to our successors, the members of this Society in days to come, the history of learning in Europe will bear witness that no body formed for the promotion of Hellenic studies could have entered upon existence with a worthier sanction, or could

[15] Charles T. Newton, *Essays on Art and Archaeology* (London, 1880), 37.

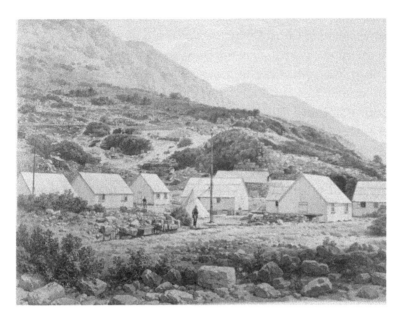

Charles Newton's camp at Knidos (from Charles T. Newton, *Travels and Discoveries in the Levant* [London, 1865]).

desire better auspices for its future, than those which are afforded by the name of Charles Newton.'[16]

In his oration, Jebb told the Society for the Promotion of Hellenic Studies that Newton's life had three well-marked chapters. The first from his birth in 1816 was spent in study, from Shrewsbury to Christ Church, Oxford, and thence in May 1840 to be a Junior Assistant in the Department of Antiquities at the British Museum. Here he devoted his time to studying the sculptures from that Wonder of the World, the Mausoleum at Bodrum. These studies were preparation for the second chapter of his life, a remarkable turn of events.

In 1852, now paid a miserly £215 per annum,[17] Newton accepted the better-waged British consulship at Mitylene on the island of Lesbos, an Ottoman stronghold in the eastern Aegean. Hitherto, a quintessential academic, Newton travelled and embarked upon extraordinary archaeological adventures. The chapter closed in 1861, soon after parting from Knidos. More of this chapter in a moment.

The third chapter came about as seamlessly as if the second had really not occurred. In 1861, now married, Newton was invited to be the first Keeper of Greek and Roman Antiquities at his former museum. He held the post for twenty-four years, penning book after book. In 1880 he moved across a few streets in Bloomsbury to become the first Yates Professor of Archaeology at University College. In this long third chapter of his life the essence of Newton is apparent: a man of sustained though undemonstrative ardour, allied to caution. Jebb summed this chapter up thus: 'no man was less sanguine, or quicker to foresee the difficulties of a project; but, once

[16] R.C. Jebb, *J Hellenic Studies* 14, 1894, liv.

[17] I. Jenkins, *Archaeologists and Aesthetes: the Sculpture Galleries of the British Museum 1800-1939*, (London, 1992), 172.

engaged in it, he was tenacious and intrepid...he was an exacting, but also a stimulating ruler'.[18]

To Jebb's remark must be added Ruskin's observation: Newton had an 'intense and curious way of looking at things'.[19]

Newton did not seek to be a celebrity. From his roots he was a scholar, and yet was this always so? In a portrait by Henry Wyndham Phillips dating to 1850, the thirty-four year old Charles Newton projects a rakish Byronic gaze and clutches his tie. (See portrait, page 60.) Is this oil painting a careless hint of his ambition, a junior keeper in search of a brighter future? Far from feckless, and with a steely sense of purpose, the second chapter of his life stands out, rather like Darwin's adventures on the *Beagle*. Connections had helped. His contemporary at Christ Church, the liberal peer, Lord Granville, became Foreign Secretary in 1852 and offered Newton the Vice-Consul's position on Lesbos. Granville was soon out of office, whereas Newton stayed. From April 1853 to January 1854 he was at Rhodes, taking every opportunity the posting gifted him to explore. So, he landed on the tiny island of Calymnos and excavated sculptures that he had shipped to the British Museum. In 1855 the Prime Minister, Lord Palmerston, offered him the Regius Professorship of Greek at his *alma mater*, Oxford. The stipend being nominal, Newton was left with little choice but to turn it down. In any case his sights were on a greater endeavour. That year he first saw the mighty castle of St. Peter's at Bodrum built by the Knights of St. John from about 1402 onwards and discovered fragments of monumental sculptures embedded in its walls. Bodrum was ancient Halicarnassos, the birthplace of Herodotus, and it beckoned Newton. The port had been the capital of the Carian kings and, as far as the British Museum was concerned, the site of the

[18] Jebb, *op. cit.*, liii.
[19] Jenkins, *op.cit.*, 171.

Mausoleum, a wonder of the world. With spring he visited Knidos for the first time on *HMS Medusa*. The Dilettanti were his guide. Encouraged by the venerable British Ambassador to Constantinople, Lord Stratford de Redcliffe, Newton returned to London in late summer to proposition Her Majesty's Government.

At first the sheer gall seems farfetched. Let us measure Newton's ambitions by the barrow-digging antiquarians in the English shires. These involved a gardener or two and the commitment of a day to a lumpen tumulus. Archaeology was an amateur entertainment except when it came to the gravitational pull of the legacy of the Greats. The power of ancient sculpture as a lodestone for the Victorians cannot be underestimated. These were the new Greeks competing with the Romans in the New World across the Atlantic in the search for some celestial imperial authority. In the autumn of 1856 – rather oblivious to the Crimean War – the forty-year old Newton approached Sir Anthony Panizzi, Principal Librarian of the British Museum, who in turn lobbied the Foreign Secretary, Lord Clarendon. Newton wanted the government to support a major expedition to bring back the Halicarnassos sculptures and others from the region. One wonders today what arguments were made and whether there were those opposed. Was it Newton's scholarship or his connections which won the day?

With apparent ease Clarendon gave the go ahead, and the subsequent debate in the Houses of Parliament supported the Minister's decision. A steam corvette, *HMS Supply* was put at Newton's disposal. With the ship came sailors under Captain Towsey, as well as an officer of the Royal Engineers, Lieutenant (later General Sir) Robert Murdoch Smith. This generous sponsorship was completed with two thousand pounds for expenses.

Military planning went into this operation. R.P. Pullan acted as architect, but pride of place went to the new art of photography, less than a generation old, and made possible by two corporals, B. Spackman and L. McCartney. These early photographs were transformed into lithographs by T. Pickin, esq. when the expedition returned to London.

In a matter of months this fairy tale had become true. *HMS Gorgon* sailed from Spithead in October 1856 and after firmans had been obtained from the Ottoman authorities it deposited Newton's expedition in the port of Bodrum the following month. Excavations began on 24 November. Newton's objective was to discover where the Mausoleum of Halicarnassos had once stood. Mausolus was a satrap here, ruling on behalf of the Great King of Persia from 377 BC until his death in 353 BC. His colossal tomb had been despoiled by the late crusader engineers responsible for the castle of St. Peter's. The Dilettanti in 1812 had first identified the likely site, and Newton's team soon affirmed this. Numerous sculptures apart, the project soon faced difficulties the following year as the price exacted by local landlords inflated to dizzying levels. In June 1857 *HMS Gorgon* sailed for London with a cargo of 218 cases and packages, the fruits of his excavations. The ship was replaced by *HMS Supply*, a large transport under the command of Captain Balliston.

Unwilling to entertain being further cheated by escalating prices and calculating that the residents might see sense if he looked to Knidos to harvest sculptures, Newton struck camp and sailed southwards to Cape Crio on 10 December 1857. No-one lived there to distract his attention. He built an organized camp with barracks worthy of a Crimea encampments of the British army at this time, its centerpiece being a flagpole. Next, local workmen were hired, while others were ferried from Bodrum. (See the plate on page 65.)

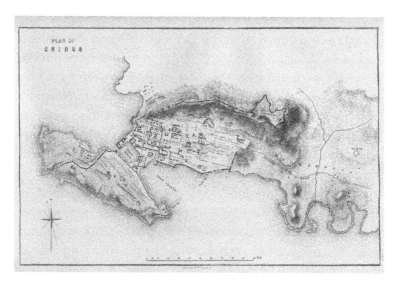

Charles Newton's map of Knidos (from Charles T. Newton, *Travels and Discoveries in the Levant* [London, 1865]).

Newton lamented the conditions in a letter to Anthony Panizzi, librarian of the British Museum:

'An exposed promontory like Cape Crio gathers round it all the tempests of the Archipelago. We have had this year a winter of extraordinary severity. A Crimean north wind blowing a hurricane in our huts and nothing but half-inch planks to keep the cold out. I had asked for stoves, which usually accompany huts, but they had none at Malta.'

A hundred Turks were soon labouring in the ancient city, on occasions posing for photographs in their cotton headgear and ballooning vestments.

At Knidos this unlikely company of men came of age. Newton appears often in Spackman's prints. Posing rather as if he was a hunter who had chased down a great beast, Newton stands round-shouldered in his frock-coat emitting the bearing of more than his forty years. Only his wide-brimmed hat, sometimes surmounted by a Turkish head-dress hints at a little rakish vanity. The few plates leave one wondering about him, but his dry account is told in the first person singular. The reader might be excused for supposing he had personally excavated every hole, and moved mountains. He was very sure of his aims and objectives. Well prepared, Newton had poured over the writings of the Dilettanti and, in particular, of Colonel Leake. No effort was wasted to take a gargantuan next step in mapping the planned Hippodamian street grid. Within it all the principal monuments of the Greek epoch are located. Those remains from the Roman and Byzantine eras were air-brushed out to leave a clean metropolitan result that in itself was a huge achievement. This was only the start.

Newton moved determinedly across Knidos, selecting and excavating with a controlled fury nonchalantly obfuscated by

the casual poses he and members of his team adopted in the photographs. Their task was to find trophy art. Each excavation was to be a harvest on behalf of the British Museum and Her Majesty's government. Stratigraphy and the nuances of building histories were considered irrelevant. Moving rocks, scree and earth were what mattered. The published plates tell a different story. On the jetty unloading equipment, in the camp, at the Temenos of Demeter, in the odeon, beside the theatre, and most spectacularly beside the colossal lion tumbled from its tomb top, there is a pastoral air as though Newton was a country vicar out with his gardeners. The reality was entirely military as opposed to parochial.

The campaign began in the theatre by the harbour, removing rubble that the sappers deployed to enlarge a landing jetty. Next Newton sought out Aphrodite's temple. The Dilettantti had been here before him. Newton dismissed it as Roman. Next he crossed the terraces to an evident platform below the cliffs reaching to the acropolis. Newton at first supposed this to be a cemetery. But soon his sappers and labourers unearthed a headless seated statue of Demeter, *la mater dolorosa*. Chancing upon the separated head he came to name this elevated platform the Sanctuary of Demeter and Persephone. One hundred and thirteen years later I was to be the next to dig here. Could there be other treasures to be found here? Iris wanted to find what Newton had missed.

Next Newton moved to the Temple of the Muses. An inscription identified it. Next on the list was a rich tomb in the necropolis. His greatest trophy, though, was known to him from local hearsay. He had heard talk of a great lion sculpture from his Greek informant, Nicholas Galloni, when he was excavating on Kalymnos. In a letter to the British Museum Librarian, Panizzi, with feverish excitement he recounts how the beast was found three miles south of Cape Crio:

'Since my arrival at Cnidus I have from time to time instituted a search for this lion, but the winter was so intensely cold, that distant expeditions were most formidable undertakings and a Crimean north wind swept over all the promontories with such ferocity as to deter us from exploring them. Since the weather has been milder, Mr. Pullan has occupied himself a good deal with excursions in the environs. I particularly pointed out to him this lion as an object to be sought for. On the 15th instant he presented himself to my astonished gaze in a state of most unusual excitement, for he is naturally of a most equable temperament. His hat was crowned with a large wreath of oleander flowers, his eyes had a wild expression like those of a person who had passed the night on Parnassus or Snowdon. 'I have found the lion', he said. Those words explained the discordant state of his nerves. No wonder that he was astounded. The noble animal is ten feet long from stem to stern. He is of Parian marble and in very fine condition. He is in a couchant attitude, his head turned to the right. From the base to the top of his head he measures six feet. His weight I should imagine to be eight tons...'.[20]

I shall return to the lion. Today, it sits atop a plinth in the Great Court of the British Museum, emptily regarding the throng of visitors. This placid scene belies its capture. This required a month of extraordinary engineering efforts. Newton believed the tomb commemorated the Athenian defeat of the Spartans in the early 4th century. Ian Jenkins in his delightful little book on the lion believes this is unlikely as the tomb dates to the later 3rd or even the 2nd centuries, but its presence was undoubtedly no less important than Aphrodite.

[20] Jenkins, *op. cit.*, 187.

The lion was the climax to the Knidian campaign. In May 1858 Newton and his team set off for Didyma. He was to return to Knidos with a smaller team the following spring. In May, though, *HMS Supply* was ready to bear a course to England. In June 1859 the crazy Englishman left the Levant for good. His ship was waylaid at Malta, so he made his way to Bloomsbury to receive the trophies when on 6 August 1859 the cases arrived at the British Museum.

Newton's thoughts about Knidos, especially about quitting it go unmentioned in his account. The end, it seems, was not wholly foreseen, nor perhaps with any perspicacity was the next chapter in Newton's life. The next three years set the course for the rest of his career.

Bloomsbury was a hot bed of debate about how to show the sculptures. Within days Newton was at odds with his colleagues. Once more fate intervened. Presumably he was contacted by the liberal Foreign Secretary, Lord John Russell, and, satiated with his discoveries, felt satisfied to take an unlikely step onwards. In 1860 he moved to Rome where he became consul. How he reconciled diplomatic life with its exigencies after the adventures of digging in the Levant can only be measured by significant changes in his personal life.

Rome was in thrall to the prospect of revolution. Garibaldi and his thousand marched inexorably from Palermo towards the eternal city. Newton's thoughts were elsewhere. Diligent to a fault, he was preparing the publications of his expeditions. The heady prize of the Keepership of Greek and Roman Antiquities was to be in his grasp by 1861. Then, on the eve of ending his Roman consulship, Newton married the daughter of his successor as consul, Joseph Severn, years before the bosom friend of Keats and Shelley. The courtship is lost to the mists of time. Ann Mary Severn was 28 years old, fourteen years younger than her husband. More to the point, she was an artist

who had studied in Paris. It is hard not to conclude that with a certain bohemian spirit she was thrilled at the prospect of living in Bloomsbury.

Within a year of returning to London, Newton's monographs were published. Dedicated with pride to (ambassador) Viscount Stratford de Redcliffe, at whose urging Newton had undertaken his endeavours, these volumes vouchsafed Newton's place in the pantheon of great archaeologists. R.P. Pullan, his discrete second in command, is credited with being an assistant to the author. As we have seen, the folio-size illustrations, though, feature the new Keeper.

Having consolidated his academic credentials and with a wife at hand, there began what Jebb in his memorial oration defined as Newton's third chapter as a Victorian notable. It was to be a long twilight after Knidos and Rome. His harmony, however, was punctuated tragically by the death of his young wife in January 1866.

Ernest Gardner, Director of the British School at Athens, was no less fulsome than his colleague, Jebb, in his memorial to Newton. Measured candour, too, is unfurled in his peroration at the end of the ten published pages:

'Apart from the wonderful success of his excavations, what is most remarkable about Newton's work is not brilliant originality or skill in the construction of ingenious theories but the breadth of interest, accuracy of fact and sobriety of judgement expressed in a clear and flowing style. His mind was readily open to new ideas; thus he was one of the first archaeologists to appreciate the great value of Schliemann's discoveries at Mycenae … Yet he was always cautious to distinguish the probable from the certain, and rarely, if ever, lent the weight of his authority to an opinion which was not based upon sure and sufficient evidence. These are the

qualities that are needed above all others in the present state of archaeological knowledge; and it would be difficult to hold up a better example for the imitation of those who are following in his steps'.

In June 1859, a century or more of investigations ended, leaving Knidos as a place best known to visitors to the British Museum. Newton's publications lent detailed Victorian diligence to the abandoned crags of Cape Crio, but the ancient city itself was soon colonized by tobacco farmers. Demeter and the lion entered the pantheon of great art. Nevertheless, failing to find the Venus, Newton and his illustrious forebears furnished the ruins with the motive that brought us to this unlikely place. Once there Iris Cornelia Love was ensnared by Newton's maps and notes and late at night the Victorian frequently became a fey nemesis. His shadow still prowled these terraces and proved ever more imposing with each new excavation.

4

Awaiting the Director

Excavations are essentially a succession of arrivals and departures. A team comes together and then comes apart. The isolation of Knidos, all but an island, attached to Turkey by a craggy umbilical cord, heightened the staccato of life. Friends made, followed by friends parting for points in Turkey, Europe or, beyond my world, America. Leaving as they found Mehmet and Ruşan and a few others to populate the makeshift cafes and tobacco terraces of Cape Crio.

After Tim, there was Henry with Marie and Ilknur, then our shaken Willy's jeep load, then with each day, our private world was interrupted by another weary and no less animated arrival. Each driver looked grateful to release his agitated passengers. None travelled in tranquility to Triopion. An architect, a trench supervisor, a commissar to make us mind our ways and a flock of specialists to study finds. All on planting their feet in Knidos' dust, joyous to renew summer friendships. All grateful to have survived the journey from Datça.

Three East Coast girls, whey-faced at this point in their summer, and preppy in each and every way: Jan, Lindsey and Midge. Constanza, the conservator from Stuttgart, twig thin and visibly disoriented by the journey she longed to forget was soon putting puzzles of sherds together with apoxy resin. There were the Trausdales, architects. The emollient epigrapher, Mark and the prematurely severe Cathy, who managed the finds cataloguing, were collected from Marmaris by Tim. Sheila Gibson arrived to a welcoming party. Henry, Tim, everyone came out to greet her. Nermin glowed, positively glowed, just

to tell me about her. Sheila had survived after her jeep went over the cliff three years ago. She had dragged the driver out and suffered a broken collar bone (she pointed to her own collar bone). Nermin paused, to add: she is special. Indeed, this petite lady with a bob of white hair – in her pressed pale lime blouse and matching pleated skirt she was every inch a lady – was Iris' talisman, the only person who could rebuke the director and survive. That same day came Dick Keresey, a lanky blond carrying his kit bag over his shoulder. He brushed back his locks and with a seemingly unnatural insouciance explained that the driver had left him at Yasiköy. He had then walked with an officer's bearing, ten kilometres. He was in Knidos to study the glass finds. Strange at first, being self-contained he was the likeliest candidate to command armies of workmen and with a certain nobility to dig alongside them.

Soon after Dick came an old Istanbul Oldsmobile, the kind of limousine that film stars then drove along Californian highways. It was, in fact, an Istanbul *dolmuş*. Out stepped the driver, a tall broad-chested Turk, obvious at once for his air of entitlement. He opened the rear door and there appeared the willowy legs of the German black-glazed ware specialist, Barbara. From Heidelberg, Nermin whispered, well out of our league. Tall, erect, and with a regal self-confidence of early middle age, this blond bombshell crisply commanded that her four leather suitcases be brought to the tables near us while she sought out Iris. Imagine her smouldering discomfort to discover that the director had not arrived. Barbara had beaten her to it, and so needed to introduce herself to us herself after dismissing her driver with a surprisingly gentle touch to his shoulder. For a moment her eyes were all over him. They are lovers, Nermin whispered to me before adding something in Turkish to Ender. With time we would come to know more, but only after the passage of weeks in which Barbara became the leading lady, upstaging Iris herself.

Soon we were twenty-five, eager for the excavation to begin but unable to do more than wash pottery because Iris Cornelia Love had been delayed.

So, for hours, under the cane canopy of the lean-to extending out from the dig-house, we sat on cheap beach chairs and washed fruit crates of featureless sherds. Mostly rosy and powdery after a few moments in the salt water, the pottery was the tangible refuse of Knidos' citizens when the metropolis was at its apogee. These fragments were to be numbered, sorted, drawn in profile, then treasured and studied by those who had given their lives to classical archaeology. Mostly the pot people inhabited the store-room and moved selected sherds around their deal tables. Like badgers they inhabited a half-light connected to parallels of sherds logged at other places in other times. Their code was almost monkish and old school.

Within the beams of sunlight threaded through the canopy of the cane lean-to my junior companions and I did the menial work and chattered freely, a little less as the heat inflated till the sun was pitched right over us. We were unconstrained by the animus of the finds and their part in a larger story. Our story was simply the adventure of participation. No more; no less. Sometimes we listened to one of the two tapes of music, revolving away in a burr of distortion and static – Elton John's *Your Song* and Karajan's Beethoven's *Fifth Symphony*. These disorienting echoes carried like spring scents in the wind, but soon passed.

Of course, one topic of the chattering was Iris herself. Eminently more fascinating than Charles Newton, with whom Tim was all but engaged, musing on the celebrity of our director was enough to salve the tedium of a whole crate. Tim, eyes rolling, variously described her as a shrew or worse, while

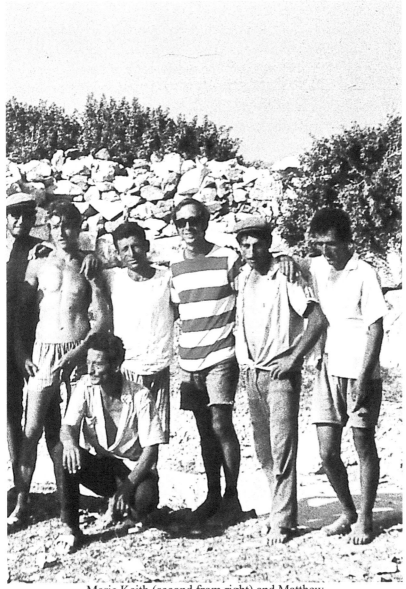

Marie Keith (second from right) and Matthew
(third from left) with Mumtaz Sariyaz and other workmen
(photo by the author).

Ilknur and Nermin held her in awe, a spectral figure. Soon she would descend upon us, as if from deification. Then, as Nermin muttered darkly in a deeper bass note, it would change. The 'it' was hard to pin down even with the passage of days.

Nermin with a deep silken olive skin and raven hair with hints of blue, dark clear eyes, was my muse. Under the dancing shafts of sunlight she practiced her English on me. Mechanically, as the filed-down tooth-brushes did their jobs on the encrusted edges of the sherds, I pushed the limits of her lexicon, enjoying the freedom. We toyed with jolly words and silly words, and words that felt good like 'scintillating'. As she experimented with 'scintillating' her eyes brightened. Her visible pleasure was shared as she enunciated the languorous intonation of the syllables. She had a full-throated laugh, cooing like a dove. There was no intrusion on these hours of lessons. Tim was chewing Henry's ear off about the stratigraphy in his trenches or in other trenches that had been excavated too hurriedly. Matthew was out on the hillside selecting photographic angles. Ten of us were charged with these menial tasks and ten of us found a commonality, which with each day had an indefinable pleasure. Over the years I recall Nermin's head scarf, red with small white spots, as bright as the balletic light. Six years older than me, adolescence was a fresh memory sharpened by the freedoms of Knidos. The only daughter of an engineer and a school-teacher who had met as guest-workers in the austerity of post-war Germany, she was destined to be married to an army officer. Little of this had any shape as we dipped our hands into the shared basin in search of amphorae fragments. Stories from afar, as distant as could be from my Wiltshire. Then there was Knidos. Iris' lost metropolis of love. Last year she had met an American here, older than her, a pacifist who dodged Vietnam by working as a porter in hospitals. Nermin had lost herself and her hope to this boy, as

she christened him affectionately after a week of potwashing, and then he had written to say he was engaged and Knidos was out this year. So here she was with the spectre of some reincarnation before her in a spotted red head-scarf.

One afternoon after a nap, Marie Keith approached and briskly asked me to help her. It was her way of issuing an order. Days had passed since she had spoken to me, such were the many duties of stand-in chief. Still in her khaki drill outfit, and no less punctilious as she had been on the long drive, she wanted to build a toilet. She summoned Emin too, and Mehmet, the light-housekeeper with mephitic breath, in all but name our host, joined the party. Emin carried two picks and two long-handled shovels.

Marie and Mehmet led us up behind the walled compound of faded frame tents. Following a short path to a point where the wind congregated from both directions, she and Mehmet paused at a narrow terrace. A hollow already existed, traces of a pit from the previous year. Mehmet mumbled and nodded, his haunted eyes, bloodshot casting around before he ambled off.

'The pit has to be two metres deep, then Mehmet will find some lime for Emin to line it before he surrounds it with something. You can handle that can't you?' Then Marie trudged off in her oversize boots.

I wondered, thin skinned for a moment, if I should feel insulted. Had I been demoted to latrine duties? Was I no good for anything else: could I handle it? But Emin grinned the same grin that announced our imminent arrival in Knidos days before. Marie might be tacitly echoing Tim's acerbic criticisms of me, but so what?

Emin and I stripped to our shorts and with gusto bludgeoned the ground with our stubby picks, ignoring the still heat. As dusk approached, we had sunk a square hole to the

requisite depth, carefully shoveled quick lime into it, put a rough-hewn broken wheelbarrow plank across the back half of the pit, then another at the front leaving a gap between. Emin found four wooden posts that came up to his chin that we sunk in beside each corner, then with frazzled twine we lashed matting around our edifice. Its door with a knotted loop to hold it to a post gave out onto the ridge terminating at the lighthouse and the seaway reaching to Kos. In an afternoon we had constructed the 'loo with a view'. Its only frill would be a toilet roll. Here, as inevitable as the daily weather from dawn to dusk we all came at some time or another, cruelly struck by bowel ailments. In our frail agony, the clouds of black flies – eliminated only by the weekly lime dumping – were mitigated by the precious serenity of the seascape.

Afterwards Emin paused to appreciate our efforts. 'Çok güzel', (very beautiful), he said with muffled pride. Together we had added a landmark to Knidos. Emin put his muscular arm around my shoulder and like warriors we descended the narrow path to camp. Momentarily we were treated as heroes by the potwashers finishing up for the day. The only other toilet was a fetid concrete box that boiled as the infernal flies invoked carefree carnage.

'The loo is well built. You should be pleased', Sheila said to me in her characteristic lisp as I was taking my place at breakfast. I pointed to Emin as he brought me a cup of black coffee, and deftly explained that I was only the willing assistant.

'How about helping me today on a little task?' she asked, uncapping her pot of Robinson's marmalade brought for her own breakfast; she was a diabetic. I stared at the jar momentarily wondering why, and she explained without hesitation why she had to control her diet. That was that. Now, how about helping? Of course I agreed, wondering what Henry and Tim would make of my skiving off from pot-washing.

Nermin pot-washing in the camp, July 1971
(photo by the author).

'I need someone who can handle all the numbers, the tape measures. It's hard for some of them. Standing still in the sun and memorizing figures just don't seem to go together. I want to finish off the Temple of Dionysos today before Iris comes. Otherwise I fear there won't be time'. She continued between mouthfuls of the thick crusty bread brought in before dawn from Yaziköy.

Breakfast over, I informed Henry, who bleary-eyed as ever in the morning, muttered, sweeping flies away, that working with Sheila was tough but really fun. A crate more or less of washed pottery didn't matter to him. Nermin arrived as the sun started to rise and repeated almost verbatim what Henry had told me, though she had never actually worked with Sheila. I detected a modicum of envy. The English were hanging together (Sheila, in fact, was Irish).

Finishing up at the Temple of Dionysos took twelve hours. We could have built several loos in the time we spent on this little task. Sheila led me out at six-thirty. I tagged alongside quite unprepared, marveling at her. She was my mother's age, prim and correct, immaculately kitted out, her white bob of hair tied high with a scarf, visible under a wide-brimmed straw hat that Newton might have given her. She also had impaired hearing that accentuated the lisp of her Anglo-Irish accent and allowed her, as she would say with a girlish smile, to ignore what she did not want to hear. Ignoring Iris was something she mentioned often.

A bag of architect's tools seemed to be permanently attached to her shoulder, and tucked under her left arm was a plywood drawing board – her own, she explained because the other boards were too heavy and unwieldy. I was armed with three thirty-metre tapes and two red and white ranging rods. Already, with the first flush of the morning sun it was hot and for a time humid until the breeze kicked in.

Apparently, she had tried to enlist Bülent's help, but although he was aiming to study architecture, his numbers were confused under the pressure of Sheila's relentless work ethic. I also learnt, as we approached the temple, not far from the *Jandarma*, that Sheila had been an architect for twenty years and every vacation she made drawings of archaeological sites – in Italy, Libya and now, Turkey. She was one of John Ward Perkins's 'people' and hardship seemed to be no issue provided the drawings could be made and published. Through Ward Perkins, Iris had obtained her precious services.

Sheila strode towards the only lone fig tree and beneath its hint of shade deposited her drawing board and bag. I stood close by, a butler in attendance. She found a flat wall on which to place her board and now I could see the outline of the temple, overlain with a monumental cuckoo, an intrusive Byzantine church modeled on St. John's at Ephesus.

'Let's walk around and just get our bearing, shall we?' she said with firm intentions.

'You'll soon see it looks like an earthquake demolished it!'

And off we went. Sheila had a slight limp, but with purpose she pointed out each wall, plinth, column, and feature from which we had to collect points. The temple had been shattered and its columns and their capitals looked to have been thrown to the air and landed with no rhyme or reason. By contrast, the outlines of the Byzantine basilica made a thousand years after the temple were readily traced.

Sheila would hang on to the toothy terminus of the tape. For my part, armed with a ranging rod, I would march to each column and capital, holler the length then move on. And that was what happened. For hours. A gallon of Cool Aid in a red thermos was brought by a shirtless water boy at mid-morning. He stood shyly by as we emptied our helpings. When we paused to rest Sheila talked about horse-riding in Ireland in the

1920s or about surveying in Libya with John Ward Perkins and Richard Goodchild, both veterans of the British Eighth Army and its North African campaign.

By midday the sun was sizzling the stones and only the lizards could have enjoyed the immense warmth. With a corner point cross-checked, Sheila mopped her creased brow, smiled wryly and commanded we return for lunch. We had barely spoken in the intervening hours. Instead, one point followed by another I had trotted obediently around the great bleached white podium, dodging the rubble and finding the polished ashlar plinth. These bleached stones murderously reflected the heat, consequently my cheap Italian Che Guevara shirt was sodden wet with sweat. Sheila on the other hand looked a little pooped but nothing more. As we set towards lunch, she swung the board up to reveal the gilded outlines of a great monument, recorded with a soft pencil brought from Oxford. It was my first sight of Sheila's distinctive style. Made at great speed, with faintly quivering lines betraying the staid perfection of the original. A little cartoon figure, no more than a triangle with a blob for a head, was poised discreetly in one corner as a human measure.

She was pleased. I could tell because as we approached our lean-to with the lunch being spread out to await us, the finds team emptied out of their dark chamber to appraise her work. Tim was soon with us too. The length and breadth and orders of the sacred spot were being archly compared in loud assertions to temples further up the coast and even further afield. Sheila held the board but said nothing except at one point to wryly cuss the Byzantine church for making it all so damned complicated. In a lull, though, for her clever audience's ears, she praised my efforts. It was our work.

I napped after lunch; Sheila meanwhile, white head bent low over her board, fashioned the details, rubbing her pencil

lines and tracing them anew. Nothing was wasted. At three-thirty back we went to the temple, remaining until the sun dipped towards Kos, when as if to catch the moment she smiled a lavish smile. The great temple had been tamed.[21] I guess it had taken her three or more days, but it was our concentrated blitzkrieg that delivered it. I watched Sheila many times over the next decades, transfixed by the understated magic of her art. Economy was essential to her thinking, as much as her unwavering certitude to capture the full grandiosity of a building and bring it to life on her drawing board. My baptism, as so many times in later years, ended in her tent where beside her jars of marmalade was nestled a bottle of Gordon's gin. With Marie Keith beside her on the camp bed, we toasted Dionysos, and, as ever the subject turned to what Iris might make of it. That is, when she descended upon us mere mortals.

Every dig has a watering hole. Here the romances take shape and the gossip evolves to a nightly rhythm. Bars, pubs and cafés are the engines of excavations. Without them and their pliant owners, digs become arcane talking shops of the most arid kind. Knidos was no exception. To escape Art History 101, before and after dinner, the bottom half of the long table found freedom in Ruşan's.

This little square two-storey white washed house was anonymous as you entered Knidos. Beside it was a long washing line where our laundry was hung out by Ruşan's tireless wife for all to see. Its real purview was the water-borne visitors who jumped onto Ruşan's rickety dock and ended up under his matted lean-to canopy or dared to delve towards the rear, the bottom half of his house where he and his wife, almost always cradling an infant, made omelettes, fried fish, brewed tea and

[21] Sheila's plan with which I had helped is published in *American Journal of Archaeology* 76 (1972), 396, and Christine Bruns-Özgan, *Knidos. Ein Führer durch die Ruinen*, (Konya, 2002), Abb. 39.

coffee. This dark interior was where the workmen played cards and where the real diggers found freedom from Iris' omnipresent personality.

Ruşan's was a hole in the wall and discrete unlike his neighbour, lanky Cengez's bar. The latter was perched up the hill and was open on all sides and modern, and where all could be identified from the dig-house. Cengez could barely conceal his cupidity. Any chance to take us for a few lira more was never forsaken. He was a hustler, middle aged and reserved, he had none of Ruşan's occasional grace. Fights too took place here between knife-men, trading village vendettas. It was best avoided.

Ruşan was a rotund little man with a spread of unkempt hair and a languid, permanently bewhiskered chin. His vanity was to be seen in his solitary golden molar, just visible if he laughed. He often wore a stained white pinny. How he won his younger wife in her white headscarf was a mystery given his naturally shy manner. Her lot was a benign version of slavery. But once you knew him, as in so many bars, you found favour and his rictus smile. Then, he would ask about Iris, about the dig and its treasures and whether someone really loved that girl. His lugubrious face positively inflated a little when Lindsey or Midge were present. Was it their decorum, short starched shorts, halter-tops and acres of tanned skin, or simply their overt otherness. Ruşan knew his business: Catch a few of us of an evening, he grasped, and like magnets the yachting types anchored in the Commercial harbour would row ashore, dressed for Nice or St. Tropez and find a table close by. These were French and Italian tourists, always minimally dressed or rather not dressed. Knowing no Turkish he added his own tax for each offensive infidel, but discounted us as often as not. Like a true dig bar, he knew how to rack up consistent custom. Here was an oasis out of the infernal heat or the *meltem*, spraying

the light of the lamps. It was good to be cool, not to drip with sweat or shade one's eyes from the sun. Added to that, late evening, when the dig was in full swing, old Mehmet would bring out his saz and the elfin, beaked-nosed Mumtaz Sariyaz would jig, arms flaying in balletic movements, with potsherds as castanets. Beginning with a whimper the music would accelerate and gain strength with the flat stabs of the drumming. The abstemious workmen found the lyrics irresistible. Way into the night they would sing village songs, knowing as we did that this was for a time only and the long seasons in the fields without any such entertainment might last a lifetime.

Sometimes Mehmet the lighthouse keeper was secreted deep into the rear shadows of Ruşan's. He would signal acknowledgement with a slow shift of his hand, then slug back a tumbler of raki. Prematurely old, his bloodhound eyes, were bloodshot with the prodigious ingestion of alcohol. Complicit with the *Jandarma*, so legend had it, he plied these treacherous waters with his own caïque, bringing in contraband from the Dodecanese, the Greek islands on our horizon. A bottle of Johnny whisky, it was said, cost the price of a cow with all the taxes imposed by Turkey's martial government. Other treats from the West were as scarce. Mehmet coyly tempted the gun-boats out of Bodrum, it was said, occasionally incurring trouble, but always looking out for Iris' best interests. He was the local fixer, the oil needed to resolve near impossible problems that every dig confronts. His reach extended to Marmaris, a latter day pasha in perpetual decline to resemble a compact cask with legs. Yet it was Mehmet, after all, who cared for Iris' Zodiac, her speedboat and outboard motor, and her precious water skis. It was Mehmet who found special dog food for her canines. And it was Mehmet who kept a wife making fresh yoghurt, hidden in the stumpy, white-washed lighthouse far beyond our

rim each day. Mehmet's billy-can of thick yoghurt found its way to breakfast most days. For the picky East Coast girls and the Germans, the yoghurt was crucial balm as they swatted away the flies. For them especially Mehmet could do no wrong and they would hug him, half-cut, grinning sardonically at his unwanted status.

It was not hard to appreciate Mehmet's standing in our company or the importance of pre-dinners prepared by Ruşan. The simple ration of aubergines cooked three hundred and sixty five ways – even though I had never tasted one before – soon declined beyond the monotonous. Bulgur rice and pasta with vegetables followed by water melon were pretty much the daily fare. Always bread and oil had to fill the margin of thrift. Emin valiantly attempted variations. But the budget was limited, so I heard, and so were the vendors.

One evening Marie took Emin and me to a bay beyond Çeşmeköy where a *hodja* with a thin stringy beard was willing to supply us pretty much all we could eat. This was a rich screen of opulence. The lattice of fields contained by drystone walls were full of fruit trees, vegetables and cereals popping up below the benign canopies of olives as far as the eye could see. On closer inspection, though, the pliant *hodja* only grew aubergines and onions and a few mouth-watering new potatoes which, under supervision with a precious consignment of mayonnaise from the American military stores at Izmir, Emin transformed into potato salad. Marie attempted to explain her problem to Emin who half understood but was confident he knew fully well and so tore the emollient *hodja* off a strip. The old man was like rubber. Unoffended by Emin's boyish zeal, he politely renewed his offer of all he had, and knowing we had no choice, marked up a good price too. I loaded sacks of rice and pasta as well as countless crates of melons into the landrover, but these lasted no time at all, and soon the bearded

hodja was heading a commuter train of snorting donkeys over the twelve kilometres to our door every few days.

Then, as we were napping one day Tim, who liked to sleep under the canopy after a daily post-prandial disquisition on sherds, let out a feral cry. Lots of us sleep-deprived wrestled to wake, as he of course intended. His excitement was irresistibly in our faces. Two of his workmen from the previous year, both from Yazıköy, had shown up with a freshly shot wild boar lashed to a rueful donkey.

'They want a hundred lire for it!' Tim exclaimed, leaning against the creature. 'I told them, not on this earth. They can't eat it so they'll come down.'

The magnificent beast had been dispatched with a muzzle loading rifle in the mountains. The clean shot was worthy of an ace assassin. No-one in the villages wanted the creature, but the emboldened workmen thought they might make something on a deal with the Americans. Tim was their perfect fob.

Henry grinned a dolphin smile at the gastronomic prospect. He looked at Tim and me and ventured a proposal:

'Why don't we three treat everyone? Tell them 75 lire, Tim, take it or leave, it, twenty-five lire each. Food for a week'.

Tim did just that. His workmen hugged him, hauled the creature off the ass and then mounted the animal and promptly trotted off. Henry took charge with glee. For a few hours he was transported back to his undergraduate days at Cambridge organizing feasts for fellow students. Initially, of course, he encountered a certain squeamishness which he disdainfully ignored. Emin made himself scarce. Bülent and the Turkish girls took a rain check, as Bülent gleefully told him. They could not eat pig. In the end, Henry did the lion's share, hacking off the head, Tim butchered the body and I dealt with its thighs and legs. Henry was in his element, thrilled by the challenge.

Personally I found the skinning distasteful but ploughed on manfully, well aware of the potential outcome. Filleting the creature with its bristling armour took wrist and finger strength and not a little skill with the camp's dulled knives. Then, the meat had to be cooked, preferably in an oven. This is where Mehmet came in. With a little cajoling of Ruşan and his baleful wife, we had pork that night and the next night and for almost a week afterwards. Tender and fat free, the meat cooked slowly was just as Henry had hoped. In truth it was a miracle, or at the very least Henry (and Tim's) triumph. Aubergines with pork, rice with pork, pasta with pork, everything with the fronds of pork parts as the fêted beast produced more meat than ever we had expected, bearing in mind the faint-hearted graciously turned their noses up at our philanthropy.

'We jipped those poor boys', Henry concluded, dishing out the last slices of the creature. For three pounds sterling the English boys and a few less choosy companions had lived like kings for the better part of a week.

With the warm wind strengthening we were finishing those last slices of the wild boar when Mehmet the lighthouse keeper suddenly put in an appearance beside Marie Keith at the head of the table. He looked different. No melancholic forced grin, just stiffened. It was as though he had been rocked to his senses. Nermin gauged it instantly and turned to Ilknur who told Bülent and Ender and then Celia knew and so did Jan and Midge and Lindsey. The moon hung like a parchment lamp, casting light over the corniche. In the Commercial harbour, given the stillness, the chains and lanyards of the yachts gently shifted, providing a minimalist overture for the arrival of our director. Mehmet had heard from the *Jandarma*, Henry told me. Typical to come so late at night, Tim said without thinking. A party entrance with us all gathered to do homage.

Now we watched for the lights in and out of the shadow of the perforated cliffs. There were none at first, only the feeling that nothing would be the same, that our serenity was about to be invaded. And at that moment Nermin turned to me and said exactly that: 'Nothing will be the same'. And nothing was.

A pregnant silence ensued as the beams appeared, diminutive pin-pricks the size of stars miles away. Mesmerized by this force from beyond our cape we could not ignore the slow but steady progress of the headlights, searching out the curves and drops, and accelerating as we had done, on the dusty straight sections. Then she was gone, lost in the last hairpin as the road passes through the city's necropolis where Newton had excavated and Iris eagerly followed him. The headlights spun out to sea, penetrating even the moonbeams, before racing down towards us, momentarily concealed by Ruşan's, emerging triumphantly along the short beach to face us all. Now, we, the audience, became the players.

Marie and her elder peers had mechanically risen from the table, aroused by the on-coming landrover, each locking down his or her own thoughts. Henry who had only corresponded with Iris before now looked nervous as he anticipated this first encounter. I stood too, as did all at our end of the long table as if to acknowledge our duty to her will. Then, shrill gasps, shrieking and untroubled laughing, muffled in the pure wind by the gaggle of people with Mehmet deep in the throng.

Then she was with us, finally.

Striding ahead, arm around Sheila, Iris entered into the shadowy light cast by the tilley lamps. Beside her, a vizier, Mehmet. Square-jawed with a wide mouth and piercing eyes, tired but consuming us all in her excitement. Like a proud admiral, she took her seat at the head of the table, thanked Emin firmly by his name in Turkish for the tumbler of Jack Daniels with rocks in place, and plucked up her two sausage

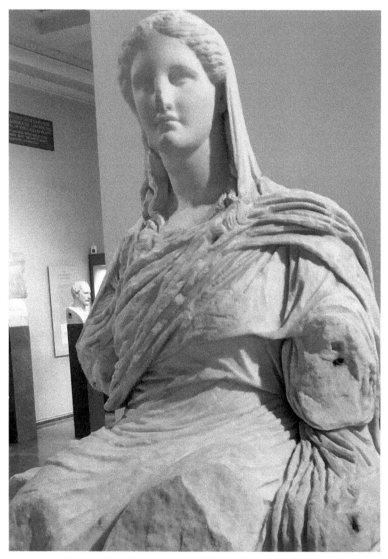

The Demeter of Knidos in the British Museum,
London (photo by the author).

dogs, each wriggling like rats. Even Tim, rudely relegated by a chair or two down the table settings, knew in his heart that Newton could never have entered Strabo's stage with such braggadocio.

5

Digging Days

Things had changed. I discretely left the steamy cloud of mirth for the sanctuary of my tent, feeling sensitive about my age. Iris' arrival put everything into a new perspective. I had just completed my freshman year. True, I had been digging on and off for nearly four years. But now this had become a project with objectives I barely grasped. I already knew what was expected of me. I was to oversee the excavations at the Temenos of Demeter in search of ancient body parts, votive trophies that meant little to me. Henry and I had zig-zagged our way up to this vertiginous eerie one evening to work out a plan of campaign. Henry had been in a good mood, enjoying the freedom of Knidos' acres of archaeology. On reaching the Temenos he played the role of deputy director and held out little hope of finding anything particular. His reasoning was easily explained.

With Victorian ruthlessness, Newton had all but blasted his way across this raised platform. The archaeology had been erased. Henry and Iris had decided that I was young and fit and could cope with the long climb every day and, no doubt, left to my own devices, I could do little harm. Besides, I surely had a humble yearning for learning. Lindsey was to be my assistant, and we would have a platoon of workmen at our disposal.

Next day, awake in the mellow light before the sun came up, I was almost the first at breakfast. Almost, because at the head of the table was an alligator-eyed, lanky man with a shock of fair hair and a milky right eye as transfixing as a facial scar. He emitted the truculence of a conspirator without any shadow.

Politely I saluted him in Turkish, and he mouthed a disdainful reply. I retreated to the far end of the long table and opened my book and did what he was doing. I ignored him.

Emin smiled as he handed me a coffee. "Muktar," he whispered, referring to the village head man universally known to us as 'The Big M'. With Iris now here, negotiations had to begin about how many workmen she would hire, for how many lire a day, and what was in it for him? Sitting in Iris' place, he was stating his rights over Knidos and the dig.

After what seemed like an age, the Muktar was joined by Mehmet Bey, the Commissar from the Ministry of Culture. Always impeccably turned out in crisply starched clothes, matching fawns, he was both a punctilious and emollient man. Mehmet was probably younger than his attire and bearing presumed.

Many Commissars appointed to oversee the foreigners were said to be tin-pot dictators. They could arbitrarily determine the placing and the sizes of trenches, and demand reports, and, so it was said, even halt an excavation. Our Commissar seemed unlikely to behave so badly. Coming from inland Anatolia, he found Knidos enchanting and until now had spent his days visiting every inch of the metropolis. His bright eyes also suggested he took tacit pleasure in the American as well as the Turkish young women. Nermin reported as much. He had gravitated each evening towards Bülent, Ilknur, Ender and Nermin, avoiding over exercising his archly formal English. Now he would have to handle Iris and doubtless he was bottling his nerves as I was mine.

Instead of Iris in her seat, he was palpably relieved to find the Muktar. With a dolphin smile he offered his hand to the local leader, and with an arm still on his shoulder, he sat beside him. Soon, sipping coffees, following his easy gestures, they became lost in conversation, oblivious as the table first filled and them

Votive statuettes from the
Temenos of Demeter in the British Museum, London
(photo by the author).

emptied of bleary-eyed colleagues. Coffee and bread and honey consumed, I repaired to my tent.

Five minutes or less later I heard Iris pass by, the strong timbre of her voice unmistakable, and after waiting a moment I looked out to see her with Ilknur, the Muktar and Commissar briskly advancing upon Cengez's bar. Iris was in her trademark short shorts, her toned body confidently leading the lean figures of her three companions and the two hounds, Phryne and Carlino. Out of our earshot, I supposed, she intended to set out her terms.

Chores still had to be done. Nermin and I were taken off pot-washing to mend tents as though the fervid celebrations of the previous night were an illusion. All eyes were looking for white smoke or some similar signal from the negotiators. At lunch, then at dinner, Margot, Iris' cousin who arrived with her, told us that the talks were continuing. Patience was needed. Iris had bags of patience, she said. Still, Iris had simply been eviscerated as promptly as she appeared in our midst. All the next day the talks proceeded. Now, Cengez's bar had attracted groups of men, inquisitive villagers in caps. They stood outside, or close to the room where Iris and the Muktar were searching for an accord. Every so often, the men would remove their caps to mop their brows and sneak glances at us, just as we were spying on them.

It boiled down to a Chinese whisper that passed through the villages. At Miletus up the coast, after a strike during which the German archaeologists were supposedly besieged in their camp, new daily rates were paid on the excavations. The one-eyed Muktar was holding out for the same per diem rates. Then, after dinner on the second night a buzz of caucused silhouettes animated Cengez's café, whereupon Iris appeared with the Muktar and arm in arm they returned along the beach to take their places at the top of the table, to toast each other

with Jack Daniels on the rocks. Older, unshaven men, some with sticks, all with flat caps, cautiously eased themselves into the camardarie illuminated quixotically by the tilley lamps. On the beach, in the moonlight, were younger men, as silent as shadows, watching the theatre like illicit voyeurs. It was their labour that was at stake. Iris was intent on paying less than the Germans. The bargain struck at Cengez's was twenty lire a day per man, or 12 shillings and six pence by the sterling rates of the time. It was an unequal match. Peasant measurement of time and distance was done by the number of fetid cigarettes smoked. Dinner and beers in Ruşan's were covered by a day's toil.

Land now had to be purchased. Herein the wings of the millionaire could be clipped after her Pyrrhic victory over pay. Next day a big black sedan arrived with the Big M, the deputy governor – the *Kaymakam* – soon to be known to us as K-K – and his inebriated circuit judge. Their task was to arbitrate, principally for their benefits. K-K was an oleaginous creature with a viper's smile and a bulging stomach. Polished black shoes and a spotless white shirt contrasted starkly with the Knidos team and its director in her solar topee. Iris corralled them at one end of the table and the K-K's maudlin eyes roamed, at an instant seeking a raw wound to poke as a starting place for the deliberations. I was the wound. Nermin and I were still washing pottery close by. The K-K caught my eye, rose slothfully and advanced on us, drawing Iris' attention as he did so. Arching over me he poked with a spade-like hand at my Che Guevara shirt (bought in Rome's Campo de' Fiori street market on the way to Knidos) and spat at Nermin. Nermin lurched backwards and he spat again, and he instructed that she translate:

'Communist. We hate communists here, my dear'.

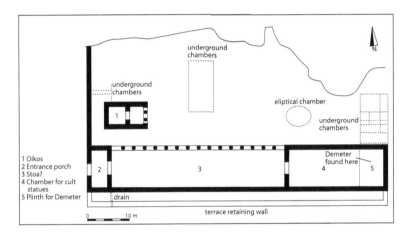

Plan of the Temenos of Demeter
(after Ian Jenkins, drawn by Sarah Leppard).

Catching her eyes, solicitous that I might react, I offered only a mellow smile. The K-K shrugged and point made he returned to sit beside the judge who tossed back a beaker of bourbon.

The exercise worked a treat. Iris was alarmed, and with a hostess' poise proposed they adjourn to Cengez's and to strike a deal in secret. As I result I never learnt the mysteries of haggling prices with these toadying officials.

Long before sunrise we heard an army on the march. Premonitions of dawn, at first it was a muffled sound from afar, and then the rasping noises of men chattering indistinctly, as their mules occasionally gave vent to their irritation at trotting, with laden paniers, at such an early hour. Some men were running like infantry preparing for battle, others rode towards us, bolt upright, bobbing rhythmically like mannequins. All were in woven cotton gear, shorts and cheesecloth shirts and flip-flops for footwear. Roll-call was at six-thirty in the scruffy square outside Cengez's.

Iris was up too. 'We're diggin' today', she hollered in no particular direction, 'Everyone up!'

There was a contrived earnestness not least in her dress code for the occasion. She would take names in her safari suit and so would begin the season, Iris' fifth at Cape Crio.

So I began sixty days of digging.

Each day had a rhythm to it, not least that once on the excavation no two days were the same.

I do not remember what made me wake as a rule. Was it the celebratory crowing of Ruşan's mangy roosters or the imminence of Marie about to whisper "it's five-forty"? With her words the night-long sighing of the tide across the fine sand seemed to cease. Marie had become our god-mother, ever

there for us. Outside it was grey, for another half-an-hour almost English in its dullness. Already in the old ruined town, stretched across the lower terraces, our workmen were awake and busy. Donkeys hobbled in the flat around the Temple of Dionysos bellowed, signaling their tentative disobedience. Next to me Henry was awakening slowly. Beyond, Tim was always up about the same time as me. Dick in the last of the chain of four beach tents was well asleep. Marie never had the nerve to shout rather than whisper at him. His snoring sometimes even carried to the breakfast table. He told me he had slept through an earthquake in Mexico. On that occasion, hours afterwards, he recalled, he awoke somewhat puzzled on the far side of the room.

Breakfast in the cool was balm. Heaps of slimy goat's cheese, a basket of roughly hewn bread piled unceremoniously high and a bowl of honey were the staples. Boiled eggs were sometimes laid on too. Everyone approached this differently. Henry was not a morning person and at one troubled breakfast took his irritation out on the flies. Each of a round one hundred was viscously crushed with a plastic fly-swot. Sheila took everything and everyone in her stride, and was a contemplative initiation before Iris arrived like a zealot at six-twenty-five, hair affray, a splash of white lustrous zinc like a blob of pus on her nose.

In preparation the routine bore a resemblance to school. We each had a regulation knapsack with our regulation green hard cover site notebook. Our pack also contained plastic finds' bags, finds' (luggage) labels brought from England, a ball of rough string and pencils for drawing. In addition, our most important instrument was a light drawing board covered with a sheet of A1 graph paper. I always smuggled in a book as well, familiar company in the lonelier hours. Kitted up, we straggled out along the beach to manoeuvre around the billowing crowd

Mumtaz Sariyaz
(photo by the author).

of men assembled for roll-call. Here the resemblance to school stopped.

On that first day, a fierce disorienting sight greeted me, an eighteen year old with the faintest trace of stubble. Arranged behind the Muktar in loose lines it could have been a bandit party or a parade of pirates, all unshaven and bleary eyed. Seventy to ninety workmen were slated by the Muktar. Many of the men, no doubt, were my age, but leaner and older in the face, raised on a diet of vegetables, goat's cheese and a-once-a week portion of mutton in return for work in the fields since they came of age at ten. They were no less organized than we were. Many were scrambling over the final yards, with no shoes or half hopping in their scuffed flip flops to avoid the stones, to answer to their name. On hearing Iris call their name, they would respond, nodding their heads and mumbling 'Müdür Bey', Mr. Director, in polite reverence. Gender was not an issue for Iris. She was the director and in the tradition of many great pioneering women, took to leadership with dignity and ease.

The assembled men weren't bandits or pirates, just villagers. Steadily we were addressed with 'merhaba, merhaba, merhaba', a symphony of pleasing greetings kindly advanced to kick off the day. 'Gün aydin', more formally by the older men, plainly bemused by our adolescence and otherworldliness. We parted in all directions, to our trenches, ahead of Iris completing her inspection.

So I began the twenty minute climb to the Temenos of Demeter. Past Ruşan's where a trace of smoke signaled his smouldering kitchen fire. Occasionally, woken by the rumpus, his little girl might whimper. Past the Hellenistic theatre where some nights we lay on our backs searching out shooting stars from the matt blackness. Past Mehmet the watchman's squat house where his miniature plump wife would already have hung out the day's washing. Just there, at a sharp incline over

some buried (unexcavated) annexe of the theatre, the sun thrust its way into our faces, released from the shadow of Boydağ. Its power demanded a fresh kick to match its instant resistance.

Along the road I marched as far as Stepped Street Number 7. By this time the workmen were overtaking me, and mingled with them was Tim's squad for this was his excavation. Here was one the great thoroughfares of the ancient metropolis. Like the preceding six it ran at right angles to the boulevards that traversed the main city, connecting the upper theatre to the seafront. This excavation was Iris' concession to John Ward Perkins and his passion for ancient town planning. Her reward was his talisman, Sheila Gibson. But no good deed goes unpunished. It needed a Tim to deal with its fiendish complexity of the stratigraphy and tumbled buildings.

Alongside the almost vertiginous fifty exposed steps, Tim had uncovered the well-preserved remains of a mud-brick block of Hellenistic dwellings. Making sense of its destruction posed a forensic challenge. It was always a fire pit, ferociously ensnaring the sun throughout the day. The archaeology, though, was worthy of a Pompeii. The upper storey of the rear house had collapsed into the vestiges of the lower floor of the front dwelling. Tim was said to be a slave-master, fastidious about every detail. Perhaps so, but he had picked apart the concertina of mud-brick and with Constanza's help had set about conserving the wall-paintings remaining intact and ravishingly vivid on many pieces. More importantly, his assiduous mastery of the place was nothing less than a passionate missive to the magician in Sheila Gibson to rebuild the houses on paper.

I often paused here in awe, regarding the excavation as if it were a work of art.

More than once a workman would lean in towards me as I heaved my way up the steps and ask if he might join my crew.

Then each would add, by way of explanation, that they had heard my excavation was dull. In other words, the Temenos and the sun were less punishing. The truth was that the lazier men were irked by Tim's bursts of petulance laced with Turkish obscenities.

At the top of the street, where the excavation halted, was a drystone wall worthy of the Cotswolds. Lizards scattered and in easing over its unstable courses you learnt to search for near invisible scorpions. From here on, the full force of the morning sun bore down as the path threaded across the patchwork of terraces. The flowers were no more, though their frazzled stems clung to the base of the occasional gnarled olives. Sage and oregano trodden under foot released an unforgettable aroma that with the floating islands were forever Knidos. Then there was the first experimental clacking of the cicadas that by noon was raucous and as constant as a million mechanical toys, and just once a covey of partridge took flight, to the delight of the workmen, by now roaming out ahead of me, the birds beating their wings frantically into the crystalline blue brilliance.

It was here that my little force came together. Those with mules joined us, having arrived by other paths. Each creature bore a heavy oaken saddle with woven coarse-coloured paniers. Gingerly the lean animals picked their way through the blasted ruins of antiquity, squeamish about the scree and generally oblivious to the curses of their riders. Used to being kicked and hit, the animals struggled on and up and, with a patch of cleared terrace, accelerated effortlessly.

Along this stretch I came once close to death. As a rule the villagers were oblivious to danger. Perils were a constant in a world without doctors. One thing made them snap with an inflammatory fear: the bleached little vipers. One morning I missed stepping on such a reptile by a millimetre. Invisible in the molten dust of the path it was only faintly a reptile until it

coursed away. The older men around me spied it, though, and shrieked 'Allah, Allah!', half anticipating their own demise before they drew knives across their throats to emphasize their imprecations. Later, Iris expressed the same mortification. We had no snake serum and only the US Navy might save us. Might.

The viper was but a wink of an eye. The constancy of the hornets commanding the last tract of our daily odyssey was altogether more disturbing. They floated like helicopter gunships in search of victims. Tim was nose-dived by one when once he visited me. It left him hobbling in pain for a day. Resistant to my rational pleading, the workmen every few days, faux guerrillas intent on skirmishing, fought back against the hornets, and laughed with unconstrained mirth when one or more of their number was stung.

The hornets guarded the entrance to the Temenos. Beyond as in some tale from antiquity we found sanctuary once over its polygonal wall, seeking the shade of its blissful orchard of olives swaying and swelling in the puffs of wind. Unfettered, olive roots had wormed their way deep into the crevices of the ancient walls.

Like the workmen, I eased my shirt off, now clinging wet after the twenty to twenty-five minute climb (fifteen minutes down). A violent blue paradise lay before us after the heady commute. Almost all of Knidos, bald in its summer vestments, fed into the limpid early morning sea surrounding Kos, Nisyros and a clutch of other misty volcanic outcrops. This was the world of dreams far from the claustrophobia of camp life. In this parallel life I regained my breath under the low ceiling of heaven.

Tucked beneath a slate-grey cliff reaching towards the acropolis, the Temenos occupies an elevated terrace before the ground falls steeply away to the city fortifications. The cliff itself was prominently punctured by two precisely cut niches

intended for statues. These presumably were the clues that led Newton here in 1858. In a massive clearance excavation, ripping his way through metres of fallen earthquake scree and then the ancient levels buried beneath, he came to the conclusion that this precinct was dedicated to the cults of Demeter and Persephone.

The cult prized the fertility of women and the seasonal renewal of the earth itself. Women officiated in the precinct, some of whom were probably honoured by statues representing either themselves or their goddesses. Numerous marble fragments of these sculptures were harvested by Newton's men, some no more than a chipped finger, hand or foot. The trove soon proved to be far greater. A votive pit contained precious 4th-century animals, including calves and pigs. Newton drily observed of these lesser treasures: 'terracotta pigs, broad of back and steady of poise, and a number of those interesting Katadesmoi, leaded tablets stamped with curses … have thrown such a flood of light on the subject of classical vituperation'. Dedicated to the goddesses, these disposable creatures show just how special this celestial place was for the Knidians. More extraordinary still, Newton found the goddesses themselves: Persephone dressed in tight fitting robes, wearing a top hat worthy of a circus act, and a venerable life-sized Demeter, no less, wedged into a throne. Newton was not enchanted so much as moderately puzzled by his prize: 'The features and form are those of an elderly woman wasted with sorrow, and do not exhibit that matronly comeliness and maturity of form which usually characterize Demeter in ancient art'. By any measure a masterpiece, it was probably the work of an anonymous Athenian sculptor around 350 BC. Some believe it to have been commissioned by Mausolus for his tomb.

The survival of both goddesses was little short of a miracle. Almost certainly the Christian community of Knidos, apt to smash these earlier idols, chose to revere Demeter as the Madonna, as in the case of the colossal goddess from Eleusis outside Athens. Hence the serendipity of her survival.

Newton had no interest in the Temenos itself. He sought trophies to justify Her Majesty's largesse to him. Just over a century later Iris needed trophies to satisfy her donors to the dig: essentially more marble fingers or toes. Her secret wish was that battered body parts of Praxiteles' Aphrodite might just turn up in the churned up levels of the Temenos. Her thesis was as follows: among Newton's many finds from his excavations here was a marble, over-life-size head of a young woman. Newton proposed that this brutalized bust was an Aphrodite. Iris, after days in the basement stores of the British Museum, caused a sensation in the newspapers by claiming that this head was not any old Aphrodite but none other than the Knidian paramour, Praxiteles' Aphrodite Euploia herself. As I shall explain later, many in the British Museum dismissed her as hysterical (i.e., an untrustworthy dilettante). Her instincts were not wrong, even if the identification was farfetched. For reasons that we can only imagine, perhaps out of sight and mind, the Temenos seems to have been a place where statues were gathered and either burnt to make lime or stored in secret. Could the goddess have evaded exile to Constantinople, as 'the mad consul' and many others believed, and serendipitously ended up in Newton's hands, only he didn't know it? Iris passionately longed for this explanation to be true.

Henry, on the other hand, wanted me to understand the sequence of building works. Had the Temenos been destroyed by an earthquake? Was there a Roman successor precinct? What became of the sanctuary in Christian times? Of course, if I could find a missing marble finger or toe, this would light up

parts of Manhattan and bring a smidgeon of disappointment to establishment grandees in Bloomsbury.

The Temenos was 74m. wide and 40m. from its massive front to the cliff-face. The polygonal elevation was the work of cyclopean giants; the east and west side walls were minimal by comparison, sometimes interrupted or buried by Newton's dumps of spoil. The main entrance was marked by two rectangular sill blocks set into the west wall.

Henry quickly spotted that the polygonal wall belonged to the original sanctuary, but much of the place was rebuilt at least once. The rebuild probably dated from Roman times, a workmanlike makeover which obliterated the architecture associated with the matronly Demeter. Plainly we had to outwit Newton. Deep trenches were needed with some urgency to make sense of the building history as well as to delve into places untouched by the Victorian.

Line up my team and they looked like ruffians until they smiled: three Mehmets, two Husseins, two Osmans, a Kemal, two Cengezs, a Mustapha and Mumtaz Sariyaz. In a photograph of us all I am Peter Pan, fluffed up fair hair and ruddy cheeks, alongside the pirates (minus Captain Hook of course) and a ringing blue sky.

Little did I know then, that I was set to pass two months with one of the most memorable men in my life: Mumtaz. Mumtaz was blessed with the primal presence of a jester to animate every moment of our Temenos life. A copious and extravagant figure, he was compact, sinuous with sharp eyes that searched you out like a spotlight, the nose of a hawk, as well as a shock of jet black hair not yet flecked grey as was the hair high on his cheekbones. Celebrated for his dancing, he was oblivious to stage fright, transported into a trance to hold an audience in thrall. Being short he could crouch low and spring up as the saz and drum dictated, holding two potsherds as castanets

between his scarred fingers. On the dig he sang. Mostly in a sweet baritone he sang indecent rhymes, concocted as the time and day demanded. The other men would buckle with laughter and hurl abuse at him with unrestrained glee, joining chorus lines to his mellifluous jigs. Timeless, he could have performed for Suleiman the Magnificent.

Mumtaz was from the first moments my mentor, teacher and architect of the dig. He taught me Turkish and I taught him English 'for the time when the tourists will come'. Surfacing the road to Knidos, he believed, would change everything and bring him his fortune. We would have strong-arm matches that I always lost and he would practice stunts like planting a knife in his calloused hand.

The elder Hussein was a fine man too. Older than the others, yet still strong, he was quietly authoritative. He was a kind man who regularly brought me almonds, figs and occasionally the sugary cakes that his wife baked on Sundays. The younger Hussein, by contrast, was wild. Perhaps my age, though he looked older, he was always getting into knife fights. One weekend, Mumtaz told me, way up the peninsula, he knifed a fellow guest at a wedding party. I was puzzled how nothing came of it. Life was beyond the reach of the law as long as you avoided the military. The younger Hussein was an athlete and would always volunteer to hare back to camp from the Temenos to collect some forgotten item. The one dissident was Mustafa. Tall with the bearing of a partisan in a Greek war memorial, he was plainly disconcerted by my age and above all by my cordial relations with Mumtaz. With fixed, stern features and a sardonic smile, he was infuriatingly lazy about picking and plainly detested the awkward iron wheel-barrows. And yet, when I was least expecting it, like a conjuror he would pull a paper bag of almonds from his panier and with disarming eyes present them to me.

With the thrilling flush of the breeze we set to clearing the stiff scrub below the canopy of olives. Then, joined by Henry, using a photostat of Newton's lithographed plan of the Temenos, we debated how to make sense of the Victorian's excavations. Of course, there was no sense to be had. Newton almost certainly began at one end and with indefatigable resolution bulldozed his way across the terrace leaving only the cyclopean wall.

First, we had to build up a set of relationships between the great front wall, the remaining buildings contained within the Temenos and those original ancient deposits and layers that Newton omitted to obliterate. We were pursuing the old adage, go from what you know to what you don't. If the original ancient deposits and layers contained potsherds that could be dated, we might then reinterpret the building history of the sanctuary. Seemingly straightforward, and blessed by Iris from afar, we strung out the bounds of a long deep trench at the east end of the terrace, and a smaller one at the west end. With the strategy arranged, Henry left the bower of the olives, waving cheerily, to return across this invented landscape to the excavations at the Round Temple where whirling clouds of dust melted into the seascape.

Mumtaz gathered up the nails and string from my knapsack and together we followed Henry's instructions. The others lay beneath the olives on their backs, like fallen soldiers, arms across their eyes. Lacking sleep, with the breeze, this was a blissful reprieve, and they were paid for it. A six-inch nail was plunged into the rocky soil at each corner, then the taut string was tied in place. With a solid iron machete and the blunt ends of the picks, Mumtaz battered away at the surviving scrub and then like a sergeant major summoned his team. There was no reluctance, just duty and the day began in earnest. Three men set to work – one with a pick, one with a long-handled shovel

and the third stationed beside a cumbersome iron barrow. With so many men, I took the decision to open a third trench, making the most of the workforce. By any standards, these men could dig without breaking sweat. Their mechanical force honed on stony tobacco terraces by comparison with my unnatural energetic bursts of digging was immediately telling. Lindsey, who had joined me by this time, her nose glistening with the regulation zinc sunscreen, adjusted her straw hat and monitored us from beneath the olives. With a hint of what I assumed to be a Brooklyn drawl, she would with deference ask me if she might help.

By lunchtime each trench was neatly carved out and sunken by a foot, all despite the irrational roots threaded through the sub-soil. By nightfall we had an excavation, and the men had chopped and stacked the wood from the clearance to cart away for their camp fires. Newton, I realized as I raced down to the camp enjoying the liberating gravity of the descent, would have been puzzled by the impediment of our system. He simply sought trophies as expediently as he could.

Methodical picking, shoveling and barrowing for hours brings results. Always using the axe against a clean edge to trace a level and catch the momentary glimpse of a sherd or a piece of glass or even marble. Always creating a smooth level to ease the effort of person shoveling, who can pursue it without breaking rhythm. Shoveling with a swing, thrusting the earth with a flick into a barrow beside the trench. Shoveling rubble is altogether different. This staccato experience, halting, rolling over stones, sharp-eyed for scorpions, bending back to try to get traction with the implement, all consume effort. Finding something also halts the rhythm and is almost irritating except, of course, if discovery brings with it heartening pleasures accentuated by surprise. The pick-man and shoveler pause and lean into the ground while whatever they've

envisioned is carefully uncovered with a stout British WH Smith 4 inch pointing trowel or a slightly larger but no less robust Marshalltown trowel. Of the three tasks, no-one wanted to barrow. Heaving up the wrought-iron beasts made by smiths in Izmir required an excess of animal impetus. Then the creatures wobbled. On my first digging day in Wiltshire I tumbled with my load into the trench, cloaked with damp earth and embarrassment. At the Temenos, to assuage their tedium, the barrowers led the singing. Effortlessly they propelled these vehicles to the terrace edge, accumulating mounds that grew longer and higher and needed boards to accelerate higher still until the vantage points towered above the Temenos or served as viewsheds for Knidos' other multiplying barrow runs, signalled by balloons of dust like spiraling smoke as well as the business of the coral seaways. At times the upturned loads of soil blasted back on the barrowmen as the breeze broke violently. Goggles were needed. We, meanwhile, turned into ghouls plastered in the fine whipped up waxen rime.

Digging is a cautious craft. As a rule the stratigraphy of levels is traced by the pickman. So, supervising a dig is about keeping the diggers alert, primed for a moment of change. Moving rubble takes more motivation; it is tedious, invariably hours unpunctuated by the slightest event. The western trenches in the Temenos were filled with infinite scree. There was no redemption. Reprising the work each morning took determination. The bare cold earth under the sparkling prism of the olives defied any pleasures, only sweat. Weeks passed to carve featureless chasms, men who at the start stood large being dwarfed by the depths. Yet each layer and each moment contained a piece of a story of the place just as an individual histories summon up a nation.

My role, rather like the conductor of an orchestra, was to beat time and keep everyone focused. The men didn't like me

to dig, but tolerated it for a spell in the morning and another in the afternoon. I would race Mumtaz to remove shapeless mounds of rubble, practicing my Turkish as I did so. At other times there was unrestrained banter. About my age, my prospects in love, and most often about my stained shirt bearing its faded print of Che Guevara, because they detested and feared communism. The melody of their voices changed as it had when I nearly stepped upon the viper. Only Atatürk was a hero. With his name they would swoon, before cursing their modern leaders. He was Grey Wolf, their father.

Associating Atatürk with Churchill stilled any irascible cursing, matching their best with someone they assumed I regarded as a hero.

Otherwise my job was simple. I pedantically recorded the layers in the lined pages of my notebook, layer by layer, in sterile unembellished language, and on the opposing page I made measured sketches of the features in plan or elevation. Every layer from the topsoil onwards and each wall was registered. Then, each trench was planned on graph paper at a scale of 1:20. Each plan and section showed the size and significant elements of the trench. By far the most exercising and prized task was making drawings of the trench elevations. A string was set up on the horizontal using a line level and then, juggling a plumb bob and a tape measure, the profile of the sequence of layers and other features embedded in the trench side were recorded.

The deepest east section of the eastern trench was the real challenge. Down several metres, help was needed to take the readings. Mumtaz and I did this together, each confecting a personal lexicon as we exchanged English and Turkish words. Like pulling apart a chocolate sponge cake, we had a record of the rich and poor layers as well as walls and pits - seams and pockets of cream – associated with each level. Above all, like

slicing through a sponge cake, we now possessed a stylized impression of the deep tips of earth piled by Greek slaves, we surmised, behind the polygonal wall, making the base of the precinct. This artwork was some small compensation for Newton's indifference to those whose laborious work of making this place was concerned.

And treasure? Well seldom, even at Knidos. No Demeter or her like was to be found, that was Newton's privilege. My discoveries were of a more pedestrian kind. Even so, like the tooth fairy everything is unexpected and for a moment inexplicable because until it is unearthed it is lost or forgotten. Lindsey would shriek, a little shriek of joy usually accompanied with an over-emphatic 'Whoa, oh my god!' The workmen would be stilled to silence. For them every object promised a journey to a world of riches. The promise was fleeting and of course illusory.

My trowel would clear away the hint of an object and with the patience of an elder take time and give the thing space. A sherd that still has its glean after being buried two thousand years has a scintilla of beauty. Finding it in the rubble or as the pick breaks apart the earth transports you in a way that a rusty coin does not. Now a hoard of coins or a skeleton with jewelry brings the machine of the dig to a halt and evokes a story, a moment in time in this place. A votive offering is the same. A terracotta figurine with anthropomorphic meaning and at the same time inherent aesthetic intent for its maker, its owner and those of us fortunate to retrieve it, is something altogether transcendental. An inscription provides a clip of history, a marker, every indented letter a symbol of surprise. A sculpture is treasure, blessed, as though the silkiness of the marble has been entombed in an eternal veil. You are hurtling past epochs, trying to understand why, and all the time charging your fingers

to feel because training, however slight, contains you emotionally.

Then it is time to consign the treasures to the finds team, to those who exist to know. These people would be missionaries in other lives. The depths of their faith could not be plumbed. Taking into care the objects, were they just a little envious of the discovery and a little high and mighty about how I (at my age) found this on my dig?

Visitors to the Temenos always asked what have you found? Finding is a rite of passage and a measure of status and perhaps a certain seriousness. Recording the monument, the time and place of these findings, is almost an office job. But an office job, of course, with a difference. Being a large modern dig, all tasks were specialized at Knidos and I could call on technical help, and willingly did.

The Trausdales - he was a bean pole, she was petite, both had thatches of blond ruffled hair and a Californian languor – visited me to plot the points of the trenches onto a map of Knidos. It took no more than an hour to update Newton's meticulous topographic masterpiece. Matthew, the professionally saturnine photographer, was a more regular visitor. In his hooped red and white shirt, he was visible from afar, a bumble bee panting and grunting upwards with his prized silver case of camera gear. Often he arrived with a lamp sherd in his clammy hand and burst into a long disquisition - because he was writing a thesis on Roman lamps - about its antiquity, form number and provenance. Each photographic shot, first in black and white, then in colour, took an age, as he fidgeted, calibrating every elemental feature. The workmen stared indifferently until I summoned one to be a scale in the trench. This caused much mirth that lay beyond the limited lexicon of my Turkish. With resignation Matthew parted, reluctant to quit the breeze for the furnace and the roaring

Lindsey Folsom (centre) and the Temenos team with
Mumtaz on bended knee to the right
(photo by the author).

blasphemies of Tim's trench. The ballast of his case soon had him bowling down the slopes.

'Poor Mattu', Mumtaz would mutter, imitating closely words he had learnt from me. Lindsey chimed in to agree.

This elaborate performance was aimed at creating a photo archive that future generations would actively engage with as we did with Newton's legacy. And to a fulsome scientific publication that illustrated in detail the archaeology including the objects, trophies and otherwise, from the untouched buried layers. Like so many digs, especially in the Mediterranean, the gravitational pull of all else in life, once removed from the place itself, diminished to an account that covers no more than two pages. Justice was not done to our efforts, although for the workmen such luxuries on behalf of their Knidos were beyond their reasoning. More of this later.

Other visitors were few. Iris came twice, put off by the poverty of the archaeology. On the first occasion she talked about dinner with W.H. Auden and the latticework of his prehistoric face, not the Temenos. Of his poetry she said nothing. Tim clambered up several times, working his portly way along the path in his flip-flops. The trench into the scree dismayed him and he encouraged me to stop it. Nermin, as I shall tell later, also came on a number of magical occasions. Just occasionally a tourist would appear, astonishing us because it was so unusual, but the majority of the play-set confined themselves to the area around the harbours. Those who ventured more widely around the metropolis were lured into hiring the village donkeys at inflated rates.

The approach of each yacht, carving a line glib and pert in the blue, caused our barrow man to shout 'geliyor; geliyor' (it comes; it comes). Even the tramp steamers and the daily Kos to Rhodes white ferry induced the same cry. Its lingering echo passed along the slopes of the ancient city from excavation to

excavation. The steamers were like insects on leaves, they moved imperceptibly. The yachts were altogether different and moved majestically, bending to the breeze. As a vessel glided silently into the Commercial harbour and its crew adjusted the sails, the confected banter amounted to ill-concealed avarice, presaging salacious comments uttered with asinine brutishness. Turkish seems to possess a wanton lexicon of curses and the like.

For some weeks the spectacle that held the men in thrall was the mesmerizing sight of Barbara in a micro bikini, long hair tossed back over her ears, water-skiing deftly behind Iris' Zodiac. At the wheel was none other than the Big M, head up and surely complicit in some larger game. So they said, the Big M took a member of the project each year, infecting collective prurience in the camp and villages. The performance on skis was a new departure. Never before, I learnt, had the Muktar had the effrontery to parade around the Commercial harbour drinking the wind in front of every excavation. Mumtaz was venomous about him. He had more than one wife, it was said; she had a child elsewhere, it was said; why was Iris encouraging the theatre? Day by day what began as a few lurid comments inflated to fill our lives as Iris' patronage increased to the point that the water-skier eclipsed her own celebrity. Fawning over her each night at dinner served to further confuse and challenge all of us. Only when Iris promoted her to supervise a dig did matters surpass even Iris' control.

Lascivious talk of the water-skier sucked the levity from the daily breaks on the dig. Mid morning and mid afternoon there was a 'sigara mola' where we nestled and some dozed amongst the rocks and soughing olives. Cold water was brought up by the water-boy from a spring near the harbours in a perspiring globular amphora that we shared. It tasted like nectar. Raising it up to your mouth to drink by its firm rim lug took strength and

dexterity. Settled beneath the platinum-grey leaves, the air quickly filled with thick acrid smoke. Almost every man puffed a cheap shaggy cigarette, costing no more than a few pence. While the others smoked, Mumtaz would lick the end of a pencil and with studied effort sketch a cartoon portrait of me. All would gather as the break ended to admire his work and he would smile paternally.

What did we find over the course of two months? Very simply, the Temenos, as Henry predicted, had existed in two very different periods. The earliest sanctuary graced by the enthroned goddess was dated by fine black Megaron bowl sherds that we retrieved deep within the loamy tips behind the polygonal wall. This discovery was my very own trophy. Belonging to this precinct were several underground chambers, one on the east side where Newton found the statue of Demeter, an elliptical one close by, and one in the centre towards the rear. Centuries and an earthquake or two separated the first from the second building periods. Distinctive Roman pottery and glass from the Augustan age provided the approximate date for the revival of the cults. Constructed of well-coursed but more modest walls, the Roman Temenos had a grand front set back from the earlier polygonal wall. An entrance porch at the west corner led into a portico-ed stoa, which in turn led to a small rectangular temple in the eastern angle of the front. This simple cookie-cutter building had an outer hall for the cult statues inherited from an earlier era, and an inner room where the plinth for the matronly Demeter was discovered. Set back from the western precinct wall, partially buried by the wretched scree was a small bi-partite building where, we imagined, the priests resided. From afar, in both periods, the Greek then the Roman, elevated on the huge terrace, this temple was close to the ceiling of the city. Unlike the brazen naked statue of Aphrodite, erected as a seamark to

thrill sailors, Demeter's constituency occupied the countless tenements that spread across the terraces, barely visible from the two harbours or seaways.

Ironically, of the few finds I made, the most precious was a small terracotta statuette of the Knidian Aphrodite, sealed deep in the tips behind the polygonal wall. It had surely belonged to the earliest temple in the south-east corner. On reaching camp with it nestling in my knapsack, I extracted it and offered it up as though it was my votive to our deity. Iris all but levitated into ecstasy. Her performance drew the company of the finds team as well as Tim to debate the date and purpose of the icon. Iris was emphatic. It was proof that the Temenos was the final resting place of Praxiteles' masterpiece. As she said it, Henry, his washed-out pink shirt marked with sweat stains, winked at me.

On many days that August the great pure wind beat the waves into chaff as they fell upon Cape Crio. Come wind or heat we wound our way up to the Temenos to have it disgorge its story. Even when I was stricken delirious with mild dysentery I was placed onto a donkey and arrived on my mount to be laid beneath an olive where I could catch the breeze. Here I read Runciman's *History of the Crusades* and *Madame Bovary* and wrote long lyrical epistles to my mother in Wiltshire. In the Temenos I learnt patience, endurance and love. Seen through the lens of memory it seems so enchanted that even this cascade of thoughts are unworthy of it.

The mornings seemed long, the afternoons less so. At midday I hollered '*paydos*' and it was time to clear up. Loose soil was shoveled away, tools were cleaned and stacked while

the barrows were arranged upended in a military line. Fruit trays of finds were checked by Lindsey, each for its (luggage) label noting the place in whichever trench these had been found. Some men headed for their mules, caressing them fondly before mounting and setting out. The young Hussein and Osman would charge like Olympians across the terraces, balancing the trays on their shoulders. Most of us left at a leisurely pace, returning the Temenos to its sacred serenity.

Care had to be taken as we zig-zagged across the terraces not to topple into one of the many ancient cisterns. These cavernous mines were certain death, if not from the fall, then from the beasts they entertained. Down we rolled watching other teams being gathering in camp far below. Once Mumtaz picked up a pebble and with one continuous action let fly at a finch, hitting it cleanly. The bird was stunned and after showing it to me he released it. Some days he dispatched bigger birds for the pot with his muzzle-loading musket. His bullets were cast by the same smith from Çeşmeköy who had furnished Iris with the dynamite to blow the rock around the Round Temple on the day the astronauts landed on the moon two years before.

Down we filed to the polished upper rim of the Roman theatre. Here Mumtaz had made his dark hut for the summer and he bade me goodbye. No bigger than my tent it was fitted with blankets as well as blackened tin cooking pots. His confection of posts and covering gave out onto the Temple of Dionysos where dozens more lean-tos were wedged against the bleached wall of the ancient stoa. Out beside the Temple their mules were tethered to boulders. Their tails writhed like a nest of serpents to beat away the flies. Beyond, at a trough outside Cengez's, the men came together once more, shirtless, to wash off the worst of the waxen dust. Bushes close by were covered with our laundry, spread out in a pastel kaleidoscopic display of lingerie and shirts after a battering at Mrs. Mehmet's

hands. Often as not in the early evening a fisherman had anchored in the Trireme harbour. Pot boys excused by the finds team were summoned to help him. Their task was to thrash an octopus into a slopping blob on the damp black rocks.

I would thread my way through the men and pass Osman and Hussein, having dutifully consigned the Temenos crates to the finds team. Radiantly happy they sped back towards their makeshift homes. Camp was disarmingly unchanged. It was as though we had never been away. The chilly air of order ruffled only by the ragged assembly of ten-lire-a-day potboys was chillier still at the prospect of the towering trays delivered up from the digs. Supervisors were greeted with suspicion as though we were prisoners out on parole, unlike them. Some threw off their shirts and shorts and dashed into the sea; some sat to read if the mail had arrived by way of the Muktar from Datça; and some just sought repose from the heat in their tents. Then there was time for lunch or a beer before dinner, or time in the evening to seek yet more pleasure from this exotic experience.

6

Sir Mort

'Sir Mort's coming. That'll put the cat among the p-pigeons!' Tim exclaimed with a mischievous smile directed at Henry. Henry looked at him, puzzled, then startled. Tim had heard about the visit from Sheila when she was drawing the Hellenistic houses at the Stepped Street. Sheila had heard it directly from Iris because Iris for all her Manhattan bluster knew that Sheila might find this visit a little hard to take and Sheila was the one person on the project that Iris valued as much as or perhaps more than herself. If Sheila was nervous it, I failed to detect it.

Sir Mortimer Wheeler, often self-styled the greatest archaeologist of the twentieth century, brilliant at parodying himself, was a guest lecturer on a Swan Hellenic Cruise and visiting the city of Aphrodite with Ms. Love in residence was too good an opportunity to overlook for this supreme opportunist. Now, as it happened, on the ship, as we all were to learn, was Sir John Wolfenden, the Director of the British Museum and *ad interim* guardian of Newton's trophies including the battered head of Aphrodite that Iris had transformed into an international celebrity. Herein was the nub of the soap opera. As much as Sir Mort coveted controversy, having matured with the Bloomsbury writers, stuffy Sir John eschewed it.

The controversy was about judgement: academic judgement and plain old judgement. In November 1970, Iris announced in *The New York Times* that she had discovered the battered head of Praxiteles' Aphrodite in the basement of the British Museum. Iris afterwards claimed that she was forced into a premature revelation by the near-treachery of the British

128

Museum. Hearing the story many times, listeners tended to divide along ethnic lines. The Americans mostly had sympathy for her and noted the implicit sub-texts: how is it those Brits didn't have a handle on their own stuff, and, of all places, a less than salubrious basement store? The old colonialists needed taking down a peg or two. The Europeans including the Turks tended to take the British Museum's part in the story, knowing fully well what it was like to confront this cyclonic heiress.

The British Museum told a different story. This was perhaps why Sir Mort and not Sir John had the urge to confront Iris in her sanctuary.

In May the previous year, Iris accompanied by her cousin, Margot, and Sheila asked to see the sculptures collected by Sir Charles Newton but not on display. The British Museum dutifully acceded. Proctors were dispatched to the museum's cavernous basements, then like dungeons, where they retrieved a galaxy of fingers and toes and battered bits and then lay these out within the hallowed halls of the Department of Greek and Roman Antiquities for their honoured guests. In Newton's erstwhile bailiwick, his metaphorical successor a century later was paying homage to the treasures he had found. It is hard not to imagine the scene: the bluff officiating academic gravely confronting the zealous scion of the house of Guggenheim.

Alas, one piece was missing. Was it deliberate or an inadvertent error made by the Keeper or the obsequious proctors in the haste to deal with this daffy heiress and her party? Iris spotted this in a jiffy, as Sheila recalled with measured bemusement. Newton's catalogue number 1314 was the object that Iris had set her heart on handling from the outset not body parts. Bust 1314, according to Newton, and affirmed by his great successor (an erstwhile Director of the British School at

Rome), Sir Bernard Ashmole, dated to the 4th-century BC and was very likely the work of one of Praxiteles contemporaries.

The encounter in the British Museum entered legend.

Iris recalled, 'As soon as I saw it, I thought, "was it, could it be...*the* head?" Her eyes had that limpid gaze that has been described so often. They were so *Praxitelean!* So I screamed at Margot, "I think this might be *the Aphrodite*".'[22]

Sheila confirmed the outburst with only a hint of a smirk. One can only imagine the atmosphere in the room with its musty authority of a London men's club.

That summer Iris had found the epigraphic fragment that read PRAX and a hand of Parian marble that was right for Bust 1314, Iris' Aphrodite. The fingers of the trophy hand had been dowelled employing a technique used in Praxiteles' only known surviving masterpiece, the statue of Hermes at Olympia. I could only imagine the nightly festivities as Iris stated quest neared its triumphant end.

In late September the previous year, Iris returned home from Knidos via the British Museum. Here she met the bluff Keeper once again. She asked if she might publish her discovery appertaining to her Aphrodite in the basement. Permission was apparently granted. Then things went horribly awry as the two academic cultures endured a transatlantic incident.

In November a film crew from CBS making a documentary about Iris and Knidos visited the British Museum. They were permitted to film everything except Iris' Aphrodite. Bust 1314, they were told, was unavailable, being cleaned for imminent exhibition. Iris was immediately apprised of this by phone from Bloomsbury and attempted to reach the Keeper to give him a

[22] Katherine Bouton, The Dig at Cnidus, *The New Yorker*, July 17th, 1978, 64.

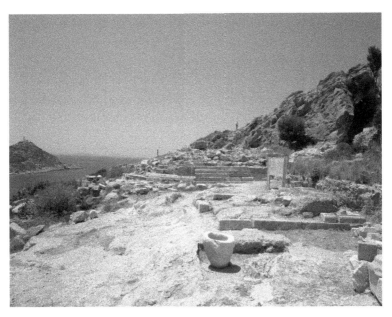

The Round Temple of Aphrodite
looking towards the lighthouse on Cape Crio
(photo by the author).

friendly ear-wigging. The department and its staff melted away in the hope that this cyclone might pass. Sheila had other ways and means and promptly and politely learnt that there was no sinister plot to exhibit the Aphrodite. Undeterred the CBS crew returned, only to be rebuffed once more. On the Saturday in question Iris was doubtless suspecting all kinds of treachery and so she acted following a long Manhattan tradition: she published to be damned.

She gave an interview to The New York Times that appeared in time for Sunday brunch on 8th November. The headline offered no compromise: HEAD OF APHRODITE BY PRAXITELES FOUND. In a stroke Iris Cornelia Love found fame for herself, Praxiteles and Knidos. She also made mortal enemies in the British Museum who now grasped that she was far from daffy.

Iris recalled that Margot and she sounded like the Bobbsey Twins at the British Museum. The interview had a touch of a film noir. 'It was dark and dank with electric light bulbs breaking into the gloom', Iris was supposed to have said, while Margot apparently added that it was 'Spooky, too, with all those white faces in tiers of shelves, looming'.[23] The British Museum acted with dizzying alacrity. Twenty-four hours later on Monday morning Bust 1314 was on display, having indeed been cleaned. The Keeper, presumably with orders from on high, resignedly told reporters: 'We thought that since this whole business burst upon an astonished world, we had better get the object out'.

What would Charles Newton have made of all this?

The opening salvoes of this colonial skirmish now led to a quintessential academic struggle.

Taking up the story the London Times thundered meekly: 'apparently a little shaken by Miss Love's claim that they have

[23] *Ibid.*, 64.

been sitting on a masterpiece all these years' the museum took the 'unprecedented step… of issuing an abstract of previous scholarly views of the head'. Bloomsbury's testy irritation is instantly recognizable when the Keeper himself was interviewed: 'We know that this head was found in the Temple of Demeter [more than half a mile from the sanctuary of Aphrodite]. If it is the head of the Aphrodite, it must have walked [from] the Temple of Aphrodite. How else did it get there? Ask Miss Love?' He continued, rattled: 'To imply that we didn't know we had this piece, and that it is unstudied is simply untrue. We're overcrowded with material, but we know what we have… I'm very cross with her, if she wants to put her points down on paper we shall examine them, as we should arguments of any member of the public.'

Iris, of course, was not any member of the public and so she answered the Keeper not in any secreted academic forum, as he had envisaged. She replied through *The Times* letter page, giving oxygen to the controversy. It surely enhanced her heroine status for her donors and certainly helped CBS cut their film to popular taste.

In staid academic language Iris explained how Newton found the statue along with others in the Temenos of Demeter. Her hypothesis was that after the Emperor Theodosius ordered the closing of pagan temples and incited their destruction, a loyal worshipper secreted Aphrodite in a deposit in the Demeter precinct.

Bust 1314 is a gruesome object. The nub of the dispute was about hairdos. In most classical female statues the hair is drawn back above the ears in a bun on the back of the head. Aphrodite, Iris insisted, was different. She wore her hair half covering her ears ending in a bun low on the nape of her neck. Numerous imitations attest to the celebrated idiosyncrasy of Praxiteles' muse. Unfortunately 1314 had been broken off at the

back and cut back in preparation for reuse. The Bloomsbury team was adamant that the statue may have had a headdress. As such it could not have been Aphrodite. Ashmole, to muddy the waters, even proposed it was Persephone. The Keeper, his bluff nose well and truly out of joint, published a rebuttal in German proposing it might be a Demeter. Soon the proctors took 1314 off exhibition and discretely returned the battered bust to its century-old sanctuary in storage.

History has remembered Iris for this spirited spat, not her lingering aspirations at the time when Sir Mort was about to visit. Later she was to muse: 'I hope I am wrong. I'd still like to find Aphrodite in her magnificent pristine condition, not with a battered face and dismembered body'.[24]

Sir Mort was soon in our midst. His ship arrived mid-morning and set up the calculated cry from all the excavations – geliyor. The compact white steamer steadied to a halt just outside the Commercial harbour and we heard the grinding of its anchor as it plunged into the crystalline waters. The Temenos workmen instantly bantered about rich tourists. Here was money to be made. All eyes were on the stilled ship as no doubt its passengers were eying us. The anticipation was aching: knowing a little of the two contenders, Iris Cornelia Love and Sir Mort, it promised the tension of a world-class boxing bout.

The previous winter, I had participated in a festschrift conference for Sir Mortimer, no more than a mere voyeur – someone to move chairs around and guide participants. Almost all the great names of British and French archaeology had attended to pay homage to him as a tribal leader. Soaking up the names of the attendees was a treat. A shelf of library books had snapped to life. Sir Mort was much more than the sum of his writings. Walking within his aura was ethereal as though a Victorian like Newton appeared in my midst. More than anyone

[24] www.People.com, June 8 1981 vol. 15, no 22.

else in the field, he had brought mastery and rigour to the theatre and arts of excavation. Now a stout upright eighty year old with a bullhorn voice, he had a formidable Victorian aura. From an early age he possessed a leonine head enlarged by a silken back-brushed mane of white hair and a sharp face with a waxen eagle-winged moustache. Most of all he had the capricious eyes of a matinee idol that sought out the timid as well as the over-bearing. Known universally as Rik to his friends, he simply overshadowed whomever he stood next to. A great field archaeologist, a brigadier-general in the North African campaign, a professor and a television star, and by this time, into his ninth decade, still a legendary roué after parting with three wives.

At *paydos* we hastened to camp in expectation of being in attendance as Sir Mort came ashore. Mehmet the lighthouse-man was dispatched in the Zodiac to collect him as Iris waited on the shore with her hands shading her eyes. Lunch was on hold as Mehmet reached the distant white liner, the rubber boat bouncing uneasily in the waters beyond the ancient moles. But protocol was of the essence, given that this day beckoned some entente between Iris and the British Museum. Concealed from us, from the far side of the liner, a tender emerged tentatively and then with stately confidence sped towards us. Iris' Zodiac was simply ignored. Seeming to sparkle in the strong midday sun, the tender headed for Ruşan's rickety landing. Ruşan himself, brushing himself down, half ran to meet it. Way before the dockside he was pointedly holding his hand out to greet its solitary passenger, even at our distance, the unmistakable Sir R.E.M. Wheeler in all his pomp. As he threw off his sea legs, Iris was hurtling forwards, swept passed the lumpen Ruşan, and in one sweeping motion, fell into the octogenarian's capacious embrace.

Sir Mortimer Wheeler, c.1970, painted
by Walter Woodington
(courtesy of UCL Art Museum).

Like two lovers they ambled along the shore followed by her two wriggling badger-baiting mutts. Iris' head was on the tall knight's shoulder, half concealed by his broad brimmed sun-hat. In animated conversation, broken by wails of laughter, they took an age to appear in our shaded mist. And then there he was, like a prophet who had descended amongst his people (or, more accurately, as though one of the great eagles sailing in the thermals above Bozdağ had swooped down to grace our table). Plainly captivated – at least that was how he played it – by Iris, he greeted us all in clipped sentences, one by one, his eyes searching us out and at the same time beaming with the rapture of the occasion.

We were all grateful to Iris at that moment, Henry and Tim included. My compatriots appeared like school prefects, nervously correct but not knowing quite what to do or say. Iris was the host and already taking energy from her visitor's evident diplomacy. The fact that the ex-schoolmaster Director of the British Museum had excused himself with a chill and remained in his state room on the ship merely added to Iris' mirth.

She beckoned us all to sit, Sir Mort unclasped his silver cigarette case and with nimble figures first offered it towards Iris, who declined, them selected one for himself. He sat, his legs tucked beneath him, revealing silk socks held up by suspenders. From the expressions at the top of the table he had an easy way of speech about him, the sort of conversation that concealed as much as it revealed. Loyal toasts were offered to Aphrodite with Jack Daniels on the rocks. Before long there was a thickening of Sir Mort's speech as though he now had a sense of well-being and warmth. He began gently probing to understand this summer's excavations. Was he really smoking, inhaling rhythmically, to take the time to look at us? Iris and Henry told him about the Round Temple excavations, and,

cocking his head, like any respectful cove, he intermittently hummed to show his appreciation. The sub-text was plain to most everyone. All talk of wretched Aphrodite had been swept beneath a Bloomsbury carpet.

Meanwhile, out of thin air a flotilla of tenders and boats invaded the harbour, queuing to disgorge parties of bleached passengers at Ruşan's dock. The regatta tempted all the workmen to leave their shaded lean-tos. In groups, sporting their digging clothes, they gathered silently to inspect the tourists in their regulation British long shorts and summer frocks, all with panama hats of one size or another. In the blistering heat, their immediate confusion was soon palpable and the only escape was the shade of Cengez's and Ruşan's. Soon an army was holed up waiting for its generalissimo.

Emboldened passengers caused Sir Mort to quit the shade and lunch. Inching ever closer to our bower, some of the throng stripped off on the beach to reveal pink swollen bodies. A couple of men tied handkerchiefs to protect their bald heads and then gingerly waded into the Commercial harbour. Sir Mort who had helped Swan fashion a respectable image for his cruise line looked dispassionately at this unfolding scene and resignedly proposed action to Iris. A last elegant drawing on his cigarette and then he rose and turned on his heel. So, the two satraps with Henry and the dogs in tow left us to chatter and watch. Iris was talking animatedly as they passed the anaemic visitors on the beach and headed for the theatre where they aimed to address this invasion of visitors. Within minutes, the Commercial harbour was deserted as were the cafés. There had been a pre-determined plan that was exacted in military formation.

There was no will to nap this lunchtime. The presence of the prophet left us to caucus. I sat close to Sheila as she sipped

mountain tea made by Emin. She was eying the tourists contemplatively. To no-one in particular she observed:

'One heck of a man even at his age'.

So I asked if she knew him. Not really, she responded firmly, adding that John Ward Perkins had often introduced her to him and clearly she didn't fit his bill. I laughed.

'I know Kim, his third wife. The bill is pretty wide-ranging and he's not easy to live with. Still it's all the by and by', she added.

This Sir Mort, I could imagine, having read his autobiography, *Still Digging*. Was it the by and by? During the conference last winter he had one heck of a nerve. We had assigned blond companions to assist him who once or twice were forced to reprove him sternly. Appreciation of the sixty-year age difference went too far several times. But there lurked in my mind that his life had been ruptured by the tragic loss of his first wife, Tessa Verney and I offered this up in my worldly way. It had been 1936.

Sheila looked me full in the face; after a month at Knidos the lines drawn across her face, now tanned, much deeper and sharper.

'You know Molly Cotton[25] waited at Waterloo for every express from Paris for days to tell him what happened to her before anyone else. Poor Molly was so concerned on his behalf. He had read it in *The Times* he bought in Paris and knew. She was so upset and said Tessa's death opened him up to his demons. Well then. So you're right'.

Improbably, far from my arcadia, I had a sudden longing for England and in an instant had an image of Maiden Castle where the Wheeler partnership managed their greatest excavation, curtailed by Tessa's demise, aged forty-three. A saddle backed

[25] Molly Cotton was a student and later assistant of Sir Mortimer Wheeler, who had a distinguished career as an archaeologist in Britain and Italy.

hill with towering hot green reefs of earthworks where clay and
chalk meet. For Thomas Hardy it was the setting (in *Far from
the Madding Crowd*) where Bathsheba was entranced by
Sergeant Troy:

'At one's every step forward it rises higher and higher
against the south sky, with an obtrusive personality that
compels the senses to regard it and consider'.

Forever connected to the Wheelers and the paradigmatic
loss of innocence of British archaeology, here, in a cow path as
slippery as silk I found pebbles like eggs that were used as
slingshot by the British to fend off Vespasian's legionaries in AD
43. All in vain. An unused pile of these missiles was found by
the Wheelers who sold each for a shilling to fund their
excavation.

Not long afterwards Sir Mort appeared with Iris on Ruşan's
dock. Some of his flock like idolatry pilgrims followed at a
distance. He bent down and in a lingering finite motion kissed
Iris first on one cheek, then again longer on the other as though
he was taking in her perfume. He raised his hand in a languid
salute and stepped cautiously into the tender, occupying a seat
at its rear. Iris waved with liberated enthusiasm until the boat
passed out of sight behind the ship. With this she turned on her
heel, engaged the visitors gathered close and in a bound set
forth with pilgrims who were now hers.

We watched the platoons leave in the tenders in the
lowering afternoon sun. Little parties of people, no more than
pin pricks from the heights occupied by the Temenos. The
boats carved busy lines across the harbour and paused before
the ship, bobbing, as the breeze rippled the sea. It was an
elegiac moment as the ship weighed anchor and with a bleat
from its horn set a course southwards bearing away its
conflicted knights.

Henry was star-struck and not just with Sir Mort. Iris had impressed him as she handled the fading star. She had been deferential but also firm. In the theatre all the Americans in the Swan party had shrieked, 'It's her, Iris Love'. Some had wanted her autograph on Swan's handbook prepared by none other than R.E.M.Wheeler. The CBS film had secured her those fifteen minutes of fame, while Sir Mort was an authentic memory for those venerable Britons in the party who had possessed televisions fifteen years before. Few, if any, would have known of his lasting achievements at Arikamedu, Maiden Castle or Verulamium.

'He seemed to enjoy her fame', Henry added.

'They agreed not to argue', Henry told us, his nimbus still glowing from the experience.

'Sir Mort stated this from the beginning. He was quite charming'. Then he paused, puzzled, 'He blanched at a chicken being throttled as we passed up to the Round Temple. Strange. I thought he'd have seen plenty such sights in India and North Africa'.

Bust 1314 did not come up and you could tell over dinner that Iris was very happy and not at all giddy about this. The fawning Barbara was all ears about Iris' small victory. Iris recognized a real living legend and plainly felt her composure had worked. As it had, to our assembled relief and, dare I say, admiration.

7

The Lion

I came to Knidos with a small frame rucksack augmented by the capacious pockets of an US naval officer's blazer. The spotlessness of the alabaster coloured coat suggested it had never been worn in the Mediterranean or Pacific theatres. Each pocket accommodated a book. The most precious of these was the *Collected Poems of Edward Thomas*, a much reprinted original edition, a hardback present from my mother. I have it still with a picture postcard from Nermin tucked into the back flyleaf. Truth be told, I did not read the poems often, but its mere presence was an attenuated connection to home. If anything the book of poems invited me to look beyond Cape Crio. I had already learnt from Thomas that to walk was and is to think.

The flap doors of my tent looked out over the Commercial harbour to the moles closing the port and far beyond the peninsula where Newton's deputy found the Lion Tomb. Dick Keresey's tent at the other end of the line had a partly obscured view, but almost as soon as he arrived at Knidos it was his aim to visit the spot of Newton's most celebrated discovery. One Sunday we would walk there. But most Sundays I was bidden to other places and the dark headland lingered in the penumbra of my world.

Washing and marking pottery generated the first excursion. Or rather the boredom gestated an idle thought. Could we scale the fastness of the far horizon beyond the acropolis, claim it and see ourselves, so to speak, from there? The rhetorical

questions became reality when (only) three of us set out more out of duty than curiosity. We should have started out early but somehow we didn't. In oppressive heat Ilknur, Dick and I followed the road to Yaziköy, resisting the urge to climb until we arrived at a sharp ravine carved deep into the flank of the peak itself. The winter stream that dashed down here was dry and dusty, just a line of boulders. Zig-zagging upwards this airless afternoon we resembled mad dogs. Trapped in the stilled olives, the cicadas were deafening.

Dick, shirtless and meditatively silent, pacing his long stride reached the top lip of the ravine from where the pyramidal mountain had to be attacked. As he did, he let out a howl. Out of nowhere Tim in swimming trunks and flip flops brushed passed him. Tim bellowed at him, squinting in the sharp sunlight and blowing like a puffer fish out of water as he pounded awkwardly on up the steep scree slope. Dick paused, cupped his hands over his eyes then shook his head in disbelief (and disdain). As Dick turned, he was surprised once again. He came face to face with Henry, attempting lamely to emulate his compatriot but panting too heavily to keep up. Laughing ruefully he paused and bent to put his hands on his knees before limply stumbling forwards to pursue Tim. A trail of sweat on the bare burnt ground marked his path on and up. Dick asked him why, but Henry, breathless, half-heartedly flapped his hand.

Dick waited for Ilknur and me and before long we had passed Henry, buckled awkwardly over and withered by the recklessness. In his bathos he attempted to chuckle but couldn't. Tim reached the summit a minute or two ahead of Dick and me and promptly lay prone, his nostrils flaring, rasping for air. After us came Henry. His strained face streaked by molten sweat that had dried like lime in uneven lines as though he was a weeping clown. Next, with an athletic spurt into our midst,

came Cathy and she too was instantly bent double with cramp. The three of them admitted with glee, that on overhearing our plan, they had decided to ambush us and claim the summit before we did. Claim, as a word puzzled us, but we remained indignantly mute.

A photograph captures our foolhardy group, barely speaking, basking in the pure breeze off the Aegean, each a little tortured by the afternoon ordeal and what it said about us as individuals. (See photo on page 146.)

Ilknur, calmly arriving last, found it funny.

'Mad boys and Englishmen; cracking; just cracking!' she exclaimed in an uninflected rendering of being English.

Dick was not so amused. His redacted views were reduced to a euphemism in his subsequent mild-mannered afterthought – spotty. Still we gathered to record the discomforting triumph in conquering the peak. The photograph taken, conscious of our irritation, the three were soon gone, longing to get back to hydrate themselves. We contented ourselves to feast on a landscape lying close to the sky. Our human dimension was reduced to a contoured finger without edges pointing outwards past the Knidian acropolis to an uncombed blue. Turning to the east it was as though we had peered through Alice's looking glass. Surrounded by a magnified maze of stone walled fields, were the homes of our workmen, clustered white washed houses and the crooked streets of Yaziköy, Belenköy and Çeşmaköy. All three villages nestled in a little oasis. Far beyond, Palamut, an arcing bay shaped like an inverted sickle where, with Marie Keith and Emin, I had visited the richer greens owned by the bespectacled *hodja*.

From our summit we struck back along the ridge to the acropolis itself. We walked in silence beneath a blessed ceiling until the sun dipped introducing shadows and the spectre of vermilion. Soon we were upon the shattered blocks of the

Hellenistic fortifications capping a bald and diminutive outcrop. An ancient exercise in excess but now, like its architects, we fitted into the lens of this horizon.

How might Edward Thomas have reflected upon this afternoon trek? He would have understood that far from being made to think about the walk, we had been drawn out beyond our anticipated thinking by our companions and by our eagle's view of the unfettered world of our workmen. We had been perforated by the colours and textures and altering horizons. In the twilight we arrived back at Knidos, each of us aware of the riddles posed by this afternoon's adventure. In his excitement, Dick decided that the Lion peninsula should be our next excursus. This next walk we would be for ourselves, except it wasn't.

Come Monday as the Temenos excavations were drawing to a close, Midge Fraley suddenly appeared. The men cried like gulls as she entered our precinct. With a red headscarf concealing her long tawny hair, she was a Smith College version of Praxiteles's muse and the men all sensed it, instantly silenced. Bored by the confinement of drawing small shards and glass fragments, Midge was curious to see what we had discovered as well as our celebrated viewshed. The elder Hussein was not shy and took this opportunity to invite us both to lunch the following Sunday. We gladly accepted.

We hitched a ride to Yazıköy in a Willy's jeep plumed with rainbow colours. Arriving early we sought refuge under the thick canopy of platinum grey olives and unseen spied on a spasmodic parade entering and leaving the village. We heard the melodic timbre of a boy long before he came into view. For an instant there was no communion between his voice and himself. No more than eight years old with bare feet singing his heart out until his scruffy goats bolted away. Like an adult he cursed with a cracked inflection, mimicking his elders. Next he

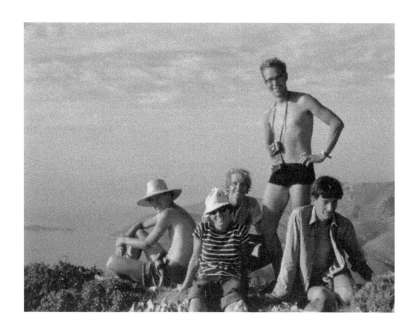

Above Knidos with RH (in hat),
Cathy, Dick, Tim and Henry
(photo by the author).

hurled stones and with straining effort diverted them from a field of maize. Minutes later new actors arrived. Two of our workmen, clean shaven and in pressed heavy suits and matching caps marched somberly by. No vehicles, just a woman in her pantaloons on a stuttering donkey mostly secreted. More animals followed, sending spits of dust air-bound and with them the ringing tones of peasants chattering infectiously, unaffected by the morning sunshine, the humming bees and the press of time.

Summoning up courage we left the bower of olives and headed into Yazıköy. It wasn't our first visit. We had accompanied Iris as a mute delegation to a wedding in an orchard. On that occasion we sat self-consciously to one side, watching the women liberated to dance to a flute and drum. In brilliant white head-dresses and long pleated skirts they had linked arms together and cried out with happiness. In time the music rolled over us as its rhythm drew everyone closer, the dancers revolving with their hands extended like the armatures of wooden puppets worked by strings. But this visit was different. We were the guests of honour.

Jelal, one of Tim's workmen, stopped us and enquired where we were going. Would we care for a coffee? We declined politely saying Hussein was expecting us. Şukru, the foreman at the Round Temple, was the next to waylay us. His younger brother was a wild one who worked for me. Children had found us by now. Oversized insects, stumbling along in hand-me-down clothes, chanting 'goodbye' and seeking Midge and her smile and her hand, both of which she freely gave. So we arrived at the café in the crooked main street. Vines leapt outwards whimsically from its façade and bare anonymity as I remembered from that unforgettable glimpse as we drove to Knidos long before. Hussein and Mumtaz without prompting, both in their Sunday best, beckoned us in to accept seats. The

other men doffed their caps revealing their full dark faces and
sharply trimmed hair, and moved into a wider circle making
honoured space for us. Coffees and water-melon were
summoned with the reprise of chatter.

Almost at once we were pummeled with questions. It was
as though years had passed as opposed to half a day. How was
Iris? Was Ilknur still there? Ilknur was honourable. What of
Cathy? Did she have a fiancé? This siege of probing questions,
I realized, was considered inappropriate for the Temenos. What,
I guess, they wanted to know was: so why did you come with
Midge? The answer, of course, was because we were invited,
but the obvious was obfuscated by the serendipity of the winds
trapped in this timelessness.

Each man was shaven and in a starched collared shirt. There
was a wedding to attend that night in Sindiköy. Most of the men
were fiddling with worry beads, a sight never to be seen at
Knidos.

Several boys joined the onlookers. Little Şukru, commonly
considered a minx, was amongst them then gone in a wink. Jalil
joined us to tell us about his new bungalow, a long discourse
brought to a close when an old bent woman in black paused
under the vines and screeched at the men throwing up her
hands in disgust. The men bantered with her and she turned
away. In the corner, seeking apparent isolation, sat the
blacksmith who had prepared the dynamite for Iris two years
before. Below greying bushy eyebrows he was staring at a
glass of raki in his huge fist, rather than at us.

I took advantage of the moment to ask about them. All lent
in towards me to chip in a phrase or a fact. They claimed to be
self-sufficient, each year making at most a hundred dollars in
cash from the sale of tobacco, olive oil and goats' cheeses.
Those who had orchards made more, though the wealthiest
were those with bees. Bees were good but the vagaries were

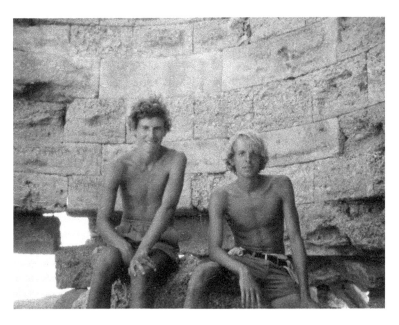

RH and Dick Keresey
(photo by the author).

many. Marmaris was at the distant rim of their world, though one man had once visited metropolitan Izmir. Only national military service ripped like a cyclone through this serene and sealed world. It sent them on odysseys to camps in the far corners of the great fatherland. Mumtaz had passed two years on the Black Sea coast. Then a deflection to another theme, no-one cared much for the Muktar. His elected office came with a dingy room on the street unembellished by vines. Some men drew back an inch or two. Was it indifference or were they eavesdropping on the Muktar's behalf? I could only imagine his alligator eye casting its venal gaze around this soulless room. No word of his days skiing around the Commercial harbour.

Lunch beckoned then we were destined to see the great ruin that Mumtaz had often spoken about at the Temenos.

Hussein had disappeared to prepare our formal entry. His eldest boy, Sunil, led us through the dusty back path to his parents' bungalow. We passed beneath a copious cherry to be welcomed once more by the kindly Hussein himself. His tiny wife appeared too and with eyes beaming with pride welcomed Midge then myself. The house was cool with the spare furnishings. Sunil guided us to a small carpeted room where we were invited to sit. No sooner done than his mother appeared with a hot blackened cauldron that she carefully set between us on the carpet. Promptly she disappeared leaving us to fish lumps of spicy goat from the stew as well as aubergines, peppers and tomatoes with our fingers. Perplexed by the protocol at first, we grew bolder in our cutlery-free experiments and over the course of half an hour, uninterrupted by either Hussein or his wife, we feasted as neither of us had ever before. Through the open window we could see the cherry and hear full-throated birdsong. This idyll had no end. Sweet fried pastries were laid before us by Sunil, complemented by a tea-glass full of thick red wine pressed from their own grapes.

Lunch ended with a syrupy coffee that drained to thick fine
dregs reminding me of Nermin in Marmaris, weeks before,
reading my future.

After lunch, as arranged, a little dazed by our appetites, we
took our leave. Hussein, his welcoming wife and Sunil, lined up
beside the cherry to wave to us after dishing out fairy pink
coloured Turkish delight to tide us forwards for the afternoon.
Flushed we were unprepared for Mumtaz's household. Entering
his yard he was visibly taciturn as though his eagle-eyed wife
had just dished out an ear-wigging. She was his height but
mostly enrobed in baggy pantaloons. Finding refuge in one of
her legs was his tiny waif of a boy. His eyes conveyed terror. Had
Mumtaz arrived home late from our meeting in the café? Were
we infidels inappropriately being offered succour? Politely we
accepted coffee and, piping hot though it was, we sipped it
swiftly to enable Mumtaz to escape with us.

Mumtaz set out resolutely, marching off on his thin bandy
legs. His body language spoke volumes. Through the labyrinth
of walled passages made for beasts and men, then the
spangled light of the orchards, we left the village far from any
vehicles and came upon a small forest of olives. Following a
mule path in single file and silently we unexpectedly emerged
on the northern flank of the peninsula. Bare, cupping and
dipping, the paths split to cross the steepening inclines. One
went to the acropolis. The right-hand one edged around the
hot exposed hillside and took us down into a pleasantly curving
coombe with a secret cove on its fourth side. Clouds were
mustering over the hills to the east, signaling an uncommon
sultriness. Tucked at the back of this hidden valley was a solitary
ruined building that on closer inspection, as Mumtaz had told
me many times, was ancient, patently a relic of Roman times.

The building was a large bath-block, open at the front with
roughly hewn abrasures and weeds attached in carefree clumps

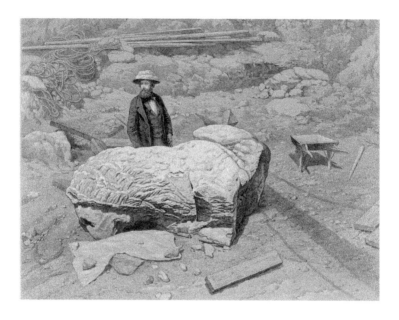

Charles T. Newton and the Lion of Knidos (from
Charles T. Newton, *Travels and Discoveries in the
Levant* [London, 1865]).

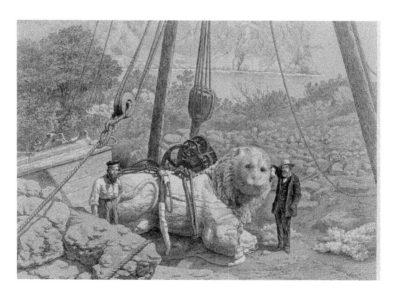

on its almost intact concrete dome. Lined up before it we were all startled by a shrill, half-human cry. High on the ridge behind us was a figure dressed foot-to-neck in skins surrounded by grazing goats. Mumtaz smiled and shouted back, his cry echoing in this closed world. Mumbling, he strode off the meet the dyspeptic shepherd.

Midge and I gingerly entered the cavernous bath-house with its dry palpitant air. In the gloom we were vigilant for vipers, scorpions and carousing giant hairy spiders. The ground was churned up by animals. Here and there fragments of the roof had implanted themselves in the dried mud. Long without any decoration, or the marble baths for that matter, the building was little more than a void recalling great affluence. It was discomfortingly separated from the civilization it served, as though bathers boated here from Knidos for the indulgent folly of a secret bath.

Outside stood Mumtaz alongside the old, black-faced shepherd complete with a stick that towered above the silver scruff of his hair like a halo. Tekir Buku was the name of the place, Mumtaz said. Ancients lived in it. The old shepherd ranted rather than spoke, having no teeth his words were a confection of sounds and spitting. Around him, noses glued to the ground, ceaselessly circled his goats. Mumtaz told him proudly about Knidos and about us. The old man's walnut face pierced by large saucer-shaped brown eyes brightened then sighed, seemingly dismissively.

'Do you think he has been here since Roman times?' Midge whispered, catching the old man's keen eyes. He certainly smelt like it.

The clouds in the east retreated as the sun started to dip. Mumtaz looked anxious to set out for Knidos. So, bidding farewell to the shepherd, once again we set off at a steady clip. At times he was almost running on the tips of his balletic toes.

As we reached the fork in the paths high above the hidden valley, Mumtaz paused and shouted out in echoing tones to the old man whose legacy was the Roman bath house without its baths. The odyssean phantom waggled his stick above his head and the goats all paused from their diligent grazing.

After an hour the path forked, the trail down to Yazıköy went left and Mumtaz, waving serenely, took it back to his fraught household. He smiled bravely at us, insisting the way was easy and safe. We speculated on what greeting he might receive and felt for him. At one point, talking as we journeyed onwards Midge halted and turned on her heels to face me. Sternly she asked me what I thought about Nermin. Her eyes, I realized, were compassionately yearning to learn more. Being as English as cricket I played a straight defensive bat, and she threw her head back and laughed disapprovingly. These moments increased our pace.

Following the right-hand path for more than an hour we passed along the lower slopes of the acropolis, taking us beside the far slate-grey valley to the darkened point beyond which lay the Round Temple, just as the sun drifted into a musty grey haze over Kos. Ruşan had lit his lamps and a yacht in the harbour was illuminated like a fairground attraction. We carried our thrill from the day's walk to Tekir Buku into dinner, or at least to our end of the long deal table. I sat next to Nermin with Midge opposite.

Tekir Buku and its antiquity whetted my appetite to walk to the other great monument in the hinterland of the metropolis, the lion tomb. Dick, inimitably courteous, appeared pleased to accompany me. No other Brits, he left unsaid.

A week later Dick and I followed the dusty track to Yazıköy until we came to a trickling roadside spring contained by makeshift stones. Donkeys had been drinking here so the ground was puddled. Its popularity was easily understood. The

water was divine, sweet and icy. From here in the midday sun
we struck out across the headland, ever vigilant for vipers.
Threading our way carefully through the low scrub and ilex we
dropped down to a point parallel with our tents, now little more
than pin-pricks, but a mite higher. Looking back along the line
of spiky surf-tinged bays to Cape Crio, the Commercial harbour
was still crisp in its detail, the crystalline blue bay being
ploughed by Iris as she water-skied in ever sweeping circles.
Out to sea we spied a lone yacht no larger than a sliver of
sapphire languidly pursuing its path through the Dodecanese.
The soft swelling breeze arrived just in time, balm for our over-
heated torsos. It ruffled the terrain, the only other sound being
the battering chatter of the cicadas. Immersed in formless
clumps of desiccated scrub we soon found the ruins of the
mausoleum on the crown of the headland and sat against the
hot blocks and composed ourselves to recall the most lyrical
part of Newton's Knidian account.

Richard Pullan on 15th May 1858 found the mausoleum,
following, we imagined, the path we took, and soon afterwards
he came upon its crowning glory, the lion. Newton leaves us in
no doubt about Pullan's excitement. Nine years Newton's junior,
he was an architect by training and medievalist by choice. He
had joined Newton the previous year at Bodrum, an experience
that prefigured a lifetime excavating in Turkey and Italy long
after Newton was back in Bloomsbury. I liked to think of him as
Newton's Sheila Gibson, someone with a passion for buildings
and the past as well as the taste of civilized adventure.

Charles Newton first heard about the lion at Knidos when
he was prising the lions from the castle of St. Peter's at Bodrum.
His visitor, Nicholas Galloni from the neighbouring island of
Kalymnos, told him about a much bigger lion some short
distance along the coast from Cape Crio. Such was the press of
work when he arrived at Knidos, and so wretched had been the

weather, that Newton allowed the lion to slip his memory until Richard Pullan set out on a mission to discover the beast. Perhaps Pullan had heard something from the workmen. Perhaps it was simple intuition. Following the path inland, more or less as Dick and I had done, he then veered out to the promontory that closes Knidos' eastern near horizon and that is the first to be illuminated by the summer sun as it rises. Pullan was doubtless delighted to find the mausoleum with comparative ease. We can scarce imagine his excitement at discovering its crowning epithet on the ground some distance to the east. Lying face down with his nose buried in a stony slope, the monumental sculpture weighed about seven tons and measured ten feet from end to end.

Finding it, as Newton must have known, was easy; capturing it was altogether another thing. What would have puzzled and strained any modern excavation simply could not be countenanced by our Victorian forebears. The lion had to be delivered to Bloomsbury. The practical ingenuity of making this happen fell to Newton's other colleague, the twenty-two year old engineer, Lieutenant (later General Sir) Robert Murdoch Smith.

Murdoch Smith, let's recall, was Dick's age and four years my senior at this time. His first challenge was to hoist the sculpture to a sitting position. Block and tackle were found aboard *HMS Supply*. Not just ordinary block and tackle for dealing with a Knidian statue, but stout ropes and mechanical gearing sufficient to re-erect a mast, replace a cannon or remove the boiler from a steamer. Getting this kit to the lion with men and donkeys was no small feat. The preparation must have spanned many long spring days. Raising the creature and consigning it into the hold of the ship took a whole month, and defies modern imagination.

Newton was well aware of the expectations and challenges and recorded the operation in detail and with evident pride. 'The sheers having been carefully adjusted over him, he was turned over without any difficulty mounting slowly and majestically in the air, as if a Michael Angelo had said to him "Arise!".... It seemed as if we had suddenly roused him from his sleep of ages.... When I stood very near the lion, many things in the treatment appeared harsh and singular; but on retiring to the distance of about thirty yards, all that seemed exaggerated blended into one harmonious whole which, lit up by an Asiatic sun, exhibited a breadth of chiaroscuro such as I have never seen in sculpture; nor was the effect of this colossal production of human genius at all impaired by the bold forms and desolate grandeur of the surrounding landscape. The lion seemed made for the scenery, and the scenery for the lion'.[26]

Like a big game hunter in a lithograph made after the lion was upright, Newton leans on its left ear, the creature's hollowed-out eyes melancholically seeking out the artist. In his morning coat, resembling a black beetle, he was perhaps a supernumerary in this engineering endeavour. Newton's eyes are hardly visible, neither excited nor proud, but Corporal Jenkins, his companion in a sapper's skull cap, beside the tail, looks mightily weary. Well he might have been. The task cannot have been anything less than a contest of wills.

The sappers under Murdoch Smith's command manouevred the uprighted beast to a point on the heights from where, with unalloyed Pharaonic belief, the party intended to carve a track to the sea and an awaiting ship. Reinforced by up to a hundred villagers, they set to leveling the route to its

[26] Charles T. Newton, *A History of Discoveries at Halicarnassus, Cnidus and Branchidae* (London, 1862), vol 2, 480-511; Charles T. Newton, *Travels and Discoveries in the Levant* (London, 1865), 214-21; I. Jenkins, *The Lion of Knidos* (London, 2008), 11-19.

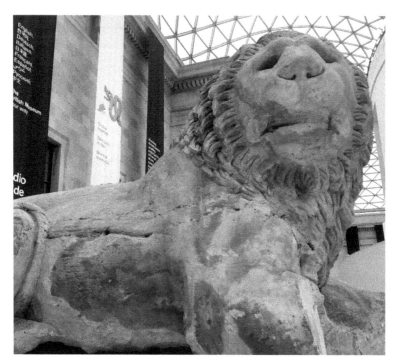

The Lion of Knidos
in the Great Court of the British Museum, London
(photo by the author).

intended destination. Rock was chipped away, hollows were filled, and a narrow road of sorts was made. The lion crate was reinforced with metal bands and fitted with sledge feet before being covered with 'a pall of old hammocks' and encased by the ship's carpenter in a massive wooden crate – 'his coffin with a resurgam'.

Forty feet above the water, Murdoch Smith aimed to swing the massive 'coffin' out over sheer rock and, using his gantry, painstakingly lowered it onto a waiting raft. The suspended crate was launched successfully into the June sunshine when the rock broke loose at the base of one of the massive wooden stays. In an instant the encased lion, now weighing nearly eleven tons, pitched dangerously to one side. 'On the giving way…, the poor Turk in charge of it was carried along with the rock which broke away, and two of his ribs were fractured. My hundred Turkish workmen set up a dismal shout, losing all nerve and presence of mind, as they always do in a great emergency. Fortunately, Mr. Edgeworth, the doctor of the *Supply*, was at hand, and I was glad to be assured by him that the Turk had sustained no dangerous injury.... Corporal Jenkins, grimly smoking his pipe after the catastrophe, observed that I was lucky not to have had what he called, in soldier's language, a heavy butcher's bill to settle'.[27]

The young Murdoch Smith calmed his team and with steely ingenuity planted the errant post back, bringing the beast into mid air equilibrium. With that, patiently, the lion made the penultimate passage on a raft (owned by a feckless Greek) towards its eventual emigration from Knidos on board *HMS Supply*.

Newton's account gives us no hint of triumphalism. Did Newton and Pullan and Murdoch Smith celebrate? If so, how?

[27] Newton, *Travels*, 217-19.

Did the sappers and Turkish villagers? The story of the lion's departure, in its exceptionalism, almost eclipses the lion itself.

The lion's destiny was to beat Newton to London where it entered the pantheon of sculptures in the Greek and Roman galleries, rivaling for all who saw it the awe induced by the Parthenon sculptures. Then, in 2000, it was selected to occupy a plinth in the new Great Court. Here, once again, it commands the dignity of a mark, a place that visitors recognize and remember as once it graced the seaway from Rhodes to Knidos.

The beast is carved from fine white marble mottled with the sea salt of millennia. At first sight battered by time as well as the elements it might have been carved from the stone of Cape Crio. Nothing could be further from the truth. The marble itself was taken from the slopes of Mount Pentelikon outside Athens and was the same material used to construct the Parthenon. Originally it would have been a brilliant white, a powerful presence to rival Aphrodite. But unlike Aphrodite we do not know who carved it or even if it was sculpted in Athens or at Knidos.

Getting it to Knidos required reverse engineering Murdoch Smith's Victorian method, using a crate, sheepskins, a wooden crane and some variant of block and tackle. The inventiveness, now, lost to time, speaks volumes about the audacity and aspirations of Knidians at the zenith of the city's history.

The lion rests on his stomach but evokes a serene majesty as opposed to the languor so often associated with these great cats. His front paws stretched out before him are missing. Much of his body was hollowed out to reduce the tonnage. A fine face with its mouth open to show his teeth is cocked slightly towards the viewer. He has a splendid ruff and his tail is tucked beneath him, its tufted tassel sweeping his toned body. His eyes are lost. The deep sockets were perhaps once filled with glass but even eyeless he conveys a regal dignity at repose.

The lion graced the top of a colossal tomb that once occupied this headland. Here where the promontory rises about one hundred metres above the turquoise and lapis blue sea lay Knidos' most astonishing tomb. Twelve metres on each side, rising about eighteen metres high, it was composed of three parts. The lowest portion was a shallow podium with a pinkish stone quarried locally. Above it was a façade of pale grey limestone embellished with Doric half columns. Lastly it possessed a pyramidal roof, constructed of steps. This supported the plinth on top of which sat the monumental lion.

The lion gazed out to sea but kept guard over the tomb's precinct and above all, the twelve burial chambers arranged like a star around a central rotunda in the podium.

Richard Pullan planned and reconstructed the tomb. His drawings possess a neo-gothic ethos and above all emphasize the diminutive scale of the seven-ton lion in comparison to the monument itself. Who had the audacity to construct such a memorial? Newton was the first to speculate, but the answer is no-one knows. Its motive has been lost to the centuries. Does the presence of a shield betray a message, perhaps to a collective burial for fallen heroes? Newton favoured that it commemorated the sea battle defeat of the Spartans by the Athenian admiral Konon in 394 BC. Stylistically, though, modern scholars believe the sculpture to be later in date. One model might be the colossal lion – pertly poised like a guardian – erected in Greece to commemorate the Theban fallen at the Battle of Chaeronea in 338 BC when Philip of Macedon captured southern Greece. An even later date has also been proposed to coincide with an attack on Ionia in 201 BC by Philip V of Macedon, when perhaps Knidos suffered casualties. A more obvious answer is that it was a Knidian grandee's emulation of King Mausolus's Mausoleum at neighbouring Halicarnassos, one of the Seven Wonders of the World. Ten

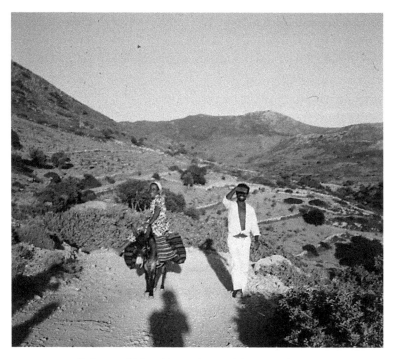

Şukru and his wife on the road from Yaziköy
(photo by the author).

times bigger (being around 150 metres high) than the Knidian tomb, this monstrous necropolis housed Mausolus's ashes in a stone sarcophagus, which was covered with gold-spangled cloth when he passed away in 353 BC.

How long the tomb served as a memorial and seamark is not known. There is no Roman rebuilding or embellishment. Instead, perhaps the victim of an earthquake, located far from the nucleus of Knidos' sprawling necropolis, it toppled over and suffered only the sacrilege of losing its decorative facings and the metal clamps that secured the great blocks together. Unlike other Greek monuments at Knidos plundered under Byzantium and then the Ottomans, it was expediently forsaken. Then came Pullan. His discovery paradoxically returned this headland to be an eternal landmark for Knidos, just as the lion itself is a meeting point today for millions of visitors to the British Museum.

Dick and I scrambled down the zig-zag path to the emerald green bay. The elements had ground parts of the descent into scree, and we slid and slipped. In parts you could see the faint traces of the route taken by the encased lion. With the translucent sea lapping over the narrow beach of rocks and pebbles, it was hard to imagine the scene in 1858. The silence and the egg-like pebbles cannot have changed much. Newton's determination was matched by Murdoch Smith's precocious skill and acumen, and by the likes of Corporal Jenkins who insouciantly puffed on his briar pipe as the going got tough. Our circumstances could not have been more different. No manner of discovery would have invoked naval resources matched if not surpassed by Victorian resolution.

As we turned back, perhaps a little nostalgic for the forgotten ruins on the headland, we could see what we assumed was Iris still skiing around the distant harbour. The sun was shaping to dip to the west, casting shadows now. Eying the headland a little wistfully, it was hard not to conclude that

something extraordinary had been plundered from this place, rendering it anonymous even if its name endured. The achievement of Newton and his men aside, it all seemed indulgent as only imperialism can be.

Or am I recalling this thought because on regaining the road to Knidos, Dick and I chanced upon none other than the tall, swarthy Şukru and his tiny wife by the spring. Şukru was the much regarded foreman at the Round Temple excavations. Dressed in shorts and little else he still conveyed a certain noblesse. His wife stood shyly in his shadow, a pert oval face peeping from behind a head scarf, and bright red pantaloons drawn up way beyond her waist. He politely asked us where we had been. Pointing to the lion tomb headland with his hands as big as spades, he nodded at us knowingly. Prompted by our explanation, dispassionately he told us the lion had been better off on the peninsula, where it was meant to be, where it merged with the rock, and guided sailors and travelers. The English consul, he said with a tad more precision as though someone had primed him or he had learnt it at school, was wrong to steal it. His dark brown eyes dilated, momentarily livid with the thought. We all paused to consider what he had said. His wife gauged the moment perfectly. Her eyes never meeting ours, she pulled at his sleeve and he whimsically curtailed his comments and promptly bade us a good afternoon.

Whenever now I see the lion in the British Museum – and I always pay him homage on entering – I think of Şukru and his wife. Possibly Şukru was right.

8

Nermin

When Iris took us to the wedding at Yazıköy she boasted – or joked – depending on your interpretation of her inflection – that Knidos was a place for love. Several of my companions cheered her. Iris trilled to their delight and accelerated the heavy landrover around one cornice curve then another. Celia, not one to miss the moment, looked at her and enquired, almost curtly, for details. Iris peeled with laughter, throwing her head back and reeled off a laundry list of love affairs and even marriages over the five previous seasons. Iris was merely the priestess. It was Aphrodite's gift to the city, she claimed.

All good and fine until Aphrodite's spell falls upon you.... I am suspended in the cloudy mixtures of memory. My grey-backed grocery notebook contains my taut cursive detailing a secret landscape. Is it enough to record that things took the form the fortune teller had predicted in Marmaris? Of course, it is a sophism to imagine that the coffee dregs and those Knidian weeks are separated. Then again, as Iris might have claimed there was the elixir of Aphrodite's presence.

Perhaps it began the night Iris arrived. In the midst of the wind and festivities Nermin and I sought our own company free of timid barriers. She spoke about Istanbul and her prospects as a guide in the Harem about to open in the Topkapi Palace. With welling tears of affection she described her father, a schoolteacher poet. How unimaginable this Ottoman fastness was when you came from a Wiltshire bower? Only Stonehenge meant something to her, druidical and associated with quirky British customs. For each the seed of fascination was planted in

the other's world as though we were each unbound. Of course, we weren't. Perhaps the union of shared interest grew stronger when we were drafted to mending the ripped tents following the strong winds the night Iris arrived. Working slowly and with accuracy the stitching offered a balm in the midst of the fervid mood now Iris was in our presence. Our words and gestures contained codes though now I was growing familiar with her deep suspiring eyes.

The cursive note in my diary is exact: 24th July: 'my eyes instinctively follow Nermin who sings in a brassy voice'. We were lying on the cooled seats of the theatre gazing into the stygian night for shooting stars. Her voice filled the cavea. At Bülent's direction we hummed.

Two days later at *paydos* I let the men hare off to their makeshift homes and, once gone, I set another course. Following the upper terraces casting shadows in the late afternoon light, passing the great theatre despoiled by Mehmet Ali, my eye on Kos as a landmark, drinking the sea wind, I came to Nermin's excavations. Decades have passed but I can still feel the comforting warmth of the Aegean breeze, smell the thyme and almost touch my excitement. Was this Aphrodite's elixir?

She was charged with the long trial trenches on the platform running out from beneath the Round Temple. In the day this resembled a prison camp with as many as fifty men in goggles working slavishly under Şukru's direction to expose the temple precinct. Nermin's deep, three neatly trimmed trenches were dull by comparison with the monumental exercise close by, though no duller than mine. Yet this was heroic archaeology and she knew it. Such trenches, whatever was found, would stand the test of memory and perhaps even time. She was in a red headscarf bundled up against the sun, which was fierce on this brutally exposed point of the city. Henry, she said, had designed the trenches to understand the terrace. She gestured

at their content, deep tips of earth as though some monster had shifted the mountain to this point. I tried to conjure up a hopeful reading of the strata and with a sulky good humour she teased me for it. Her unforced laughter like her singing fixed the moment. Still staring at the trench elevations two Swiss tourists interrupted us and, as so often happens, misjudged the moment for science. Still, we told them what we knew, first Nermin then me, and they looked satisfied as they strode off and clambered up to the Round Temple. By now the sun was poised above Kos, casting its last light like an exhausted lamp, so Nermin with me in tow ambled down the dusty path to camp suffused with ourselves rather than the riddles of archaeology.

So radiant an evening was impossible to repeat immediately. At *paydos* the next evening Iris and Henry arrived. Mumtaz, I noticed, showed a flicker of dismay before deferentially greeting Iris, and then he took to his heels. I tried to appear absorbed by their presence when of course I wasn't. Did they notice? Iris and Henry examined the trenches without much enthusiasm and then started chattering about Newton and the discovery of Demeter. There was no compulsion to return to camp so we took a long route by the Stepped Street and Iris talked about recent party guests in New York while I allowed my thoughts to wander.

That evening slipped from my grasp and the next would have as well except that at dinner Tim gave a disquisition on Haydn's cello music as he was a cellist. It was not my business but I improperly caught Nermin's melancholic eyes. Clearly she was baffled and as chance happened when he excused himself briefly, I managed to persuade her to seek refuge at Ruşan's.

29th July. 'She starts to call me "my dear" as we assemble at Ruşan's for a post-prandial trip while our elders languish at table, glum, left out...'.

Later we walked along the narrow path to the lighthouse, a tumescent presence in the moonlight until we were close. 'It is English', she exclaimed on my behalf, reading the cast-iron maker's mark on it.

'30th July. A marvelously happy day. Mumtaz full of beans.... Nermin came to see my excavations tonight. I waited on the little rise in front of the terrace and watched her approach ... later we met Mumtaz and his nephew at sunset. They had been climbing a tree fetching honey combs. Mumtaz looked tired when he spoke with Nermin, his hair tousled and flattened by the branches. His eyes, though, tell a magic story. He gave me a lump of the comb-rich delicious stuff pouring over the sides of my hands with the bees giving frenzied chase'.

An hour possibly two marked on me forever. I recall the sense of expectation before spying Nermin as little more than a speck advancing determinedly along the old mall that bisected the ancient city. She walked briskly, picking her way through the scatters of stones and smashed buildings littering the patchwork of tobacco fields.

'How are you, my dear?' an affection, that lingered and caressed.

The trenches with nothing of note were little compensation for the long walk, but she took a dozen snaps with her Kodak Brownie. The sun was dipping, casting us in haunting shadow beneath the canopy of olives when unexpectedly we encountered Mumtaz and his cousin, Hussein. It is difficult to say who was the more surprised. Since *paydos* Mumtaz had voyaged through a tempest, a bizarre sight veiled in aggravated bees. Bees were pitching on him, nestling into his matted and furrowed hair. No fewer were clinging obstinately to his dirtied muslin shirt. Stinging him and repeatedly, the bees were visibly draining his strength. Agitated as though in a ballet and compelled to stillness, Mumtaz knew his status in the world

and ignored his merciless afflictions to attend us. Politely addressing Nermin, he restlessly plucked at the bees in his shirt, then in the clotted mass of sweaty hair on his exposed chest, and lastly from the stubbled fields on his cheeks. He was removing bees as though they were bits of chaff or dust rather than venomous and deranged insects. Ignoring the bees for a moment, if that was possible, the two halves of my Knidian world were now enjoined.

Mumtaz promptly clambered into a tree close to the Temenos. Under his arm he grasped a muslin package, his face screwed taut with pain. Besieged now by the maddened bees he fixed the package into the fork of the tree and slipped off the muslin to reveal a dripping honeycomb. Honey slopped fitfully over his hands, mesmerizingly trickling in all directions. Stained with viscid spittles, gilding even his bare dusted feet, Mumtaz leapt from the tree thrashing at the bees clinging to him. His cousin, Hussein, snorted and slapped him on the back as though he had won a race to Hades. He looked as though he had.

Mumtaz punctiliously wrapped two small paper packages each containing a fragment of the broken honeycomb and presented one to Nermin and the other to me. Together we set off to camp, the light fading fast. Mumtaz was still swatting at lingering bees, but he and Nermin talked all the way to Ruşan's. I found something precious in their low voices although I was rendered powerless by language. All the time my heart was gunning. Perhaps it was a quotient freedom.

Over dinner Nermin explained Mumtaz's plans for apiculture at the Temenos. She spoke tenderly, her gesturing hands moving as though she were holding something as fragile as a honeycomb. She knew how I felt about Mumtaz. The truth was we had participated in a minor epic as poetic as any.

'31 July. Henry fancied some of the honey! With darkness, though, a new twist to the story unfolded. We danced in the theatre as Nermin sung to us of love. Then we visited Cengez's cafe for *cay* [tea]. The Muktar was there, and suffering from too much raki. His good eye ensnared us, capturing us for his silent movie. Beware, beware, he was apparently muttering. We slipped away to Ruşan's little lean-to. The cool persistent breeze ruffled the waters of the Commercial harbour, beating up up against the rickety jetty. Ruşan and Nermin exchanged words; perhaps they spoke of the Muktar. Then, as in all films, he reappeared, improbably bearing down upon us with Iris for a companion. He snaps at Nermin in Turkish, and Iris chides her too, theatrically muttering something about Tim. Nermin retreats ... Once more we flee. This time to the pitch blackness of the camp where we romance with dreams until an hour when the silhouette of the acropolis appears to touch the ceiling of stars'.

'1st August. Sunday: Iris' birthday; Henry's too! To begin with it was eerily quiet as Tim had set out with three others for Marmaris. But a party was in store. I mended a rip in my tent in the morning, awaiting events expectantly. That afternoon Nermin and I slipped away around the Trireme harbour, and clambered around the headland below the Round Temple down to a sandy cove that seemed well-concealed from Knidos. Nermin was determined I should learn to swim. Inevitably I swallowed too much water, we laughed alot, and I managed only the poorest imitation of a swimmer. She was so bright and cheerful. She might have succeeded in teaching me but for the arrival of our blond German colleague with an obese boyfriend. He had materialised in the night, bringing his Mercedes along the road and onto the beach in front of the camp. He was Turkish, possibly a businessman, possibly a taxi-driver! To them

we were no more than children, to be hounded out of this haven. In retrospect our error was our submission to their invasive wills.

'The saz player settled down near the punch, and from time-to-time was fed with Italian hamburgers. The flautist and drummer joined him. Iris was hostess. She stirred the punch and fiddled with the barbecue. Tilley lamps lit the party, hissing and catching the gleam of our assembled eyes. From the shadows came Tim, an astronaut full of his long journey to the real world and back. Hours of dancing followed. Mumtaz was in his element, spinning around and prancing elf-like to the rhythm. The others bowed to his exhibition, and a glow of excitement, whipped on by Iris' punch drifted across the ensemble. In the half-shadows sat the Muktar with a surly, evil grin. Close by, Tim. He was prattling on and on; my heart was troubled by Nermin's eyes trapped in his stare'.

Hundreds arrived in our midst, conveyed to Knidos in a fleet of vehicles. They covered each jeep, perhaps twenty to thirty people hanging on from every angle. For a few hours the metropolis was filled with families, the wives in bright pantaloons attempting to keep control of their children. The high jinks transformed the normal sobriety of the place.

'2nd August. Some days life sings along; some days it sucks, so Midge told me. Today it sucked. Learnt that my famous professor had resigned; the rationale for my university course was slighted. Worse still, while meditating this blow, a hurtful near-encounter with N and Tim on the far side of the Trireme harbour. They were close to the rocks, under the watchful eye of Kos, where two white orchids grow, cherished by sea-spray'.

'3rd August. Aloof all day; committed to archaeology and early to bed'.

'4th August. Invited Midge up to the Temenos of Demeter to draw Mumtaz. Midge was … dispirited by camp confinement.

Mumtaz likewise was eager to show off his artistic skills. He provided a little honey, and then for a vivid twenty minutes the two artists busied themselves. Mumtaz looked a little tired, as it was late afternoon, well after *paydos*. Midge, by contrast, was bubbling with a Middle Class American zest for life sitting cross-legged, demurely attired in a regulation red head-scarf. Her efforts captured Mumtaz – I wish I'd kept them; Mumtaz's sketches were shaggy prehistoric affairs, wonderful for their primitive naivety. On comparing the two sets of drawings, his eyes dispirited to reveal a sad submission. For us, though, his timeless inheritance had a magical intangible quality, and our enthusiasm roused him. Often afterwards he reminded me of the picture'.

'Our time was slipping away. N. due to leave Knidos on the 8th.... That night we sauntered out to the tower overlooking the Trireme harbour, and resumed our lives once more.'

'5th August. The conflict of natures was beginning to strain us all. Midge desired our company. Tim wished only for Nermin. At the lighthouse, under a sparkling full moon, Midge, Nermin and I sang. On the way back N. whispers that she has something to tell me. Whereupon from the shadows a figure rushes by. We freeze. The night is still, almost airless. The night consumes Tim. I knew earlier in the evening when we encountered him on the beach before dinner that something was afoot, eating him. His sallow face was consumed with a cankerous agony. Gone was his contempt and public school arrogance. Tortured, evidently, he had slipped after us to listen to Nermin singing'.

'6th August. "Nermin is going soon", Mumtaz says first thing. The workmen share my mood, and cheer me as best they can. Two friends of hers are coming today; she urges me to find her in the evening, after work. Naturally, Iris and Henry pick this time for one of their irregular visits. They never follow any pattern of

site tours…. Time is precious, though. I make my excuses and hare across the terraces in four minutes. Down and down, missing the cisterns and vipers and boulders and deep chasms between the higher terraces. Past the theatre where Mumtaz has his lean-to. Almost from nowhere he materialises. "Mumtaz..?" I start to splutter. He doesn't reply, but with a wide grin he points commandingly to Ruşan's.

'Beside her were two men: the stocky imposing one was a captain in the army. The other was simply his mirror-image. They never really engaged eyes with me, deciding disdainfully that this skinny waif with dusty, shaggy hair, filthy shorts and broken sandals was little better than the peasants clustered around the fountain. Ruşan took the scene in at once. "Look at my menu, gentlemen", and of course, the gentlemen sauntered after him to the kitchen to inspect the fare. I didn't mistake the twinkle in Ruşan's eye.

'Silently Nermin began to cry. "Tell no-one –Tim has written a note saying simply *I love you*. I feel so sorry. Tim is ok –but no…"

'The tears lit her brown eyes; her black hair and crimson blouse brought the spell of spring to this hot summer evening.

'"How different you are from them", she continues, referring to the martial bruisers from Istanbul. "I cannot get on with Turks anymore". Later I learnt that she was engaged to the captain. Later too there was a full eclipse of the moon, a protracted ominous event snatching the silver from the rippling waters of the harbour'.

'7th August. My mother's birthday. Mumtaz prophesises that I shall cast myself into the sea. Early tomorrow morning she leaves. At mid-day I dash to the old mall connecting the Temenos to the Round Temple. There I discover she has slipped and hurt her back. After *paydos* I make the dash once more,

and then together we pick our way slowly across the metropolis to my excavations. I humbly take no pride in them. In the past, as an 18-year-old veteran, I have managed better digs. But we took photos as the dimming sunlight brings an appealing reddishness to her hair. We climb down to Tim's site – a marvelous excavation. No Tim, though. There she admits a feeling of guilt. But we sit and recall the Büyük Efes and the six weeks so far. Life has assumed the timeless of the peasantry, at one with the rhythm of the season.

'Then we must recognise modern time. So we saunter down the road and encounter the whole army of Knidian workmen. They are waiting to be paid. Mumtaz winks capriciously. Iris manages a meagre smile. Next we encounter Tim. He is inconsolable. A drop of rain signals a thunderstorm. Forks of lightening and a final magical vermillion spilled across the sea to Kos, bringing a curtain down on the act. The wind gets up, the *meltem*, we sing some more, we drink too much wine, the gendarmes scurry across to upbraid us all – we might be Greek pirates, and then we part in the dead of night. Each of us in turn pays farewell to her; lastly me. A slightness of hand; a gentle kiss; and it is ended.

'Constanza, Celia, Midge and Lindsey were there to console me. Our American Aphrodite intervened on Tim's behalf: he was chosen to drive Nermin in a chariot to Marmaris at dawn. I slept fitfully in the hope of a final glimpse, but I dozed through the crucial moments, the anguished departure. Roosters outside Ruşan's awoke me to a day of anguish'.

Weeks later an airmail letter arrived from Istanbul. Light as a feather but unprompted I couldn't conceal my excitement as I handled it. I took in its form for an eternity before unsealing it. Inside it contained a clip of her raven hair (no hint of blue) and an invitation to visit her. Her father, the poet, would be pleased

to meet me. 'Please come, my dear'. The echo of her cadence, the inflection, the ecstasy, even joyful wounds; I replied affirmatively with too much passion.

And so Aphrodite sprinkled chaste magic on my life, memories banked as treasures greater than any marble statues. With this love I appropriated Knidos as mine. No doubt Tim did too. Candidly I admit now to a sadness on his behalf that I never expressed but have never forgotten. Trivial, yes perhaps, but as simple and timeless as Mumtaz's drawings and the velvety honeycombs he collected.

Reading my diary, with Nermin soon to be part of the penumbra of my early adult life, it is Konstantinos Cavafy's words I crave to hear:

> On hearing about great love respond, be moved
> like an aesthete. Only, fortunate as you've been,
> remember how much your imagination created for you.
>
> This first, and then the rest
> that you experienced and enjoyed in your life:
> the less great, the more real and tangible.
> Of loves like these you were not deprived.

9

Terracotta Drama

Our world was contained in an invisible cobweb. Only the light altered, sunset coming a scintilla earlier with the passing days, an alluring hint of autumnal days and mellower temperatures. We could have been peasants working to the seasons. Only occasional mail and tourists reminded us of our isolation. Sleek, polished yachts anchored and then slipped away. Beautiful and ugly tourists scrambled around the ruins always looking lost, they refrained from seeking our eyes, believing we were peasants, and then disappeared to their yachts to dine on rippling water at night. Like reading a glamour magazine in the barber's, their sheen and stardom lingered for but a moment and like the Knidos dust was gone. All very different from Newton's campaign. With canonical Victorian insouciance at one point in his memoir of Knidos he recalls the threats from the sea:

'The next morning, my Turkish workmen announced to me that a strange looking vessel had been seen hovering on the coast. As she had thirty men on board —a number much exceeding the crew required to navigate her —the natives here at once suspected that she was a pirate; and this suspicion became a certainty when she suddenly made a swoop on the coast, and, landing an armed party, carried off a bullock before the very eyes of an old peasant who was too frightened to offer the slightest resistance. The night after this raid, Corporal Jenkins happened to be keeping watch at our camp at the Lion tomb, all alone, his Turkish workmen having deserted him to

176

celebrate the *bairam* in a neighbouring village. In the middle of the night he was roused by the sound of oars, and saw the piratical boat pulling into the secluded bay below the promontory where his tent was pitched. Carbine in hand, he challenged them, and, getting no satisfactory answer, thought it as well to let them know that he was ready to give them a warm reception, and so fired just over their heads. Not liking the whistling of an English bullet, they at once put out to sea again, and we have seen no more of them; but, looking at the curious coincidence of their apparition just at the moment when the money, according to all reasonable calculation, would have been in my hut instead of on board the *Supply*, I cannot help believing that their visit was pre-arranged, possibly at the instigation of the canvasses themselves (the muleteers who brought the money – the workmen's pay – to Knidos for Newton). I reported the circumstances to my friend Mr. Campbell at Rhodes, who, like all Consuls, was delighted at the chance of reporting a case of piracy to the Admiral, in the hope of eliciting in return a visit from a ship of war'.[28]

But our isolation was not impregnable, no more than Newton's had been. The sea posed no threats but our Achilles heel was to have its origin in our routine and then the disruption of discovery.

Skiing and food were distractions from Iris' feverish obsession with finding treasures associated with the Round Temple. As the summer evenings lengthened Iris tore in ever increasing circles around the Commercial harbour and indulged, whenever she could, on the hottest peppers to inflict us. We whispered conspiratorially about her calescent sense of urgency. She simply knew something sensational was certain to be discovered. Instinct, she would say with conviction. Instinct. Pirates aside, how easy Newton had had it in

[28] Newton, *Travels*, 229-30.

comparison to the tendentious scientific standards Iris was compelled to meet.

As the summer days shortened the Round Temple team was paid double-time to work on Sundays. Every day with unvarying persistence the men picked and shoveled and barrowed on these exposed terraces. On bad days the *meltem* whipped up bursts of dust, forcing the barrowmen tipping down the cliff-face to wear goggles. A resolve to comprehend the temple of Aphrodite definitively distinguished this team from the others dotted about the metropolis. Imagine, then, the exultation that swept through our ranks, now swollen to more than a hundred strong, when a cache of terracotta statues came to light. First, one terracotta statue, then numerous, votive offerings concealed in rocky crevices against the terrace wall behind the podium of Knidos' defining temple. Flecks of charcoal and fine grey soil stuck to the terracottas. Some were miniatures; some were almost a foot high; some were blackened from being scorched. Spanning several centuries from the Archaic Greek age to the Hellenistic world, these simple, locally mould-made creatures were plastic proxies of the Knidian goddess.

Halil, a foreman in that area, stiffly carried the statues down to our encampment in a stout fruit box. Next in the procession came Iris, barely able to contain her exuberance. Her man put the precious box down on the dinner table, presumptuously sweeping aside the knives and forks to do so. Displaying the yellow stumps of his teeth, he beamed a winner's grin. (His satisfaction was well justified for Iris rewarded those who made outstanding discoveries a handsome *bukşiş* –an extra sum equaling several days' wages.) Iris' carnival excitement was contagious. Trophies like these were from the text-books. They had recognition value from Greek Art and Archaeology 101 and palpable sale value too. Iris, we were quickly reminded, had her

eyes on a larger prize, her interpretation of bust 1314 in the British Museum.

'Look at the hair-do on this one!'

We all edged closer, courtiers and the rest.

'The hair half covers the ears and ends in a bun low on her nape. The Pseudo-Lucian describes Praxiteles' statue with a hair-do like this'.

Normal Aphrodites, apparently, had their hair drawn back above the ears with a bun on the back of the head.

'What date are they, Iris?' she was asked, as though the stop-watch timing her fifteen minutes of fame had begun.

With intuitive showmanship she grasped one fragile oriental-looking statue and held it aloft for us all to see.

'Archaic', she declaimed (about the 6th century BC), this one word being self-evidently triumphant enough.

The other statues possessed a cleaner, classical style, perhaps belonging to Praxiteles' time. Such early dates, Greek as opposed to being prosaically Roman, fueled her rising ardour. Most were the modeled heads of young women at the zenith of their beauty. One voluptuous group, Iris speculated airily, represented the birth of Aphrodite aided by Hora or one of the Charites. Not only Aphrodite held thrall at this podium. Other deities, Artemis, Cybele and Hermes, were also present, in apparent sublimation to love. Faded patches of a water-soluble paint the size of sunspots still adhered on several votaries. Iris decided their hair to be red, in some cases with blue earrings. Her goddesses had to be on fire with a receptive genesis in the figural arts of the Minoans.

Iris' blazing eyes and gestures revealed not for the first time that she had studied silent movie queens. In Bloomsbury, you could hear her cogitations, her critics would soon be dining on humble pie.

To celebrate Emin was dispatched to prepare four fingers of bourbon on the rocks, the two dogs were given a special luncheon of canine treats procured from the US naval stores at Izmir, and we all relaxed satiated in the knowledge that things were going Iris' way. Not unlike the rewarded workmen, life in camp, we confided in one another, was bound to get better.

No respite for the Round Temple team. Iris exhorted them to expose as much of the precious terrace surrounding the temple as possible. Her sponsors in New York needed to be rewarded for their support, and over dinner that night she boasted of torpedoing the British Museum once and for all. Wolfenden, we began to believe, had made a mistake. If only he had shown a little humility by accompanying Wheeler ashore. You could easily imagine hearing these lines repeated at every point of her return to New York and then some more.

All finds after being washed were marked and catalogued. This is where finds went astray. As a rule finds were laid out on trays to dry, and many a time pieces close to the edge worked their way capriciously over the side. This was especially true of finer pieces. Someone passed by, spied the fine specimen in the middle, picked it up, examined it, chortled dismissively, and carelessly put it back on another tray. For that object its context in the site – the area in the metropolis, the trench in the excavations, the layer, its relationship to an important wall, perhaps, to the history of the place – may have been lost forever or at least jeopardized unless the trench supervisor remembered, checked and rectified the mistake. The worst muddlers of finds were the washers and markers themselves. The abject banality of the job generated perpetual lapses of concentration. To make the system work properly the finds' supervisor needed to be one of Wheeler's NCO's. Rebukes, on the other hand, resulted in painfully slow output. The village boys were slapdash workers in

the extreme. Each was a sprite, occasionally charming as they practiced their English (at their mothers' bidding), but finds' labels were an incomprehensible American concept and best ignored. How many times did I hear the finds' team, Cathy, Constanza, Midge and Dick reproach the boys? With sponge smiles, the chiding over, on thin bandy legs the boys would hare off along the sand chased by the yammering Carlino.

The boys got to see more of camp life than their fathers – they heard the whining tapes of pop music, once they even sampled Iris' nescafé, and they could feast their eyes on the skimpy floral bikinis and white flesh as lunch beckoned. Who knows how much of the gossip they understood? Largely ignored, deprived for eight hours a day of any compass bearings, collectively the boys were a tinder box waiting to be ignited. Certainly it was their chattering that led to the fuse being lit.

Mehmet the *beci* (the guard) somehow heard first that one of the figurines had gone missing. It unhinged this normally dignified man. Since the discovery each night he had mounted guard on a ledge where Aphrodite had once been a seamark. Pint-sized, accompanied by a German Mauser as big as him, he would willingly confront any antiquities' thieves who threatened to descend from the acropolis at night to dig for more treasures. His turmoil began when he learnt after his night shift that a statuette had been misappropriated (our word). How the whisper surfaced mid-morning two days after the great discovery was far from clear. Being late down from the Temenos I entered the camp as Mehmet's fury was winding down. Everyone's pained eyes told a different story ranging from diffidence to plain demented in the case of the village boys, fearful of a fierce thrashing.

The *beci* had stomped with outsized purpose into camp, demanding an admission as to who had stolen the figurine. His

behavior spoke to his own fear. Should any suspicion somehow fall upon him, his sinecure as site-guardian was in peril. Apparently, the team of eight boys stared rigidly at him doe-eyed, half-understanding that they should be fearful but not quite grasping why. The pot-shed crew emerged from their lair puzzled by the theatrical ruckus to witness his instant investigation. Iris, meanwhile, was on the excavations and had yet to learn of Mehmet's grave suspicion.

Mehmet opened Pandora's Box. Little Şukru, a rather sallow boy with deep dark eyes, pointed at then yelled at Halil. Babbling and half weeping he blurted out that Halil had confided in him about stealing the statue. It would be sold to a black marketeer on a yacht. Halil, so Şukru explained, hoped to buy some music with the money. Momentarily, this accusation lingered like a violent cloudburst before the speechless Halil was apprehended by Mehmet and marched off for interrogation at the *Jandarma*. The shaven-headed militia had nothing to occupy themselves with apart from raising and lowering their little red flag and washing their flimsy clothes. Since their mission at Knidos was to prevent any foreign mischief, when confronted by Mehmet and the apprehended Halil they apparently acted with alacrity. The encrypted words were black market, yacht and music and money, assumed to be American. With improbable speed a grim-faced Corporal was dispatched to stand guard in the camp until Iris returned. His task, we presumed, was to emphasize how serious this was and that the Americans needed to be held accountable. Before Iris' arrival the *Jandarma* at Çesmaköy had instructed that the offender be removed and detained in custody. It was not difficult to explain this. Çesmaköy being a sleepier posting than Knidos was eager for diversion and pulled rank. The diminutive Halil was bundled into a Willys jeep and with an armed guard

driven away. Scarcely thirty minutes had passed since Mehmet had denounced the theft.

Midge burst into tears; Cathy berated Iris furiously and Iris, at first somewhat baffled, stood back and simply tried to comprehend how the quotidian serenity had imploded. Her eyes for once were filled with marked timidity. In chorus the finds' team assured her of Halil's innocence. Constanza repeated over and over again in inflected English that it was simply preposterous. He was a wraith and no more, she repeated. Iris had the presence of mind to make everyone sit. Her eyes sought an explanation and this was no performance. Cathy was invited to describe precisely what had occurred. All the time, like a mislaid circus mannequin, the lone Corporal with his carbine beside him, stood bolt upright under the shade of the portico.

The real import of the affair soon became clear. No second guessing was necessary. A delegation of workmen including Halil's father stormed along the sand. Iris beckoned most of us away, and then stoically awaited them. Each man was offered a tumbler of bourbon, and Ilknur was summoned to translate. Their message was unequivocal. Family came before everything; there would be a *grev* (a strike) unless Halil was released. Halil's father said that his son was innocent, and the other men either cooed to his emotive words in mumbled unison or nodded their heads affirmatively.

There was a strike anyway. In an astonishing display of solidarity all the men hurried off after lunch. In different columns they hastened to their villages to consult with the Muktar and other elders. Iris had no choice but to act with similar speed. She and Ilknur strode to the *Jandarma* from where they telephoned the militia at Çesmaköy. Then they set off in the landrover, pursuing the scurrying workmen along the coast road. Well beyond the city limits the landrover paused to pick

up laggards. With men clinging all over the machine, setting up a spurt of dust, Iris accelerated towards the villages and was gone from sight. The exodus sapped the energy from the ancient city much as it must have seemed after we all eventually departed. In this imposed limbo we diligently checked our notes and drew plans, but for one and all our thoughts were on what might happen next.

Well after dark Iris and Ilknur returned. The landrover lights wound wearily around the hillside before accelerating down the decline into Knidos. But this was no re-run of Iris' arrival. She was plainly deflated; Ilknur sped off without speaking 'to cry in my tent', she told me afterwards. The interrogation at Çesmaköy had developed into a nasty imbroglio. Halil had insisted that he had not stolen the figurine. His father supported by the elder men had raged first at Iris and then at the shaven-headed militiamen. Then Şukru was introduced into this confused, highly charged setting. Faced with such odium he had burst into tears. Ilknur had screamed at him, calling him a liar. And he admitted it. Suspicion automatically fell upon him. Of course, he denied taking the terracotta, but his feeble defense, despite his poor father's beseeching, was to no avail. The madness had been cranked up a notch. After dusk the luckless Şukru was driven off in an armed jeep to the little gaol for political prisoners at Datça. This was a game-changer.

Datça housed the lair of the sub-governor, the oleaginous *kaymakan* – or K-K as we had christened him. As we all knew well by this time, the K-K had no time for American archaeologists. Overtly officious and as overtly lassitudinous until this large man with a barrel for a chest would erupt volcanically setting up sparks like a heavy hammer hitting an anvil. One objective was uppermost in his mind. Iris was a means of scoring points in the provincial political arena and a

sure-fire pathway to national politics. A virulent political charade was now set in motion.

Content that justice had prevailed, the workmen returned, albeit despondently, the next day. All but Hussein, Şukru's father, that is. Iris was welcomed with humble respect as she read the roll-call from Cengez's patio. Afterwards I rode up to the Temenos on Mumtaz's mule, balancing uneasily upon its skeletal frame. For a good while my little band were noticeably silent and pensive. Their anxiety lingered like a morning storm. I did not see who thundered first. It was of no matter because the urge for collective therapy was compelling. A young goat-herd, no older than the potwashing boys, minding a flock of shaggy black animals, crept into the precinct to silently listen as the village men began to argue with one another. Osman and Mustapha were especially furious their spade-like hands motioning at the others. Mustapha was Halil's uncle and trapped in this senseless web. All murmured when Mumtaz praised Iris' decisive action. She had won esteem from the incident. Şukru, by all accounts, was a capricious lad, a known liar. The word echoed beneath the canopy of olives and I caught the wariness in the deep-set eyes of the young shepherd. Maybe, Osman spat, braying like a donkey, but he wasn't a thief. How was he so sure, Hussein asked? Because none of them were thieves, Mumtaz interjected ferociously ... none of them. Silence followed as they weighed his words before they all nodded in agreement. Şukru hadn't taken the statue, old Hussein then ventured and we all knew he was both certain and right. Boys would be boys, he said, but why should he steal the statue? How would he know someone to sell it to? How many statues were there, Mustapha chipped in? Then Mumtaz introduced an incendiary thought. Holding their attention with a taut gesture of his hand, he asked, how did Mehmet know about the theft? Rather perversely no-one until

then had asked this question. A momentary silence ensued. We all stared at Mumtaz momentarily frozen as if a statue. To a man the cruel contempt for the officious, sometimes fulsome little *beci* erupted, an orchestra reaching its coda with the baton in Mumtaz's hand. No-one went further, though. No-one asked whether he might have been the culprit or in fact knew the culprit. That was going too far. No-one even mentioned the dark colouring of his skin – a racist innuendo as far as Mehmet was concerned that I had overheard when trivia was being aired. As for the authorities, they all bowed their heads and their words were at first mocking then incomprehensible. No-one trusted the K-K. Politicians like tourists belonged to another galaxy. Merely uttering his name muted the session. Talking of such poison, Mumtaz once said referring to the Muktar, might do harm because he might be listening.

After two attenuated days Iris and Ilknur set off at sunrise to attend the hearings at Datça. By then I had translated Mumtaz's question into camp-life. How many terracottas had been found on that fateful day; how did Mehmet know about the theft, and so forth? The questions had drifted because I was too junior to compel anyone senior to pay heed. Was it my imagination that facts had become irrelevant? Or were they irrelevant because a genuine suspicion could not be confronted?

Iris showed real backbone. She went to attend court knowing that the K-K would likely as not be charging her rather than little Şukru with the misappropriation of antiquities. In Turkey, where antiquities' smuggling was considered as venal as handling drugs, Iris might have been better admitting to murder. Her excavation permit was now put in peril. To disprove the charges was impossible unless a culprit or the lost statue might be found.

Şukru was soon swiftly deemed innocent of the charges. He tearfully confessed his jealousy of Halil, and described how he

misled the *beci* to shame Halil. Above all he wanted to share in the confidence Halil had won from the American girls. This pathos was wholly credible, even to Iris' nemesis, K-K. No sooner had the accusation against Şukru been dropped than Iris herself became the subject of the prosecution. K-K had little doubt as to who was the guilty party. Apparently, so Iris recounted, Ilknur with glaring eyes and a sulky manner without warning shrieked and screamed with an unexpected theatricality, fired up by sleep deprivation and her contempt for the handling of the loss of the terracotta. She and the governor engaged in a shrill but weirdly even discourse. The latter mutated into a bear at bay, hurling oaths and imprecations, until facing Ilknur's anger with a wave of his hand the craven monster dismissed the proceedings with an open verdict. A question-mark was wilfully suspended over Knidos that could only be resolved in Ankara by the Minister of Culture.

Iris collected the mail from the post office, and then set back in the landrover for Knidos. She took Şukru and his taciturn father to Yaziköy, and then sped along the coast road. Once at Knidos she retired to her tent, probably with a bottle of bourbon, to reflect upon six days of exultation and torment. Ilknur disappeared to be with Ender, plainly ravaged by the sordid catena of events and the charmless politician. Next morning after roll-call Iris bounced back in her own way and time and water-skied for hours. Halil returned to a warm welcome. Şukru himself returned a fortnight later, and was treated as though nothing had happened. Life at Cape Crio was tightly meshed, robustly fortified against grudges and bitterness. Honour and integrity were valued, but family –the one big family, was supreme. No pirates, just temptations: Iris had recognized this and had proved firm and positive when it counted. Gestures had been eclipsed by actions. Terracotta statues mattered less than the lives of children, even if they had

an archaic antiquity. The incident revealed that we could trust the friendship and integrity of our workmen, and that it was best to stay far away from the petty twentieth-century pashas. As for the stolen terracotta, we began to believe that in the excitement of discovery no-one counted them in and so the number was inflated and the lost one never existed in the first place. Our theory was that Mehmet's head was addled by votaries rising nightly like phantoms from the Round Temple. In his imaginary community there were thieving devils not unlike the pirates Newton had to face.

It was an expedient explanation; but as events would show it wasn't true.

10

Vomatorium

'It's a devil of a business,' I could hear the soft cadence of Sheila's whisper, the Irish inflection being on the devil. In the amorphous dancing shadows cast by the tilley lamp I sensed Marie Keith's presence, her face screwed up by anxiety. Marie dabbed eau de cologne on my forehead and then was eviscerated. I was asleep and yet awake, felled by the vicious bug that had already struck Henry and Tim.

Tim was the first. Two men carried his limp body to camp. For a moment he looked dead, an impression accentuated by the dust-frosted faces of the workmen wearing googles against the ruthless gale. Two others carried his belongings in this funereal procession. He had been stricken mid morning but resolved to resist and, with dehydration, matters worsened. The wind consumed us in its violence, whipping the harbour foreshore into a whitened frenzy and shrieking in our tents. By early evening Tim's temperature soared and Marie and Sheila debated evacuating him to Datça or even Izmir. Fearful for his lifeless condition, knowing there was no way Tim would fake it, Iris took the Zodiac around the sleek yachts anchored in the Commercial harbour to ask for help. The rubber boat was tossed up and about but finding her balance Iris seemed not to care. On board one yacht she discovered a pliant Italian doctor who came ashore and administered drugs that soon brought respite to Tim. Before long all the yachts drifting erratically at anchor were emptied and the bars filled to the rhythm of the saz and drum. Alternately half muffled then as sharp as a beat, the music seemed to measure Tim's grim

struggle. Marie, Henry and Cathy took it in turns to watch over Tim, and from time to time to bear him up the worn path to the loo with a view with its sack walling ripped and flapping.

For a day Tim sweated it out comatose in his tent, the Stepped Street excavations being commanded by the German pottery expert in his place. It was a mendacious move on Iris' part. Had she really thought through the consequences? Everyone knew Tim's views of the pottery expert who water-skied with the Big M before the baying workmen. Did the very thought of her meddling with his stratigraphy prompt his recovery.

No sooner did he leave camp, his back arched and bent with lingering cramp, than Henry was cleaved by the bug. Then it was my turn. Having been at Knidos for almost two months, I felt impregnable to illness. I was wrong. I had been invited to a dinner at Cengez's for a yacht-full of Turkish film stars. Waxwork characters improbably thrown into relief by the authentic, Levent, a friend of Bülent and Ilknur, who arrived on horseback from Çesmeköy. Statuesque and carefree, he was studying archaeology at university and chanced his arm to get an introduction to Iris. Iris, glowing in his presence and her stardom, ordered both more wine and Mumtaz to dance, that he did with Levent. We danced, drank and had little sleep.

I had an elemental premonition as intense as any hangover. The following day it was a struggle to stagger down the path, listening, concentrating upon Mumtaz as he chattered, ignoring yet knowing full well I was set to be the new victim. I collapsed to sleep, I awoke ten hours later to discover the caring faces reminding me of my mother, and then I slept on. The violence was exaggerated by the whispering flushes of wind after the furious storm. Thirty-six hours later I awoke, and on Iris' instructions, was assisted onto a mule and led up to the Temenos where, prone beneath the olives, I dozed and smiled

wanly at the innate gentility of the men. From time to time the men checked on me, to tease me that I was hungover from being love sick. Each day I mended but it was a week before I wielded a pick again, unlike the workmen who struggled when they contracted the bug but could not afford to succumb to it. Their hollow faces bespoke to a torment I could only half understand. Unlike the storm, that faded away, the dysentery left a legacy.

Our illnesses were intrusions. The excavation machine proceeded with biblical proportions while yachts came and went, and the Big M careered around the harbour with Barbara on skis. In each trench the force of effort lowered the levels resulting in precarious towers of fruit boxes of pottery to be washed and processed. Days were passing towards the end of the season and team members were departing, making more work for fewer of us. The scale of the project now complicated matters. Like any ambitious director Iris was not to be distracted from her objective. Yet she had lifted the lid of Pandora's Box when she found the terracotta figurines and compounded her problems when she sought to purchase new land to dig around the Round Temple. Land purchase meant dealing with the Turkish state. Her maudlin nemesis, K-K, the sub-governor and the local judge responsible for the legal transfer of the land, were now drawn to her like moths to a flame. This boded badly from the outset.

Newton, judging from his memoir, had enjoyed his dealings with local potentates:

'I have lately had a visit from a remarkable character, who rules this peninsula…. His name is Mehmet Ali – he is Aga of a place called Datscha, halfway between Cape Crio and Kjova, and near the site of the ancient Acanthus. Smith paid him a visit in the autumn, when we purchased some timber from him. He

is Aga, and can trace his descent from Dere Beys for several generations. He lives in patriarchal fashion, with four harems, flocks, herds, bee-hives, fig-trees, and gardens innumerable. His progeny is so numerous that he is putative father of half the children in his village – all of these, the offspring of concubines, run about in rags, while the rights of inheritance are reserved for the two recognized sons, both children of a beautiful Circassian, a present from Halil Pasha, the late brother-in-law of the Sultan, in exchange for a landed estate in Cos.

'Mehmet Ali, though he possesses four harems and much wealth is not, like most rich Turks devoured by indolence. He is a shrewd hard-headed man of business who ought to have been a Scotchman.... He had that restless inquisitiveness about general knowledge which characterizes the Greek often, but rarely the Turk. I had just received *The Illustrated London News*, with coloured prints of Delhi and other Indian cities. I gave him these – he asked the name of each city, and, taking out his reed pen from his girdle, wrote it on the top of the picture, adding a descriptive title, which embodied such scanty information about the place as I was able to give him.

'Mehmet Ali usually travels about his small peninsular kingdom accompanied by his Cadi, Imam, and other cabinet ministers, all mounted on small mountain horses, then come three of four peasant attendants, with long guns... As for ... provisions, the villages en route are bound to provide them.

'Mehmet Ali has one great merit – he is perfectly aware that an Englishman must eat. In the present destitution ... a party of hungry Englishmen are regarded by the natives as a nuisance, only less than that of the locusts. The difficulties of victualing our small messes at Budrum have required incessant trouble, much of which naturally falls upon me. I had not been two days encamped here before a messenger arrived with ten fowls.... When he arrived himself, there came a sheep, a good supply

of eggs, honey, and figs ... Now you may, perhaps, ask why does
Mehmet Ali show so much friendship for me? He has two good
reasons. First, he wants stone from Cnidus to build a mosque
... secondly ... he has certain enemies at Mughla, who must be
put down by the intervention of the Pasha of Smyrna. "I dare
not complain of the wrong that has been done to me, except
through a Consul – they would crush me!" I wonder how many
days I might have waited for eggs and mutton if Mehmet Ali
had not had a grievance at Mughla!'[29]

The K-K was no Mehmet Ali. The Ottoman legacy was
thoroughly debased by 1971 and the extant martial law would
have shamed Atatürk too. K-K was full of sophistry as the
verminous judge accepted Iris' bourbon and they all roundly
scolded each other, generating voluble spite at odds with the
mellower temperatures following the fury of the tempest. The
landowner in attendance had pendulous trumpeter's cheeks
and a smiling mouth below a grand moustache. With almost
saintly resignation he kept his silence as the potentates scorned
Iris for her greed and for stealing. Iris studiously ignored them,
in so doing perhaps discomforting them, but of course all this
meant she redirected her eye away from our equilibrium.
Perhaps the K-K sensed this thanks to the Big M's growing
intimacy with us, because in the end the sub-governor bullied
Iris into a pact with the owner that poisoned her mood.

That night after dinner she sat and drank alone until Tim
approached her. Tim was on a crusade, succumbing to a late
summer madness after two months at Knidos. Barbara's skiing
antics with her venal beau were as festering as the fast
vanishing aftermath of his illness. His voice was as firm and crisp
as ever, even if his body was thinner and arched. Tim began
politely, asking to cease digging in order to focus upon the
drawings to be made of the Stepped Street. Iris glared at him,

[29] Newton, *Travels*, 162-66.

her eyes scorched by her day with the potentates. Brusquely she refused. Like a mule he refused to reverse or even cogitate his next action. Instead he bellowed and indignantly exhorted that he would stop the dig anyway. With one definitive word – 'fine' – she felled him. Then she followed through with the thrust of a rapier: Barbara had been his stand-in when he was ill; she would now supervise the excavations. Had she planned this? With this somersault completed, Iris sipped her four fingers of bourbon and stared defiantly as Tim vanished into the dark.

Iris stuck to her resolve; so did Tim. Barbara was introduced to the men at roll-call the next day as the new site supervisor. (She needed no introduction as they all knew her rather too well.) In the meantime, with dawn Tim was on site making his drawings. Hunched over the drawing board as I climbed up the steps, he was consumed by his race to honour his responsibilities. Wearing a broad brimmed straw hat, Barbara arrived at the dig as though it was a garden party. In a thin reedy voice she barked some orders and then withdrew to the shade. The upshot of this was plain to the workmen at the Stepped Street and with the water boy the news arrived at the Temenos. My men soon found a moment to caucus and confess they were disconcerted. The black humour gave way to anxiety about the future. There was no love for Tim but he was honest and worked with a passion they understood. His collaboration with Sheila earned their admiration, her drawings being works to marvel at. What would the Muktar do now? The answer to this question I learnt only when I reached Istanbul. After nearly two months of daily wages, the men had come to bank on this income and regretted the signal that all might end.

The men had a canny grasp of camp politics. That night the furies were unpacked as dinner drew to a close. Marie was determined to scold Iris. Perhaps she had had a gin and tonic with Sheila first. From the outset as they sat at dinner, things

went badly wrong. Table placement provoked it: Iris being flanked by Barbara and Marie, with Henry a place further beyond opposite Margot, and Tim nowhere to be seen (he was still drawing with tilley lamps!). Marie reproved Iris in a schoolmistress's tone, leaden and slow, measured by elemental insecurity. She pleaded Tim's case, fully knowing that Iris was capable of cutting her and the five-year sojourn at the Temple of Dionysos. Iris haughtily dismissed Marie's advocacy as nonsense. Tim was impossible, now she was being impossible. Why were they all being impossible? Didn't they understand the demands of her donors? She was about to get up from the table when Henry attempted to diplomatically intercede. Instead he lit the fuse. His flippant remark aimed at Barbara being a passionate water skier made in jest lingered in the air. It ignited Iris. Her wrath silenced the table.

'You don't say things like that here, Henry. It's unforgiveable. Tim is a traitor', she screamed back at him, rising from her winged seat as she did.

Henry, shaped to be emollient but his own bile, contained in the face of endless provocation over the previous weeks, escaped him in a rush and he barked savagely at Iris. Everyone drew themselves up from the table. Iris escaped into the protective anonymity of the dark and perhaps her tent and Henry, after muttering to Marie and Sheila, strode off too.

The warriors were sulking, I murmured to Midge. She shook her head and she was right. We had witnessed the end of the digging season, all because Iris had favoured the fawning Barbara on a whim.

At midnight Henry marched out of Knidos and walked by the light of the crescent moon to Datça. A day passed during which Tim completed his records, which that evening before dinner he deposited in a pile in the finds' room. Duty done, the following morning, Marie and Tim left Knidos. No

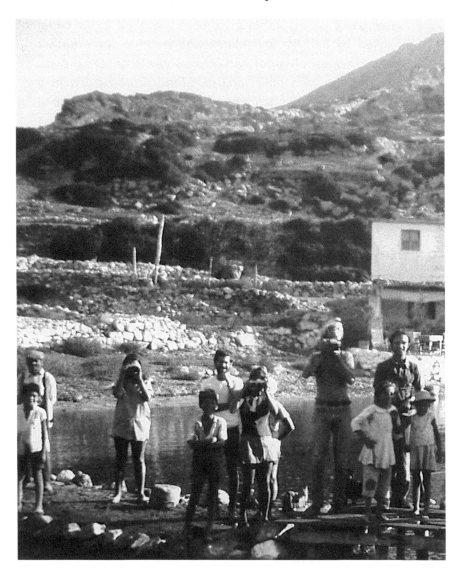

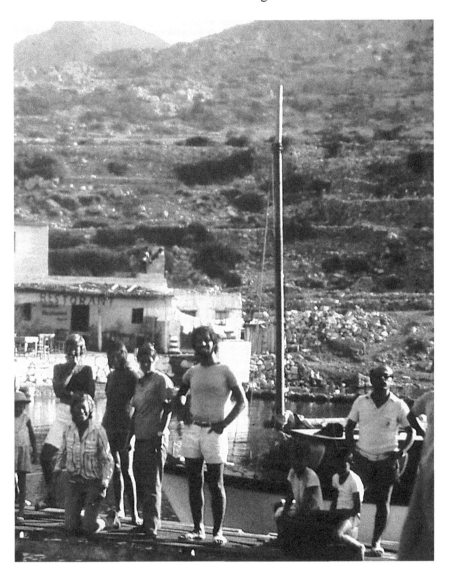

Goodbye to Knidos
(with Ruşan's bar/restaurant behind) (photo by the author).

rapprochement occurred with Iris. Tim had informed his men who lingered faithfully after roll-call to salute these two spurned chieftains. I was at the top of the Stepped Street when their landrover sped by. I waved but they were staring sourly ahead, doubtless aware of Barbara standing at the bottom of the excavations, alone and now ill at ease. The rupture, eventually traceable to the terracottas and the ensuing visit of K-K, was complete.

Emptied of my companions, my thoughts immediately turned to leaving too. I would make for Istanbul. I found myself between two worlds, embracing Knidos yet drawn to another that I did not know.

The excavations in the Temenos of Demeter had reached a good point to pause them. No great discoveries or trophies had been found, but the half-millennial story of the place had cohesion. After seeing Marie and Tim drive off I busied myself with completing my notes and drawings. This was not the Stepped Street and in a day my record was complete. A plan of the trenches, detailed plans of each trench and a selection of elevation drawings all made to scale. No-one would continue to dig here. Instead the workmen would be allocated to the few trenches still being dug.

Departure was either by jeep, as I had arrived, or by caïque. Midge asked me if I would accompany her to Izmir from where she would fly to Istanbul, then London, then New York. I willingly agreed, treasuring the details of these last hours.

The atmosphere was so soured by the rupture, and Barbara was now the new Marie and everywhere in Iris' shadow or possibly her twin. It was both comic and grotesque because, passing the Stepped Street excavations, she left the workmen to excavate whatever they wished. Mehmet the lighthouse-man sought out Midge and me at Ruşan's. His sardonic, bloodhound

eyes said all without a word: we were leaving Knidos to the Muktar's woman. He offered to take us to Bodrum in his caïque.

A full assembly bade us farewell. Iris made it an occasion. Was she cauterizing the wounds left open by the bitter departures of Henry, then Marie and Tim? Mehmet's tidy blue and white caïque was tied up at Ruşan's dock. The puffs of breeze combed the harbour water, forcing it to slap the caïque, which in turn rocked a little against the jetty. Here and there dribbles squeezed through its stolid planking. Midge looked long and hard at it, but we knew it was a preferable vehicle to the wretched jeeps to Datça and then to Marmaris.

In the bright early autumnal dawn most everyone was gathered to salute us. Apprehension trembled within me as I renounced this hard-won company. Would it have been wiser to stay? I had to leave, I whispered to myself. Only Mumtaz now tied me to Knidos.

I kissed Emin firmly on both cheeks, and then Mumtaz and each of the Temenos men who had been permitted a brief furlough to wish us god speed. Each removed his cap as I shook his calloused hands for a final time. I stooped to kiss Sheila who promptly patted me on the back and I kissed Iris who held me in her grip and looked into my eyes to thank me and wish me well. I have no doubt she meant it. I had no doubt, too, she really had no idea who I was or why I was there but I had not caused her any problems and for this small mercy she was willing to expend a few courteous moments now. By Iris stood Ruşan, bashful in the fullness of daylight. Midge exchanged a word with him and then we eased into the boat, avoiding the shifting bilge water close to the keel to find our places next to Mehmet.

From the caïque I was drawn to Mumtaz's baleful eyes. After *paydos* last evening I had given him my dictionary, paper and pencils in the hope that he might learn a little English to help

him when the tourists eventually came. He had asked if I would seek out Nermin. Nermin was very beautiful, he said firmly. The elder Hussein had nodded in agreement. Now I thought of the Temenos, left to the soft sound of the breeze as it worked its way through the olives to be blocked by the cliff beyond. No-one was digging today and perhaps decades or centuries would pass before anyone dug there again.

Captain Mehmet whipped the cord of the engine and it charged unevenly into life. He stared hard at it, willing it to work on all pistons, and after some moments it did. Ruşan cast us off. Iris shrieked above the engine noise. She had infectiously shrugged off her brooding and that's how I remember her. At her feet the two badger-baiting dogs anxiously nosed at the bubbling water slopping up now through the uneven planks of the jetty.

Level with my tent, Knidos rose up around the boat, Strabo's metaphorical theatre. Mehmet the *beci* and his tiny wife came out to wave as the lighthouse-man opened the throttle sending a plume of smoke into the air. We arced around level with the Lower Theatre where we had watched shooting stars quitting the brimming treasure box, past the Stepped Street where the men all paused then gathered to wave. Midge blew them a kiss and they waved more intently. Barbara was nowhere to be seen. With unerring certainty Mehmet directed the little craft through the turquoise channel between the ancient moles below the emptied Temenos and then out to sea towards the Lion Peninsula, before circling back to follow the crags of Cape Crio as far as the lighthouse. Triopion being past, a shadowy triangular outcrop, he throttled into the open sea like a dancer entering an open stage.

The sea was a cobalt mirror, empty of other craft. The hard echoing throb of the engine made us self-conscious but no-one now occupied any vantage points. We had gone into a horizon

merging with a sheltering blue sky. Mehmet upended a pitcher of raki and drank long from it before thrusting it at Midge then me. We both declined with uneasy smiles. My mind wandered to the day before, tidying up the spoil heaps to leave the Temenos in good order. Where was Mumtaz now, I wondered?

Far ahead, after two silent hours the shadowy perturbation that was St. Peter's Castle became a fix on the horizon. With each moment Bodrum and its castle assumed definition as our vessel ploughed closer. Mehmet hunched forward, alert as he guided us into the great bay past sloops and water-skiers across hushed waters. It was still early for the resort town. At the harbour mouth he adjusted the throttle. The engine gasped, sucking at the surface, and for some moments we glided over silk. The world lay before us after our Odyssean adventure. How out of time we must have appeared. The end arrived in unsuspecting moments. Mehmet docked and bounded artfully ashore, and a man in a cap pinched his cheeks. The engine cut and then we too were ashore and released from the time capsule. Mehmet embraced us, first Midge then me, and a bloom of raki lingered on long after we had left the pirate to resume our lives.

We took a coach to Izmir and I left Midge at a hotel on the seafront before taking an overnight bus to Istanbul. With dawn I was at the Bosphorus, shrouded in murky clouds after a thunderstorm. This aging impoverished city of minarets buried beneath melancholic empires was both shabby and exultant, and as Nermin had hinted, unimaginable in its glorious setting. At my lowest ebb, alone for the first time in months, crossing to Galata, in anticipation I realized with a start that I had forgotten Knidos and Mumtaz.

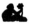

In a mocking tone Ilknur told us that Barbara had been manipulating the Muktar to steal antiquities for her Istanbul boyfriend, the corpulent visitor who interrupted my swimming lesson. All was revealed when the pottery expert was caught *in flagrante* with the Big M by Iris and a throng of fawning visitors in the Vomitorium of the theatre. Was it really true? It was a good story but hard to believe. Vipers lived in this dark lower entrance and the men were congenitally fearful of it. If true, did Iris learn from the debacle? Soon she too was to quit Knidos, though I suspect it has remained eternal for her in her Manhattan fastness. A lifetime has passed since all this supposedly happened and the stories have become myths. How might Aphrodite and her rival, Demeter, have appreciated us as archaeologists and, of course, as lovers?

Epilogue

'Journeys, like artists, are born and not made', Lawrence Durrell preached. Of this I am now certain. Knidos led me through the eye of a needle into a career as an archaeologist that in 1971 seemed as unlikely as me walking on the moon. Knidos was the start of my Mediterranean journey. There, before, during, and in its myths, I was born. Aged 18, privileged to excavate the Temenos of Demeter, I began a journey that continues on other shores of the Middle Sea. Knidos gave shape to other archaeological excavations. With each I have advanced, towards maturity in southern Italy, traveling onwards in Albania and South-East Turkey, and racing towards old age now in Tuscany.

I look at eighteen-year olds today and wonder how could I have been so fortunate. Inevitably I try to pass through the looking glass to see myself. The waif with the mop of sea-swept hair in faded colour photographs was scarcely separable from the village youths from Yaziköy. What of my tone, my inflections, my flights of bombast, my demeanour and above all my ability to do the job asked of me? Was I not so young as to be all but invisible? My notebooks survive and the entries want me to believe I rose to the challenges. I have only one solitary raw splinter of regret. When, months later, Henry asked for my final report on the Temenos excavations I failed him, not meeting the standard. Henry – correctly for sure – felt compelled to rewrite it. The published content is suitably convincing thanks to him.

Young and perhaps presumptuous, I learnt to learn. I learnt to be part of a team. I learnt to respect millionaires and peasants equally and differently. Really, I do wonder about the

gilded patience extended to me by Iris Cornelia Love, Henry, Tim, and Sheila amongst others. Iris was right, though, it was a magical place and that magic consumed us in our Cape Crio isolation. Friendships made there introduced me to cultures and worlds that lay beyond my comprehension. The greatest blessing was working with the men from Knidos' villages. Now consumed by the end of the Mediterranean peasantry, their memory and kindness entered my blood stream.

A dig provides the opportunity to be as still as a needle, to watch the place, to whisper to it and to hear its whispers as the sun arcs from dawn to dusk. Over time, tuning in, the spirit makes itself known. Was it Aphrodite or Demeter who reigned over Cape Crio? Aphrodite sprinkled some elixir on us all and shielded us with some invisible protection. She gave purpose to the excavations. Through Iris she also found a priestess to shape the daily rhythm of our community. Truth be told, terracotta figurines and disquisitions on bust 1314 apart, I cannot separate the goddess and her presence from the orgasmic pleasure of Durrell's marble Venus plucked from the sea at Rhodes: 'such was the grace of her composition ... that the absence of firm outline only lent her a soft and confusing grace. It is as if she were made of wax: had been passed very rapidly across a flame intense enough to blunt her features, yet not materially to alter them: she has surrendered her original maturity for a rediscovered youth'.[30] Perhaps, but was it not her suspiring eyes as much as her silken figure that ensured her eternity in a multitude of imitations? Supreme as she was, though, her gaze was directed at sailors. Famed for its Aphrodite, paradoxically the goddess abandoned the metropolis to isolation and occasional rupture. More than a century ago E. M. Forster commented sardonically of a wet visit to Knidos: 'There are some places that are safe from

[30] L. Durrell, *Reflections on a Marine Venus* (London 1953), 37.

popularity'.[31] Aphrodite's own legacy is to be found elsewhere. Indeed, speak of the Round Temple and it is its imitator at Hadrian's Villa near Rome that sparks familiarity not the Knidian original. Pastiche has eclipsed the authentic original.

A heinous thought then: Perhaps because of the celebrity of Aphrodite as a seamark, it was fitting that her parts should end up secreted from Christian fundamentalist lime-burners in the Temenos of the harvest goddess. Demeter ruled Knidos from its heights. She provided Knidos with harvests and with the fertility for the future. It was Demeter's fate like the great lion to be transported to Bloomsbury to elicit admiration from Victorians. Millions continue to take pleasure in these trophies. And perhaps it was Demeter whose grace nurtured the young Newton to become a commanding figure of classical archaeology. Newton's journey was not born at Knidos but it was the point of inflection for a career that reduced Triopion to no more than a bold Levantine footnote, as his obituarists observed.

The goddesses squabbled over us as over any group of warriors. Henry went on to excavate at Carthage and in the Forum of Rome, and taught archaeology at Cambridge. Tim won the enviable distinction of being appointed archaeologist to many of England's great cathedrals. Sheila Gibson dedicated her life to making the architecture of ruined monuments live again as identifiable buildings. One of archaeology's great treasures, she passed away in her eighties leaving many friends and a great vacuum. I found it hard to say goodbye to her after thirty years and did so in a short essay, ten years after organizing an exhibition of her drawings including those made at Knidos.[32]

[31] E. M. Forster, *Abinger Harvest* (London, 1936), 170.

[32] Sheila Gibson, *Papers of the British School at Rome* LXX (2002), ix-xiii; *Architecture and Archaeology. The work of Sheila Gibson* (London, 1991).

Of the many others I know much less. Bülent became a distinguished architect in Ankara, but of Nermin and Ilknur I know nothing. I met Nermin's gentle father, the schoolmaster poet. In Istanbul she introduced me to the world that Orhan Pamuk has so lyrically described in his memoir of the city. These times were precious, but passed and following the cruel murder of her father that winter, we were never able to connect again. Of the Americans I occasionally received postcards and in recent times emailed greetings with photographs attached.

Mumtaz Sariyaz has been in my mind like a parent for all the decades since. I sent him a colour photograph of himself. His legs crossed he is posing uneasily but not without vanity by a stick of orchids overlooking the Trireme harbour. My eyes are drawn to his hawkish grin, indelibly printed on my memory. Of course, he replied months later. The envelope was addressed by 'mumtazsariyaz'; inside was a page torn from my site notebook. I have it still and feel attached to its soft touch. Did he take the page from the actual site notebook, I think to ask myself? If he did, it reveals his trust in me and I smile because of course I want to believe this. Along with my notebooks and the colour snaps this letter and paper belong to the penumbra of my life.

'My Friend RICHARD Hov your do yuu Hello I AM I am English *Çok Söyle böyle* Please' followed by lines in Turkish spliced with one or two in English urging me to return. Below the carefully exercised ink cursive, was a pencil drawing of an eagle carrying the missive. Spare in its simplicity, it belonged to a break in the day at the Temenos, the *sigara mola*.

I wonder often when I catch the aroma of thyme how he managed modernity and the demise of his world with his timid lad and his shrewish wife. I picture him with honey slipping out of his hand, weighing up whether to give due respect to Nermin and me or to struggle with the odium of the bees.

Iris continues to inhabit Manhattan's society pages.[33] Something of her atavistic aura and her capriciousness accompanies her. Her eyes appear undimmed and her passion for Knidos no less infectious. Yet in recent years she has spoken elegiacally in public fora of Knidos. Weighing things up, perhaps she is recognizing the mistake she made. Iris published excellent reports for her first six seasons. The reports then ceased as did her career in archaeology. She left Knidos to others in 1977. The notebooks, drawings, and photographs from the many excavations over incalculable months are perhaps archived somewhere. Posterity may retrieve them and make something of their import. Not so the washed and marked crates of bursting bags of pottery ignobly stacked for decades outside the museum at Knidos and now returned to be the detritus of the place. Their meaning without the notebooks has long disappeared and with it all those thousands of hours of effort.

All that wasted work makes no sense. Friends rationalized this as follows. Iris never sought a career as a university professor. Publishing for her peers, therefore, lost its lustre once she quit Knidos. Being a financially independent heiress she made a second career breeding dogs. She was quoted as declaring: 'God bless my grandmother', referring to the trust fund from Edith Guggenheim Josephthal that has largely underwritten her unorthodox career, 'because I probably could never have become an archeologist without her.'[34]

[33] As this book was going to press Iris Cornelia Love passed in April 2020: https://www.nytimes.com/2020/04/23/nyregion/iris-love-dead.html.

[34] www.departures.com/art and culture/In profile/Mar 30 2010.

Was she ever really an archaeologist? Here is the rub. Iris belonged to those ranks who privileged discovery over science - Schliemann as opposed to the diligent Newton or the improbably fastidious Sir Mort. Reduced to discovery archaeology belongs to a world of celebrity juxtaposed with the watchful curation of the past and its treasures for posterity. Henry's refrain about Iris that summer was simpler: 'Lots of personality, no character!' Lots of film and interviews focussing upon Iris' personality. Character in the form of scientific reports to give the metropolis the scientific destiny it deserved are little short of a summer mirage. Iris' legacy at Knidos and in archaeology failed to do justice to her intelligence and resolution.

Iris was not alone in shirking the tasks expected of an archaeologist. Countless other excavation directors from these times were as negligent. Why, non-archaeologists ask, puzzled? It makes no sense. The explanation is an excuse. Writing up an excavation is no less punishing than the excavation itself, but takes even more time. Yet it is the measure of the responsibility to the place and the diligent people who participated in the digging. Trophies deprived of their context and place are orphans, rootless and without histories. This is not sophistry. Knowingly depriving art and object of context was and remains little better than looting. Unpublished, the sacred soil is traduced and its many histories and treasures wantonly dissipated. Iris surely recognized this, as now her dedication to Knidos lives on as no more than a marginal footnote about her celebrity, retrieved only with a digital discovery tool.

Aegean Airways to Rhodes; overnight in the city of the Knights; a hydrofoil dashing through the crystalline channels to the unedifying resort of Marmaris, and now a surfaced road barreling through Yazıköy to Knidos, serving myriad hotels awaiting reservations online. The dream of my Temenos crew has come true. Cape Crio is no longer isolated, though it is still the company of yachts that frequents the modestly refurbished bars on the isthmus. No Ruşan, of course. No Mumtaz and no tobacco is grown here. Returning to the Temenos after decades, I am surprised how easily the deep trenches are traced within the low scrub beneath the canopy of untended olives. The stratigraphy has a hardened patina but can still be read as Mumtaz and I did. Does it really matter that we found no marble limbs of Demeter, or a fragment of her nose? Not to Mumtaz and his men, who loved the airiness of the elevated Temenos and the relaxed direction I administered. Not to me, endlessly enchanted by this extraordinary setting. From the Temenos, in the "gods" of this Knidian theatre all the ancient city is as it has been for nearly two millennia. A landscape reverted to its own disordered patterning.

There remain transcendent moments before the sun plunges into the Koan sea as I follow the goatherd paths along the high contours past the monumental theatre to the Round Temple where, with dynamite, the sanctuary was discovered that housed Praxiteles' famed statue of Aphrodite. Standing here I think of Nermin, my heart gunning. After visiting her in Istanbul, she sent me Akurgal's guide to Turkish archaeological sites, inscribing the title page with a dedication in blue ink: 'many happy days from yours scintillating, Nermin'. Was it a

countergift for the promise of England? I honestly cannot remember but I keep it as an icon to those times.

Today, this little ashlar-made podium for the lost masterpiece continues to draw the yachting crowd, as it did when Iris Cornelia Love was a magnetic presence here. The salty aroma from plants sprayed by the Aegean along with the suggestion that this ancient Aphrodite thrilled many an ancient visitor still has an enduring appeal. Truth to tell, *pace* Aphrodite, the abiding mystery of Knidos is Demeter's legacy of a metropolis reborn as a blessed seascape wherein, despite Charles Newton's and Iris Cornelia Love's best efforts, a multitude of monuments and stories remain secreted.

Further Reading

Iris Cornelia Love published preliminary reports about her excavations in *American Journal of Archaeology*: 72, (1968), 137-39; 73, (1969), 216-19; 74, (1970), 149-55; 76, (1972), 61-76; 72, (1972), 393-405; 77, (1973), 413-24; 79, (1975), 214; 81, (1977), 303; 82, (1978), 324.

These are brief reports and do not do justice to these huge excavations. The best introduction to Iris herself as well as the excavations is Katherine Bouton's, The Dig at Cnidus *The New Yorker*, July 17th, (1978), 33-69.

Ian Jenkins, *The Lion of Knidos*, (London, British Museum Press 2008), includes a good introduction to Charles Newton and the Temenos of Demeter. Better still is Ian Jenkins's *Archaeologists and Aesthetes: the Sculpture Galleries of the British Museum 1800-1939*, (London, British Museum Press, 1992). This has an excellent section on Charles Newton and his Knidian expedition. Charles T. Newton himself amply described his expedition in *A History of Discoveries at Halicarnassus, Cnidus and Branchidae, (*London, 1862). The volume of folio-sized plates accompanying the lengthy text is a magnificent assemblage of early photographs and lithographs. Newton also published a shorter account of his adventures entitled: *Travels and Discoveries in the Levant*, (London, 1865).

Antiquities of Ionia vol. iii, 1821, often attributed to Richard Chandler (1738-1810), but actually by William Gell and his associates, provides the first clear picture of Knidos in modern times. A short description from the same period is to be found in Francis Beaufort's *Karamania or a brief description of the*

South Coast of Asia Minor and its remains of Antiquity, (London, 1817). This exceptional book is a gripping adventure story. A modern attempt to summarize the wealth of stories about Knidos, including fictional interludes, is Oktay Sönmez's *Knidos. Sleeping Beauty of the Blue*, (Istanbul, Livane Matbaacilik, 2003).

Acknowledgments

My thanks to Alan Morrell and Jonny Pollack who led me to John Colby and Brick Tower Press. Thanks, too, to Ian Jenkins for kindly reading the text for factual errors and encouraging me to pursue this project.

The cover was designed by Craig Coulthard with whom it has been a real pleasure to work. I am indebted to the Archivio Fotografico, Scala for permission to use the image of the Roman copy of the Aphrodite of Knidos in the Vatican Museum, to the British Museum for the Philips' portrait of Charles Newton, and the Institute of Archaeology (University College, London) for Walter Woodington's portrait of Sir Mortimer Wheeler. My thanks, too, to the Universitätsbibliothek, Heidelberg for their wonderful rendering of Charles Newton's work. The unpublished Konstantinos Cavafy poem, *On Hearing of First Love*, translated by Edmund Keeley and Philip Sherrard, is from http://www.cavafy.com/poems/content.asp?id=157&cat=4, the official Cavafy archive (originally published in E. Keeley and P. Sherrard, C.P. Cavafy. *Collected Poems*, London, Chatto & Windus, 1975, 143). Finally, my thanks to Sarah Leppard for the line drawings and Harry Greiner for his digital rendering of my old photographs.

This is a coming of age story – an especially privileged experience – which was made possible through the kindness of Iris Cornelia Love and Henry Hurst. I shall forever be indebted to them. It changed my life in so many wonderful ways.

List of Illustrations

Page 60
Charles Newton in a portrait by Henry Wyndham Philips
(courtesy of the British Museum).

Page 65
Charles Newton's camp at Knidos (from Charles T. Newton,
Travels and Discoveries in the Levant [London, 1865]).

Page 70
Charles Newton's map of Knidos (from Charles T. Newton,
Travels and Discoveries in the Levant [London, 1865]).

Page 80.
Marie Keith (second from right) and Matthew (third from left)
with Mumtaz Sariyaz and other workmen (photo by the author).

Page 85
Nermin pot-washing in the camp, July 1971 (photo by the
author).

Page 97
The Demeter of Knidos in the British Museum, London (photo
by the author).

Page 100
Votive statuettes from the Temenos of Demeter in the British
Museum, London (photo by the author).

Page 103
Plan of the Temenos of Demeter (after Ian Jenkins, drawn by Sarah Leppard).

Page 106
Mumtaz Sariyaz (photo by the author).

Page 121
Lindsey Folsom (centre) and the Temenos team with Mumtaz on bended knee to the right (photo by the author).

Page 131
The Round Temple of Aphrodite looking towards the lighthouse on Cape Crio (photo by the author).

Page 136
Sir Mortimer Wheeler, c.1970, painted by Walter Woodington (courtesy of UCL Art Museum).

Page 146
Above Knidos with RH (in hat), Cathy, Dick, Tim and Henry (photo by the author).

Page 149
RH and Dick Keresey (photo by the author).

Page 152
Charles Newton and the Lion of Knidos (from Charles T. Newton, *Travels and Discoveries in the Levant* [London, 1865]).

Page 158
The Lion of Knidos in the Great Court of the British Museum, London (photo by the author).

Page 162
Şukru and his wife on the road from Yaziköy (photo by the author).

Page 197
Goodbye to Knidos (with Ruşan's bar/restaurant behind) (photo by the author).

Index

Lightning Source UK Ltd.
Milton Keynes UK
UKHW020629020221
378106UK00011B/565

9 781899 694877